season

to

taste

season
to
taste

HOW I LOST MY SENSE OF SMELL
AND FOUND MY WAY

molly birnbaum

Portobello
BOOKS

Published by Portobello Books 2011

Portobello Books
12 Addison Avenue
London
W11 4QR
UK

First published in the United States in 2011 by Ecco Books,
an imprint of HarperCollins Publishers.

The right of Molly Birnbaum to be identified as the author of this
work has been asserted by her in accordance with the Copyright,
Designs and Patents Act 1988

Grateful acknowledgment is made for permission to reprint from
"Sonnet in Search of an Author" by William Carlos Williams,
from *The Collected Poems: Volume II, 1939–1962*, copyright © 1962
by William Carlos Williams. Reprinted by permission of New
Directions Publishing Corp. and Carcanet Press Ltd.

Some names of places and people have been changed in an effort
to protect their innocence. And some of the material in this book
was first published, in a different form, on the blog, My Madeleine.
Other small sections were first published in the *New York Times*
article,"Finally, the Scent of the City," on December 7, 2008.

A CIP catalogue record for this book is available from the British
Library

9 8 7 6 5 4 3 2 1

ISBN 978 1 84627 383 4

www.portobellobooks.com

Printed in the UK by CPI William Clowes Beccles NR34 7TL

for my family

. . . smell and taste are in fact but a single composite sense, whose laboratory is the mouth and its chimney the nose . . .

—JEAN ANTHELME BRILLAT-SAVARIN,
THE PHYSIOLOGY OF TASTE

CONTENTS

1

duck fat and apple pie

IN WHICH I ENTER THE KITCHEN

1

2

sour milk and autumn leaves

IN WHICH I START FROM SCRATCH

33

3

rosemary and a madeleine

IN WHICH I MAKE ADJUSTMENTS

67

4

fresh bagels and a boyfriend's shirt

IN WHICH I IMPROVISE

101

5

cinnamon gum and sulfur
IN WHICH I GET COOKING
135

6

pink lemonade and whiskey
IN WHICH IT STARTS TO COME TOGETHER
177

7

key lime and lavender
IN WHICH I TASTE
211

8

opoponax and cedarwood
IN WHICH I RETURN TO MY SENSES
257

epilogue
295

ACKNOWLEDGMENTS
303

season
to
taste

duck fat
and
apple pie

IN WHICH I ENTER THE KITCHEN

INSTEAD OF WRITING A COLLEGE THESIS, I read cookbooks in bed. I flipped through culinary magazines and food memoirs, burying my head in the biographies of iconic chefs until the early hours of the morning. After obsessively researching recipes online, I kneaded bread dough on my kitchen counter and assembled fat cakes layered with fruit and cream. I cooked intricate Middle Eastern tagines and watched chocolate soufflés rise slowly in the oven. I was studying for my bachelor's degree in art history, but in my final years of college I thought of little but the stove. I knew what I wanted: to be a chef.

Once I baked a different apple pie each week for months, feeding an ever-changing group of friends with plastic forks and knives in a cloud of cinnamon and butter, until I perfected

the recipe. As a result, I won a small scholarship to the Culinary Institute of America, the finest school for aspiring chefs in the country. I wanted to escape term papers and deadlines, Michelangelo and Gauguin. I wanted to master the formal technique of boning a duck, chopping a carrot, and curing a cut of pork. The only thing standing between me and my starting date at culinary school was the required experience in a professional kitchen.

Upon graduation, I returned to my hometown and moved in with my mother and her boyfriend, Charley. After days scouring the Internet for job listings, I picked one of the best restaurants in the city. The Craigie Street Bistrot, a pint-sized establishment in Cambridge, Massachusetts, was housed on the ground floor of a large apartment complex on a residential street near Harvard Square. I walked down a set of stairs to the dark-paneled entrance, opened the door, and poked my head inside. The dining room was light and airy. The scent of roasted chicken, which I had noticed as soon as I stepped out of my car in the parking lot, filled the room. A young woman was arranging flowers in vases.

"Hi," I said. "I'm here to apply for a job."

She smiled, but didn't look up from the bouquet of lilacs. "As a server?" she asked.

"No," I said, closing the door behind me. "In the kitchen."

She glanced at me, taking in my white button-down shirt and heels. In a manila folder under my arm, I had my résumé and cover letter, which outlined volunteer work in Africa and cashier positions at late-night undergraduate eateries but held nothing close to the scramble of a line cook over the stove. She said she

would get the chef, gesturing to a table in the empty dining room, which looked naked without people or plates. I sat.

Tony Maws, the executive chef and owner, emerged from the kitchen a few minutes later. He wore a stained chef's coat and fat black clogs; a long and frizzy ponytail snaked down his back. His nostrils pointed upward in his sharp-edged nose, highlighting a set of deep brown eyes. Known for sourcing his ingredients from local farms and a rabid enthusiasm for "nose to tail" cooking, or the use of every part of a whole beast, including the unsavory offal bits like the thymus gland or stomach, Maws had just been named a "Best New Chef" by *Food & Wine* magazine, one of the greatest honors for a rising chef in America. I stood and we shook hands. He glanced at my résumé and raised his eyebrows.

"You have no experience?"

I shook my head.

"And you went to Brown?" He looked skeptical.

I remained silent.

"How serious are you?" he asked.

"Incredibly," I said in a voice that surprised me with its volume. He stared at me. I didn't blink.

"Okay," he said. "But you'll start from the bottom."

He meant as a dishwasher. Maws promised that if I could handle the dishes, in all their oily, stinking glory, then he would teach me to cook—and not in the casual, dinner-party, *Gourmet*-magazine style. He would teach me how to handle a knife, wrestle a vat of chicken stock larger than my torso, and clean pounds of wild mushrooms in buckets of water, removing dirt from their knobby contours, bathing in their scent of liquid earth. I could

never abandon the sink and the dishes, but in our ephemeral free moments I could learn How To Cook.

ON MY FIRST DAY OF WORK, I paused inside the walk-in refrigerator. The heavy metal door thumped shut behind me and I inhaled the sharp scents of garlic and onions, vinegar and salt, fillets of tuna and grouper. A lamb carcass hung from the ceiling, sinuous and pink. A vat of chicken stock cooled on the floor. Four bins of fresh specialty herbs were perched on a corner shelf waiting to be plucked, their exotic labels—lemon thyme, anise-hyssop, Moroccan mint—reminding me how far I stood from my mother's suburban garden. I longed to touch the produce.

It had only been two weeks since I'd donned a cap and gown to receive my undergraduate degree. At the restaurant, wearing the uniform white-buttoned shirt and a bandanna tied tightly around my curly hair, I was surprised to find myself in a world that didn't involve laptops or cell phones, one where I couldn't sleep when I liked or lose myself in the silent recesses of the library hour after hour. It didn't involve much thought or speech, only movement and speed. It was a world filled with boxes of foraged forest mushrooms, stacks of chocolate bars from Venezuela, and plates of quail so carefully assembled that they arrived in the dining room looking like works of art. There were knives so sharp I didn't feel the slice on my finger until blood began to run down my hand. There were sauté pans so old that they no longer dented when the volatile head chef slammed them against the counter. There were eleven-hour shifts and sweat soaking every inch of cloth on my body.

I started with the herbs. The restaurant had dozens of organic

herbs delivered to the kitchen each morning. There were familiar ones like basil, rosemary, and thyme; and then there were the exotic ones, ranging from pineapple mint to Syrian oregano. They were delivered from a local specialty farm, tied in tiny bundles and labeled by hand. It was my job to clean and pluck the jumble of leaves and stems and have them ready for dinner service. I bent over the tiny metal table in the back corner of my workspace—a crowded hallway in the shadows of a staircase—and pinched my thumb and index fingers over the rough branches to release as many leaves as possible. Each herb left its scent printed on the tips of my fingers. There was the calm, woodsy odor of rosemary and the cool tang to mint. They blended into a mash of forest green that reminded me of trips to the plant nursery with my father when I was young.

"The most important thing, Molly," Maws repeated constantly, "is that you know the ingredients. If I hold up this chicory flower, you need to identify it in one glance. If I blindfold you, you need to know it as soon as it hits your tongue."

I painstakingly cleaned and tasted the herbs whenever I wasn't swamped at the sink with piles of dirty dishes. I tested myself constantly. I discovered that breathing through my nose, slowly and conscientiously, was the best way to understand the intricacies of such subtle flavor, which, Maws insisted, was the only way to become a chef.

One night in the small kitchen I watched from my perch at the sink as Maws prepared to butcher a thirty-pound fillet of tuna in the back hall. He held a long glistening knife, grasping it tightly by the handle with the sharp edge horizontal to the ground. He brought the blade sideways to his face and pressed his nose against the metal, sliding the knife slowly, painstakingly

lengthwise. His nostrils flared with each breath. *He even smells his tools,* I thought. *It's how he understands.*

I didn't spend my time with many knives at the restaurant. Instead, I was at the sink, spraying grimy sauté pans with the water nozzle. I constantly scurried to and from the bin where the servers wearing immaculate black aprons tied around their waists dumped the dirty dishes, lugging large stacks of plates to the electric sanitizer in the kitchen. I strained chicken stock and pulled delicate skeletons out of hundreds of fresh, glassy-eyed sardines. I stuck my hands into countless buckets of water and wild mushrooms—black trumpets, hen-of-the-woods, morels— to clean the slippery clouds of fungi. I sorted bunches of bright green arugula for the *garde-manger,* the line cook whose job was to make cold appetizers and dessert, and delivered them to his station, which always smelled of burnt sugar from the torched tops of his crème brûlée.

It wasn't easy. My arms shook with the strain of unaccustomed weight. My legs bore welts from hot sprays of oil, and my neck was constantly swathed in a thick layer of slime, the liquid detritus that clung to my body from the sink, from the fridge, from my late-night cleaning of the deep fryer. Maws expected perfection, and I was terrified of making mistakes. He exacted the best, though, and I spent my every moment in the kitchen watching. He moved with confidence and economy; butchered meat with swift, clean swipes of his knife; and could sear perfect fillets of fish using only the sound of its sizzle to gauge its progress. Maws plated soft poached grouper on an electric green sauce made from sorrel, scattering orange nasturtiums over the top like a painting. His flavors were bold, his concentration intense, and critics sang his praises. Only open for two and a half

years, the Craigie Street Bistrot had already been named "One of 5 Best Restaurants in Boston" by *Gourmet* magazine and the "Best French Restaurant" by the *Boston Globe.*

One late night in August I forgot to close the door of the refrigerator that held all of Maws's confits, the slow-cooked cuts of meat cured in oil or fat. At Craigie Street they were mainly an array of heartier parts: chicken thighs, lamb and duck tongues, and hunks of pork belly, which I had already spent hours pulling apart that night, my arms submerged to the elbow in buckets of slick yellow fat. When a sous-chef discovered the door wide open two hours later and told the chef, I watched Maws's jaw clench. The contents of the fridge were—*thank God,* I thought—fine. But I could have ruined thousands of dollars' worth of food. My hands were shaking as I approached to apologize. I braced myself for the chef's voluminous, vocal anger. But instead he just looked at me for a moment, his gaze level and serious.

"This is a restaurant, Molly," he said. Disappointment dripped from his voice.

My guilt hindered my movements for the rest of the night, clumsily cleaning heads of garlic for hours in the back. At 1:30 a.m., after we had finished dinner service and my fellow dishwasher, Santos, and I had completed cleaning every crevice of the now empty kitchen, I heard Maws call from his office.

"Molly, come here for a second."

"Yes, Chef?"

I came running.

"One of the trash bags split in the trash compound outside," he said casually, not looking up from the papers on his desk. "We seem to have a maggot problem."

Oh, shit, I thought.

"There are three five-gallon buckets that are . . . not pleasant. You need to bring them in and clean them." He smiled. "Now."

I cleaned out the buckets filled with juice from the torn bags of garbage, stinking of meat and milk and the sour stench of active mold, as the tiny white maggots writhed in the sink. *What am I doing here?* I thought as I scrubbed, breathing through my mouth and trying not to gag.

But I knew why I was there: to learn. I learned to listen to the sound of meat in the pan, to smell the endnote of the nuts toasting in the oven. I learned to judge by color and texture, to leave the safety of published recipes and instead operate with the senses alone. Maws could be tough, but he never failed to inspire. With his pleasure, the kitchen blazed—the fresh rolls perfuming the hallway with fresh butter and yeast. I tackled herbs and garlic, lamb's tongue and rich logs of *pâté de campagne.* I peeled beets and shallots, chopped onions and churned bundles of arugula around the barrel-sized spinner again and again until they were clean and dry. I was learning the basics one by one. That was the only way to become a chef.

Before service began one night, I stood at the sink in the kitchen while the rest of the staff prepped at their stations for dinner. I had just finished filling the bottles of oil and replenishing the chef's supply of butter when Maws arrived to take his spot. He looked over at me and smiled. His grin was broad, almost manic when paired with his chef's knife in hand. The first orders of the night were just about to come, and he stood poised. Ready to cook. Excited to feed a crowd. "This is what I live for, Molly," he said. "This is life."

During those long sweaty nights, the act of eating had never been so satisfying. My appetite roared in the face of so much

physical work. It was a hunger I never experienced in the desk-bound days of school. I plunged my fork into the massive frit-tatas, bright with green basil and red peppers in the sunny crust of eggs, which Maws cooked for the meals shared by staff before the work night began. During service, the sous-chefs would hand me samples of butterscotch ice cream or sour milk panna cotta, whispers of sugar and cold that I ate between the clouds of steam released from the sanitizer with every load of dishes. I took small bites of crisp-roasted quail and creamy Macomber turnip puree, of a buttery rabbit sausage and the marrow scraped gently from inside the bone. I inspected the sear of hanger steak's flesh, ex-haled the minted song of a sorbet.

Once, a young female sous-chef who wore her wispy blond hair tied back with a bandanna turned to me with a piece of toast. I felt tired and frustrated in front of the sanitizer after spraying myself in the face with the dishwater for the eighth time that night. "Molly," she called with a smile. "Would you like a snack?" She handed me a thick hunk of bread that had been slathered with foie gras: salmon pink and flecked with fleur de sel, a rainbow of ground pepper. I took a bite. It was smooth and fat against the flaky crust. It tasted of the earth, an intoxicating flavor that screamed decadence and delight, one that immedi-ately took me back to a happy afternoon in Paris, when I first tried the goose liver pâté with my college roommate Becca.

One afternoon Maws arrived at the restaurant for prep wear-ing denim shorts and a ratty blue T-shirt. He looked alien with-out the usual baggy whites. Together, hunched over the table in the back, he taught me to clean the case of Georgian shrimp that had just arrived. We peeled the shells off their slick gray bodies, slit open their backs, and removed their delicate digestive tracts.

We kept them in a metal bowl resting in a box of ice, which soon smelled of seawater and fish.

"Seafood," he told me, "is ideally kept at a temperature just a bit over freezing. The refrigerator is still a little too warm. Even those few degrees affect the taste." I hung on to his words. I nodded.

He worked deftly, his fingers moving far quicker than I could coax mine.

"Do you read about food?" he asked me after a moment's silence.

"Yes. Of course."

He had never asked me a personal question before. I was surprised.

"What?"

For a moment every single name vanished from my mind. I tried to picture my bookcase. I began to rattle off a list of journalists, writers of essays and warm coffee-table books.

Maws looked at me. His raised his brow.

"Get your head out of the clouds, Molly," he said. "Read about *real* food. Leave the romance for later."

I bought myself a copy of Harold McGee's *On Food and Cooking: The Science and Lore of the Kitchen* the next morning before I drove to work, ready to read about the chemistry of sauces, the evolution of bread, and the effects of temperature change while cooking fresh meat.

"That's more like it," Maws said with a pat on the shoulder as I reported my purchase back, heaving a stack of plates to the sink.

My nights in the kitchen flew by. For nine weeks, the unending parade of filthy pots and pans was sustained by quiet lessons

with the chef and a sincere hope for the future. I breathed in the potent scents of sorrel and garlic, mandarin and curry, tongue and jowl and thigh. I closed my eyes. I concentrated.

I arrived home in the early hours of the morning reeking of chicken stock and duck fat, my clothes stained with grease and crusted in melted chocolate. My body always hurt. It was an arthritic pain—especially my hands, from holding and washing so many heavy dishes, and my back, from lugging large vats of stock from the kitchen to the fridge and back again.

I loved it.

I had entered into a world that challenged me, that frustrated and delighted me, one where I could grow. I felt, for the first time, like I could see my future, like I *knew*.

WHEN I WAS SMALL, my mother baked strawberry-rhubarb pies. She used a recipe that once belonged to her own mother, handwritten on an index card stained with spice and time. I would sit on the kitchen counter and watch.

She would move quickly through the kitchen, gathering bowls and ingredients. A thin woman with her straight blond hair cut short, she chopped rhubarb, sliced strawberries, and rolled the flour-dusted dough with harried precision. I usually disliked my mother's speed, like when she took me to the mall and I had to bob and weave through the crowds in order not to be left behind. But I didn't mind it in the kitchen. Perched at the counter I wasn't underfoot. And I loved the cold, smooth feel of dough. I loved the salt-scented undertones of butter.

Stalks of rhubarb were handpicked on summer afternoons from our haphazard suburban garden out back. They were light

pink and speckled in green and lay waiting on the kitchen counter like a stack of alien antennae. Even when chopped and tossed in a bowl with strawberries and sugar, the filling didn't lose the harsh sour tang, which puckered my mouth when I plucked little mouthfuls and ate it raw.

I would watch my mother load bright scoops into a dough-laden pan, sealing the top crust to the bottom with a quick pinch of the fingers around the edge. I kept my eyes on the extra scraps of dough, making sure my mother kept a little pile off to the side. She always did. It was the most important part.

"Baby pies," my mom would say.

"Baby pies," I would repeat.

The fondest memories my mother had of her own family involved cooking. My grandfather Walter was happiest in the kitchen. He made *frikadeller,* a traditional meatball dish from his native Denmark. He made thick rice porridge and rich curries, quick pickles and magnificent roast beefs. Around Christmastime, he let my mother roll and bake the long rectangles of shortbread dough that they had brushed in egg whites and sprinkled with almonds.

My grandmother Marian baked loaves of bread, which transformed the house with their yeasty aroma when my mother and her sister, Ellen, walked home from school. From a recipe in her well-worn copy of the *Joy of Cooking,* she made tapioca puddings—"fish eyes in glue," she would say—and gingerbread, warm hunks of which were eaten with a scoop of fresh whipped cream. And there were the pies: sweet-scented strawberry-rhubarb in summer, cinnamon-spiked custard in winter.

Marian wasn't a warm woman. She lived behind what my mother felt was a thick veil of gauze. She was unable to express

the emotions that her children needed, especially after Walter died, when my mother was a teenager. But no matter what kind of pie she baked, my grandmother never failed to gather the extra scraps of dough. She would throw them into small glass custard cups, hugging thick lumps of butter, cinnamon, and sugar.

"Baby pies," she would say to Ellen and my mother, who sat on the counter watching.

When the tiny pies emerged from the oven, bubbling and bronze, the girls would carefully inspect each one, deciding which was the biggest, jockeying for the best spot to put fork to flaky crust first. In their home in Westfield, New Jersey, my mother often felt abandoned and alone. But in those kitchen counter moments, filled with the scent of caramel and spice, she felt like she was noticed, even loved. She felt warm.

It was hard for me to imagine my grandmother baking pies. It was hard to imagine her as anything but old and a little bit scary. Marian was in the final, debilitating stages of Alzheimer's by the time I reached elementary school. She lived far away in a nursing home in Hawaii, close to Ellen and her family on the island of Oahu. I visited her there one summer as a shy, frizzy-haired third grader. I walked in to her room with my two cousins, my little brother, Ben, and my mother.

My grandmother was balanced, birdlike, on her hospital bed. She looked small and confused. I watched the speckled light hitting the floor, listened to the whispering footsteps in the hall and the chatter of nurses coming in and out of the room. It was vacation; my skin was slick with sunscreen. I had recently discovered the joys of coconut milk, the terror of jellyfish, and flowers so lusciously scented it was almost too much to wear them in a lei around my neck. I couldn't really understand why we were there

in a room that smelled of baby powder and lemon juice, salt and old age.

"Karen?" my grandmother said in a soft voice. She was staring straight at me. Suddenly, I was terrified.

"No, Grandma . . ." I said. "I'm Molly."

There was a pause.

My mother cleared her throat. "Hi, Mom," she said. "I'm Karen. I'm your daughter."

My grandmother said nothing. She looked lost.

I had been warned that this would be a tough visit. "Alzheimer's is a disease that erases memory," my father had told me before we left. "It has erased almost everything for your grandmother, except for the distant past. It's almost impossible for her to understand today."

It was hard to imagine. The present was everything: the way my new plastic sandals clipped on the tiled floor, the way the ocean glowed blue outside, the way my mother smelled faintly of Tiffany's *Eau de Parfum*. How could my grandmother think I was her daughter? I was Molly; my mom was Karen. And this strange, fragile woman on the bed? I only knew that her name was Marian, and visiting her in this home near the ocean made my lips taste vaguely of salt.

But the delicate cursive writing on the recipe for strawberry-rhubarb pie belonged to her, my mother insisted. "She invented the baby pie," she said.

The custard cups my mother used for her own tiny pies were small and made of white-ribbed porcelain. She too filled them with small, misshapen rolls of dough, topped with plops of butter. They came out of the oven lumpy and bubbling, the dough bronzed in some spots and blackened in others, all pip-

ing the unmistakable scent of baked sugar. Just like our mother and her sister had, my brother and I would examine each, trying to decide which was the biggest and the best. The strawberry-rhubarb pies—sweet with a hint of sour, oozing pink inside a golden crust—were for everyone. The baby pies, however, were just for us.

On these days, the whole kitchen filled with the aroma of fruit and butter, pulling my father into the kitchen. The yelling matches between my parents that drove me to my room—and my brother to howl in response—seemed to melt away in those moments over the kitchen counter. Even Ben, whose diet consisted mainly of vanilla yogurt, loved the sound of his fork cracking crust.

YEARS LATER, when I was twenty, I spent three months in Katima Mulilo, a small town on the very northern edge of Namibia. An unlikely village carved from the Kalahari Desert, Katima Mulilo sat in a swirling mass of dust and heat hours away from the closest city in the country, an endpoint to the Caprivi Strip, the section of land jutting straight into the center of Africa. Dull brown sand covered every inch of the ground; gnarled shrubs emerged from the earth; small block houses interspersed with reed huts and charred communal fire-pits clustered along grainy roads. The world smelled of sweat and smoke. Even the sky felt brown.

I had come to Namibia with a small group of college students as part of a volunteer teaching organization. After a quick orientation, we had each been sent to our individual posts. I arrived in Katima Mulilo with three others to teach English and AIDS

awareness in the small, impoverished community. I spent my days in the classroom and my evenings attempting to connect with my "host mother" Mbula, a schoolteacher only a few years older than me. I shared her government-subsidized home with her and her husband, Bonnie, and their small daughter, Mary.

Mbula, who had luminous black skin and a wardrobe of bright green and yellow wraparound skirts, worried that I would never find a husband unless I could cook, clean, and sew like a true Namibian woman. "I have a boyfriend," I said in protest. It was true: his name was Alex. I had first noticed him—his hair, actually, which was a carrot red—in my high school English class. We were soon inseparable, a quiet relationship of skateboards and football games, pizza dinners and my first nights not spent alone in bed. We broke up for our freshman year of college, when I went south to Providence and he north to Burlington, Vermont, but were back together then, long distance only improving the butterscotch scent of his skin. "I love him," I told Mbula.

"Where is he?" she asked.

"Home."

She shook her head.

"You need to learn to cook." She gestured toward the kitchen, her throne. There, she lorded over pots and pans, providing for her family every meal of the day.

That summer she taught me to wield a needle and thread, and she laughed at the inept way I handled the bar of soap as I washed my clothes in their laundry bucket. She showed me how to make *n'shima,* or the gruel-like maize meal that we boiled in large stock-bottom pots and then rolled into potato-shaped patties using a special wooden spoon, which we ate for every lunch and dinner along with fried greens and the occasional gristle

of meat. The scent of her kitchen was jarring—the corn oil and mutton grease, the goat and kale, the unfamiliar porridge aromas of maize.

Every morning at 5:00 a.m., as the sun crept up in the incandescent desert sky, Mbula and I stood together in the kitchen and ate fried eggs for breakfast before going to school. Standing over the sizzling pans each day, I tried to control my anxiety.

A haze of disease hovered over the village. In Namibia at the time, 15 percent of the population was infected with HIV or AIDS. Wandering through the village on a Sunday morning, I watched men crawl out of the bars onto the sides of the streets before passing out, drunk by 10:00 a.m.; I passed lithe young women carrying sacks of grains, wrinkled grandfathers butchering meat in the market, and groups of children shooting basketballs in the school yard. The town was filled with the scent of boozy breath, rotting meat, and sand baking in the heat. Everything held the faint cloy of disease.

Teaching was an exercise in control—of the forty-odd children who piled in each of my classes, and of the panic I felt knowing how little could be accomplished in three months with few resources available. Between the ages of seven and fifteen, my students were lovable and enthusiastic, scruffy and haphazardly dressed. They looked at me with wide, often confused eyes. My American accent made English, the country's official language, sound as foreign as their local tribal dialects did to me.

I was often frustrated. Without training, I had no idea how to control a classroom. I had no idea how I should exact discipline, though I knew it wasn't by the force I saw from most teachers, like the afternoon I walked in on one large-boned science teacher

as she whacked each of my learners across the back of the skull with a wooden eraser. I often felt out of control.

But I taught as best I could, struggling through lesson plans and homework with the hopeful devotion of a twenty-year-old who had never failed. In the classroom we worked in ragged notebooks on letters and numbers. I had my students draw pictures of their future in crayon, which I taped around the room like wallpaper. Mpunga, who sat in the front row with a devilish little smile, wanted to be an astronaut. Sidney, often by his side, thought he might like to work for a newspaper. I read Dr. Seuss books out loud, slowly turning the pages, watching the children's eyes widen with the songlike language, the colorful illustrations drawing them close. I taught young giggling girls to use condoms on bananas and organized stacks of books into a library the principal was hesitant to use. When I walked home at night, I watched the bonfires of the camps where my students lived burning like fireflies in the distance, pinpricks on the ink-black horizon.

I didn't know that Mr. Liswaniso, the soft-spoken science teacher who sat next to me in school meetings with his hands quietly clasped, was sick with AIDS until after I returned to the United States. No one spoke of illness; the community did not yet want to publicly address its spread. He passed away six months later, but the image of his hands—like gloves, slack with time his face did not yet show—stuck with me. They were too wrinkled, too old, too worn for his body.

I took refuge in my friendship with Mbula. We sang songs by Celine Dion, Mbula's favorite, loudly together while cleaning the house, little Mary watching warily from the corner of the kitchen. We took trips to Mbula's mother's home, an apartment

in a tiny compound a mile of sand away. Once, I stirred and shaped the patties of *n'shima* all on my own, and they applauded me before we sat down for our meager supper.

But I cried at night, alone in my room, hungry and tired but unable to sleep. I could hear Mary wail, Mbula and Bonnie yell. There were no telephones capable of long distance in the house, and the only working computer with the Internet was more than an hour walk away. I missed Alex and my family. I pasted a smile on my face each morning, but I felt very alone. I couldn't eat eggs for years afterward. The scent of oil and butter and splattering orange yolk would immediately conjure the intense anxiety that clouded my gaze each morning over breakfast in Africa.

On a cool Saturday afternoon toward the end of that summer, I found Mbula in the kitchen.

"I'm going to make an apple pie," I said. I wanted to show her that I was not hopeless. I wanted to prove that I had a past and perhaps a future, too.

"Okay," Mbula said. She smiled, humoring me.

I walked to the grocery store alone, a few miles each way. I could feel the sun on my shoulders as I trudged through the sand, past young kids playing soccer and teenagers hanging out on the steps of a house near town. They called to me as I passed. I smiled.

At the store I bought a sack of apples—soft and slightly mealy—and a package of butter. I walked home with the bag under my arm and then dumped the contents on the counter. Later, with Mbula's help, I began to bake. It was my first apple pie. I hoped it would work.

I made the crust with butter and flour, a few pinches of salt and water. Its texture was cold and smooth, reminiscent of my

mother's granite counter in Boston. I peeled and sliced the apples, which smelled sweet, like autumn. There was no cinnamon; only a strangely coarse cane sugar, but I didn't care. Mbula and I draped the raw crust over the pile of fruit, pinched the top layer to the bottom with our fingers. I felt comfortable for the first time in months.

The pie came out of the small gas oven bubbling its aromatic apple juices. Rich, candylike wafts filled the house, and I smiled so wide it hurt. It smelled so familiar, so reminiscent of home and family. I was pleased when Mbula leaned in to inhale over its bulbous top.

We ate the pie together. Bonnie, Mary, and the two fellow volunteer teachers who lived nearby crowded around the kitchen table with Mbula and me. Though Mary quickly found more pleasure in tossing the soft apple filling on the ground, we were a festive group. The flake of crust, the silken sweet fruit, and the scent of my past took on greater significance with each bite. The act of cooking and eating together breached a wide chasm. *I should have saved some dough,* I thought. *Mary would have liked that.*

I ARRIVED HOME from Africa unable to shake the anxiety. The depression so pervasive in that small community stuck with me, lodging in the pit of my stomach. I couldn't shake the memory of often joyless meals with Mbula and her family. I couldn't shake the sight of Mr. Liswaniso's hands. I couldn't shake the guilt I felt for having left. For months after, I had a hard time eating anything at all. Every bite felt like an accusation: *look what you have and they don't.*

I lost weight rapidly and soon my clothes no longer fit. My

mother began to look into nutritionists; my father asked me again and again what was wrong. I cooked constantly, feeding my family and my friends. I wanted to feed everyone around me. But I wouldn't eat.

I began to see a therapist near my school in Providence. She had a bob of snow-white hair and a collection of funky shoes. We talked about Africa. We talked about eating. We talked about control. We talked through my final year of college, through my breakup with Alex and my growing obsession with the kitchen. I never left behind my guilt, but I learned to manage it. I learned about food, and what it meant. For me, it was family and warmth, nourishment and hope. It was my past and my future. For me, it meant everything.

I thought about the fried eggs I had shared with Mbula and how they remained painful, soaked in all the sadness I wouldn't let myself feel. I could still smell the maize and booze of Katima, even as I inhaled the smoke of the grill on which my father cooked a steak upon my return and watched the ease with which it slid from spatula to plate.

I often thought about the afternoon of the apple pie in Africa. I thought about the emotion that had lurked behind each bite. The scent of the orchard, of baked sugar and sweet cream butter brought with it memories of home. It reminded me of love and then of guilt, of pride and longing and friendship. How can so much be contained in a simple bite of pie? I wanted to learn the art of the stove to get at so much more.

TWO YEARS LATER, there I was at the Craigie Street Bistrot. I spent my nights chopping and cleaning, tasting and smelling.

Even when I grew tired, when my back ached and I never wanted to look at, let alone eat, a clove of garlic or pat of butter again, I knew I was there for the right reasons. I knew I was on the periphery of that much more. Sometimes during dinner service I would steal away to the hallway dividing the kitchen and dining room and stand, for a few breathless seconds, at the pass. There, I could hear the clink of glass, the bursts of laughter, the soft chatter and background rifts of jazz music. On the edge of calm, on the edge of an air-conditioned cool, I could remain invisible in my stained apron and battered sneakers as I watched plates of bluefish and hanger steak arrive in front of dozens of well-dressed diners. I could witness couples holding hands and families giving toasts with glasses of white wine. I could watch a young woman gnaw meat off the rib bone with surprising grace and an older man wearing a bow tie take the first bite of pork belly and smile swiftly, contentedly into the air. Sometimes I needed proof that there were people out there. I loved my work, but after weeks of late nights soaked in grease, I could not completely suppress my frustration. It was difficult to clean mushrooms for three hours straight and imagine there was anything beyond wrinkled fingers and dirt-stained clothes.

One evening in July, I marched into Maws's office and asked him when I would be able to do something besides pluck oregano or peel garlic. I wanted to know if this would be worth it. Why didn't I just go to culinary school tomorrow?

Maws looked at me and said, slowly: "The only way to understand a head of garlic, Molly, is to work with it every day, taste it, feel it, smell it, grow with it through the changing seasons. Garlic in May is a different species from garlic in December. The only way to be a great chef is to understand your material, instinctively

and experientially from the bottom, no matter how long it takes."

I sighed and nodded. I was frustrated, but understood. When I returned to the kitchen, to my piles of dirty dishes and recently delivered microgreens waiting to be washed, I took a few deep breaths and tried to remember my purpose, one that was larger than the immediacy of the sink. I had to concentrate on the important moments—like the day that a sous-chef blindly placed an oblong leaf on my tongue and I immediately identified its delicate mintlike taste as hyssop.

I STEPPED OUT onto the front porch of my mother's home in Boston in running shoes and shorts on a drizzly morning at the end of that August and paused to look at the postdawn sky. It was dark and cloudy; I could feel the impending rain in the thick air. *I'll make this quick,* I thought, sticking the headphones of my iPod into my ears. I wanted to spend the rest of the morning reading Harold McGee's *On Food and Cooking;* my starting date at the Culinary Institute of America was approaching and I was already nervous.

The neighborhood was empty as I began to jog down the street. Even the local high school down the block, in its last week of summer vacation, was quiet. I ran on the sidewalk, bypassing the red pickup truck that was always parked in my way, and sidled up to the corner apartment complex, which bellowed the soapy-fresh aroma of laundry from its street-level vents. I loped up a small hill, around a wooded corner, and then paused at the intersection. Glancing up, I noted the warning of the blinking neon hand signal across the way. I only hesitated for a moment before crossing the four-lane highway.

I didn't see the small Ford four-door as it sped through the light, which had just turned from red to green. I didn't feel the crack of my body against the front bumper. I didn't hear the sound of bone against glass when my skull shattered the windshield. I don't remember flying through the air, as I ricocheted off the car and onto the hard sidewalk nearby. For me, the world shot straight to black.

According to the police officer who first arrived on the scene, I lay conscious but unmoving on the concrete sidewalk until the ambulance arrived. The Ford driver, a twenty-three-year-old recent college graduate on his way to work, hyperventilated into a brown paper bag nearby.

My parents sat next to my hospital bed for the next four days. My mother said that I was confused. I didn't understand what had happened and I spoke like a child, calling out, "Mommy, I hurt," when she walked into the Intensive Care Unit that first morning. I swore a lot and thought that the hospital, Beth Israel, was a synagogue. I recall hazy images of doctors' white coats, the sound of cartoons on the television above my hospital cot, and the hard chill of bedpans. The ligaments in my left knee were torn, my pelvis broken in two places, and my skull fractured. Knee surgery came later. A bright strawberry bruise stained the side of my face and neck for weeks.

I lived in my mother's living room for the next month. I lay on a bed that had been carefully hoisted downstairs by my brother and by Alex, who had driven down from his home in Vermont when he heard of my accident. I couldn't move; everything hurt. I took pills—big ones, small ones, pink, blue, and purple ones— every few hours, which made me groggy and disoriented. It was impossible to fully focus my eyes.

And what my family found most disturbing: I wouldn't eat. My mother constantly tried to feed me. She brought milk shakes and smoothies to me in bed—a desperate attempt, she said, to get some calories into my broken body. "No," I would moan. "I can't eat."

THREE WEEKS AFTER the accident I returned to the hospital for knee surgery. The morning was sunny and clear. As I hobbled from the car to one of the Deaconess Hospital's hilltop buildings, I could feel the coming autumn in the cool breeze. I wasn't yet used to my crutches and they dug into the soft flesh under my arms like wire.

I had just barely emerged from the fog of head injury. The weeks since the accident crowded into my memory, fuzzy and incomplete. I had lain on the bed in my mother's living room day after day with limp legs and gyrating spirals of pain. Sometimes my mother and sometimes my father sat by my side, regularly in each other's company for the first time since they had divorced seven years before. While they were at work, friends came. Alex, who extended his trip home to help me pass the days, spent a lot of time watching movies next to me as I slept. I was lucid when awake, but barely. I acted loopy like a drunk, stubborn like a preteen.

In the first hours after the accident, my family had not known what to expect. When my father, a doctor, had raced into the Intensive Care Unit after hearing the news, he saw me lying on the cot with needles in my arm and monitors blinking behind. I looked to be in one piece, but he knew bleeding, broken bones, or punctured lungs could be lurking beneath my bruised skin.

With one glance at the full-body CT scans, hung on the wall by another physician, though, he felt relief. My injuries had been rendered visible by the ghostly black and white of film, and he knew that though it might take a long time, my broken bones would heal. My knee could be fixed. Physically, my family knew that I would be all right. And despite the fact that they listened to me tell the same story over and over, cringing because each time I thought it was the first, they knew the effects of my head contusion would soon fade.

It took two weeks for me to regain control of my mind. When I did, it was sudden. The world came into focus one morning in mid-September. My pelvis and head both ached and, for the first time, I wondered why. The fog had burned off.

What is going on? I thought.

Alex came over later that afternoon after a day away and though I sat in bed as I had for weeks, he found me different.

My eyes were focused and my voice was drawn. Alex held his body stiffly, which seemed both familiar and distant. The last time I saw him was fuzzy in my mind.

"How are you?" he asked.

"Okay." I waited a moment. "I hurt."

He looked at me with surprise. My strange giddiness of the previous weeks had evaporated. I was coherent and I was depressed. It was like I had just woken up.

I couldn't believe that an entire month had passed. It shocked me that my body was so delicate, that an event so violent could have come so close. I was surprised to find that I wasn't immortal, that the mobility of youth was permeable, that it was no longer mine.

It almost felt good to be hobbling into surgery those weeks

later. At least I was moving. At least there would be change. They would fix the tendon and ligament, the ropes of fiber and tissue running up the outer edge of my left leg that had been mangled in the accident. When the car tore into my side it had yanked my knee in at an unnatural angle, like a marionette at rest, like a linebacker struck from the side. "We really only see this injury in football players," my doctor had said with a little sigh.

I breathed easily as I lay on the hospital cot. When the gas mask covered my mouth and the anesthesia began to flow, I slid smoothly toward unconsciousness. It was only later—after the five-hour procedure, after the plastic surgery stitches closing the eight-inch incision that would glow in reds and whites for years to come, after the fog of my imposed sleep melted away— that I really felt the pain.

The pain began in the deep snaking hole where the doctor had pulled and prodded and reattached the tendon and bone that had receded up my thigh. It was immediate and intense and soon it expanded everywhere. I couldn't think beyond the screaming of my toes, the tension in my neck, and the nausea in my stomach. It was excruciating and encompassing, and my memory of that time is framed in a shade of burning red. The medication, handed to me in small paper cups by the nurses throughout the night, did not cut the debilitating ache. I listened to my father yell in the hallway. There had been confusion over my prescriptions and he was angry. He yelled at doctors, nurses, and orderlies. He was angry that I hurt, and that there was nothing any of us could do. I hyperventilated when I tried to move my leg.

"Breathe," the nurses said. I tried.

But after a week of thick beige curtains, thin polyester blankets, and a frequently replenished stream of gossip magazines

read to me aloud by my mother, the raw edge to my panic began to fade.

I went to my father's house in New Hampshire to recover.

It was there that I was finally able to focus on the world around me. I lay in a bed with a soft green cover. The television mounted on the wall in front of me was large. I watched *The Princess Bride* one afternoon and didn't fall asleep after five minutes. I even remembered it the next day. Things were looking up.

But the reality of my situation soon sank in. I was lucky to be alive. I was lucky to have family close by. But with a smashed pelvis and recently sutured leg, I lacked all mobility. I remained completely dependent on my family and friends, and I had never felt so low. I couldn't recognize my own voice, dark with a baritone sadness. I certainly wouldn't allow myself to think about Maws in the kitchen of the Craigie Street Bistrot, or my impending starting date at the Culinary Institute of America. They were too far from the immediacy of my pain. I wasn't ready for fear.

But I soon realized how much more was gone.

My stepmother, Cyndi, who was perpetually calm and composed except for the first time we tried to wrap my bandages in plastic so that I could take a shower and we both ended up in tears, baked an apple crisp one afternoon in early October.

My best friend was there for the weekend. Becca had come bearing books and CDs, bravely cheerful in the face of my deepening depression. Ever since we first met, as pale and frizzy freshmen in college, she has been a skilled administrator of comfort. Once, on a bone-chilling winter weekend we had taken a road trip to Montreal. It was the week before Alex and I got back together after our painful break. Becca led us to La Chronique, a restaurant with white tablecloths and dim, sparkling lights, one

evening. We had dressed up for the occasion, and I felt elegant in my high heels and fitted skirt.

Our waiter uncorked a bottle of white wine that smelled fruity and young. I had only recently begun to explore flavors unfamiliar to the safe suburban diet I knew, and as I sipped, breathing slowly in and out, the depth of flavor surprised me. We ate salmon and seafood risotto, which was rich and creamy, and monkfish and duck ravioli, laced with the deep undertones of foie gras. With each course, with each bite, with each giggle emitted for no reason beyond being young and full of life, my anxiety melted. Before dessert, our waiter placed a small plate in front of us both, each with a different kind of cheese. Becca's came bearing a small craggy round of bleu, while mine held the more familiar wedge of brie, which oozed from beneath a pale yellow crust. I inhaled over my plate. I leaned in to sniff over hers. I had never before tried any kind of mold-encrusted cheese. It smelled rich, pungent, like milk gone wrong. I made a face.

"Just try," she said.

Gingerly, I took a nibble. Again, I was surprised. Both tangy and smooth, the flavor danced in my mouth.

In the years since Montreal, Becca and I had eaten our way through Providence, Paris, and Prague. We ate Parmesan-rich risotto and delicate lemon tarts, puffed carrot soufflés and gooey cheese crepes. She introduced me to truffles and pâté. We spent a year sharing a kitchen and a fridge, learning how to cook as inventively as possible together on a student budget. There were four-layer banana-chocolate cakes and fresh pasta doused with sage and butter we browned into a deeply fragrant sauce on the stove. The joy I experienced in food had arrived in tandem to our friendship. We had eaten a lot together.

That afternoon at my father's house in New Hampshire, Cyndi had baked her apple crisp because she knew I loved the dessert so reminiscent of fall. For over a month I had had to be coaxed and cajoled into eating and my stepmother hoped that this would help. When she took the crisp out of the oven, one room over, everyone began to exclaim. "That smell!" they said. "It's delicious!"

I sniffed. *What?*

"The crisp," said Becca, pointing toward the kitchen.

"What about it?"

"Can't you smell it?" she asked.

I sniffed again. *I must not be in the right seat,* I thought. *There must be something in my way.*

I inhaled and exhaled.

"The crisp?" She pointed.

"What?" I asked again, like I couldn't hear her words.

For me, there was nothing.

Soon Cyndi brought the steaming pan into the family room. She held the fresh baked apples, ripe with cinnamon and sugar and spice, close to my face. I leaned over and inhaled. I could feel the heat on my chin and in my nose. The air felt different, thick and humid. But there was no scent.

"I can't smell." I said it softly.

There was silence. I remember the silence. It was white hot and long. No one said a word.

"I can't smell a thing."

When I took a bite, concentrating intently on the food in my mouth for the first time since before the accident, I mainly registered the texture. I could feel the softness of the baked fruit and the crunch of the crinkly top. But the flavor? It tasted of nothing

but a dull sweet, a muted sugar. The cinnamon, the nutmeg, the lemon had vanished. The honey was unattainable and the oats, gone. Where was the rich cream of the butter?

"I can't taste," I said.

Later that night, Becca and I sat among pillows and blankets on my bed. My leg in its brace fanned out in front.

"What if I never smell again?"

sour milk
and
autumn leaves

IN WHICH I START FROM SCRATCH

THE INNER WORKINGS OF THE NOSE are delicate and complex, a chain of connections and cascading signals that operate on a molecular level. Scientists have struggled to understand the process of olfaction for hundreds of years. But even as far back as the Greek philosopher Aristotle, who felt that it was the least useful of the senses, smell is often forgotten, pushed aside in favor of sight, sound, and touch.

Today, much remains a mystery.

Every smell begins with a molecule. Whether it is a charcoal whiff of the smoke off a grill on a summer evening, the lemon dish soap in my mother's kitchen, or the acrid breeze that greets me at the garbage dump, every aroma is made up of invisible particles. A single scent can hold more than a hundred of them,

combining to create the complex aroma of *Chanel No. 5,* of ham roasting on Christmas day, of the brined ocean shore in Maine.

Smell is the most direct of the senses. Aromas must literally enter the body before they can be consciously identified. With every inhalation, molecules travel through the thin craggy pathways that begin at the nostrils and head toward the brain. They speed past the olfactory cleft, a narrow opening toward the top of the nose. They hit the olfactory receptors, which are housed on the hairlike tips of the millions of neurons that peek through a gold-hued mucous membrane called the olfactory epithelium.

Every human has around 350 different types of these receptors, which are unique proteins on both the left and the right side of the upper nostrils. These receptors are the gateway to the complex dance of perception. They connect to the smell molecules upon arrival and then transfer signals toward the brain by chemical impulse. Every human has between six and eight million neurons in the nose to do just that. These signals are fired rapidly, by many neurons at a time, forming a pattern not unlike a line of musical notes, or the HTML coding of a webpage. When combined, the brain interprets the signals as a smell, an "odor image."

These patterns are both complicated and minute. Scientists have found that if the chemical structure of two smells are identical except for just one carbon atom, the patterns sent in response are nonetheless distinguishably altered. Nonanoic acid, for example, is a nine-carbon chain that yields the salty smell of cheese. Decanoic acid, with only one carbon atom added to its structure, however, smells rancid, like sweat.

These patterned signals travel on pathways made by neurons, which snake from the nose through a thin sheet of bone called

the *cribiform plate,* and are deposited in the olfactory bulb, which lies toward the bottom of the brain. The bulb takes these patterns, like reading the score of a piano concerto or lyrics to a lullaby, and sends them farther on to the olfactory cortex. The cortex, in turn, relays an interpretation to other parts of the brain like the thalamus, which deals in conscious perception, and the limbic areas, for emotional response.

Scent molecules had been entering my nose and traveling up to my brain unhampered for twenty-two years before the accident. When I breathed in the scent of chicken stock while working at the Craigie Street Bistrot, those rich poultry particles hit my olfactory receptors and spurred a slew of signals to my brain. I would stop, sniff, and think: *I smell chicken stock.* I never thought about the process. I never thought about how I could tell the difference between the scent of chicken and veal stock, between lard and butter. It was a movement too complicated, too minuscule, and entirely too invisible for me to notice, let alone to care about.

But it's a process that is of intense interest in the scientific community today. How is the chemosensory world represented in the brain?

Each step in the path of a single smell from the nose to the brain is known. What is not clear, however, is exactly how the body begins with these molecules and ends with the conscious thought *I smell chicken stock.* The process of recognizing and identifying smell, from the first neuronal firing to the higher workings of the brain, is still quite mysterious, even to the most advanced researchers and experts.

We know that it begins with just one molecule. Just one molecule of the scent of a rose, a wet dog, an old book on the top

shelf at the library enters the nose. It travels up the nostril to the olfactory receptors. And that's where the first puzzle takes place.

Theories about how, exactly, the olfactory receptors recognize and connect with odor molecules have been debated for decades. Researchers have found that each of the 350 different types of receptors expressed in the nose can pick up a specific number of odor molecules. Some can recognize a handful, while others are attuned only to one type. Similarly, some odor molecules can react with just one receptor; others, many more. Today, it is widely believed that the receptors and molecules bind to one another based on shape.

"The lock and key analogy isn't perfect," Stuart Firestein, a leading olfactory scientist and professor of neurobiology at Columbia University, told me. "But it's close." He was sitting over a plate of cheese at a table at Le Monde, a warmly lit restaurant across the street from Columbia's campus. He cupped his left hand, folding it into the shape of a small vase. He extended the index and middle fingers of his right one out straight and moved them slowly into the depth of the pod to show me how a molecule and receptor would bind. This, he demonstrated, is how they come together in the nose. Like pieces in a complicated puzzle, when a match is found, a connection is made and signals are fired. But how, exactly, that match is made remains unknown.

I asked him about how the brain makes sense of the signals sent by the receptors. That's another unknown, he said. We do know that each of the receptor neurons—millions of them, scattered haphazardly through the epithelium, a small piece of tissue in the nasal cavity—always sends its signals to the same spot in the olfactory bulb where it connects with other similar signals in

little bundles of neuronal connections called *glomeruli*. But the understanding ends there. We don't know what kind of pattern is formed, or how it is read.

"Olfaction is one system without a special map," Firestein said. "It demands for us to think in a different way."

Significant advance has taken place in the last two decades. Scientists Richard Axel and Linda Buck published a ground-breaking paper in the scientific journal *Cell* in 1991, for which they later won the Nobel Prize in Medicine. They found that the olfactory receptors were determined by genetics.

The gene family for olfaction, they discovered, is inordinately large. Working with mice, and later transferring their understanding to humans, they identified a family of upward of one thousand different genes devoted to smell, or close to 3 percent of all those in humans. They found that each olfactory neuron only expresses one type of olfactory receptor gene, which means that each neuron only recognizes a select few odorants in the nose. A large percentage of those genes, it turns out, are called *pseudogenes* and do not produce working receptor proteins, leaving humans with around 350 rather than 1,000.

Axel and Buck's discovery, and subsequent award, brought attention to the science of olfaction, which was then a tiny and unfashionable field. Theirs was an important step toward understanding the biology behind olfactory perception, a complicated process that begins with the static but silent beat of the neuron and can end with the conscious flourish of mood.

"Axel and Buck changed the way olfaction was looked at," Firestein told me. This was in part because their discovery peeled away one thick layer of the mystery surrounding the science of the nose. Even more, though, it was because their work inspired

buzz—in the media, in the scientific community. It created inter-
national excitement. This, in the world of olfactory science? Not
a usual thing. Suddenly, there was more room for funding. Rising
scientists who would otherwise have gravitated toward a different
field were drawn toward the nose. Questions were raised. Studies
began. The field expanded.

This development was important, Firestein explained, be-
cause the science of olfaction is a new model system. "This means
that olfaction can be used to make generalizations on how other
parts of the brain work. If we can understand how each neuron
expresses one olfactory receptor gene and only one gene, or how
the neurons regenerate, or how the brain organizes and processes
each smell, then perhaps we can understand how other areas of
the brain function."

On my laptop, I watched a video recording of the 2004 Nobel
lecture given by Axel, a tall, thin man who bent over the podium
like a reed. He spoke about the far-reaching implications of his
and Buck's discovery. "Molecular biology and genetics," he said,
"could now interface with neuroscience to approach previously
tenuous relationships between genes, behavior, cognition, mem-
ory, emotion, and perception."

HOWEVER MY BRAIN processed smell, however it allowed me to
understand the significance of stock or perfume, it ended when
I smashed my skull against the windshield of that car on that
August morning. Suddenly, it didn't matter how my olfactory re-
ceptors attached to those poultry-rich molecules. There was no-
where for the signals to go. When my head hit the car, my brain
had bounced against the inside of my forehead. With that impact,

there was friction. My brain rubbed against the cribiform plate and sheared off the little neuronal endings coming toward it, like a lawn mower over grass. In effect, the impact severed the neurons that connect my nose to my brain. Like the tendon in my leg, they snapped and then receded. No longer could patterns of smell be sent to my brain. With that split-second crash, my sense of smell vanished.

I had a complete case of *anosmia,* the clinical term for the lack of ability to perceive smells. Years later, I took the train to Philadelphia to speak with Beverly Cowart, who was the Scientific Director of the Monell-Jefferson Taste and Smell Center, one of a small handful of clinics devoted to those with disorders of olfaction and gustation until it closed in 2010, and to her colleagues at the Monell Chemical Senses Center, a nonprofit institute dedicated to the scientific study of taste and smell. It was a bright, clear day and I approached the center, tucked off to the side of the University of Pennsylvania campus in a thick brick building, carrying a bag of notebooks and my digital recorder. I paused for a moment in front of the statue guarding its entrance. It was the fragment of a face by artist Arlene Love, sparkling gold and as tall as the door. The forehead and eyes looked as though they had been ripped off, torn like paper ready for the trash. The disembodied nose, dimpled chin, and lips slightly agape looked mournful and forbidding at the same time. Standing there I felt apprehensive, like I was about to rip the bandage off a very deep wound.

Here we go, I thought, as I walked in.

Cowart has seen hundreds of cases of anosmia since 1986, when the center opened. She has seen well over one thousand cases of *hyposmia,* or a severely reduced sense of smell. She's seen

those with olfactory distortions, for whom the once-familiar scent of butter cookies baking in the oven can turn hard and metallic, like aluminum. She's seen those with ghostly smell sensations that come from nowhere but within, those known as phantoms. She told me that there has never been a comprehensive study done on the number of those affected by loss of smell in the United States. But numbers in various scientific studies have estimated that 1 to 2 percent of the population under the age of sixty-five has a disorder of some kind, a number that spikes with age. In Sweden, Cowart told me, a study was published to say that 19.1 percent of the population between the ages of twenty and ninety suffered from some kind of olfactory malfunction, while 5.8 percent were fully anosmic. So there must be millions of people around the world with a lost, distorted, or severely muted sense of smell.

Cowart has seen those who have watched scent gradually melt away, the aroma of coffee brewing weaker each morning, and those who lost it in an instant. For a great number, the cause remains a mystery. But, Cowart says, the "three most common problems we see are either related to ongoing nasal sinus disease, to a prior upper respiratory infection, or to head trauma."

After the accident, it would be years before I met anyone who also couldn't smell. It would be years before I understood the breadth of my invisible loss. But Cowart knew: I wasn't alone.

I RECOVERED FROM knee surgery in my father's home in New Hampshire, a condo he had decorated in schemes of burnt umber and oak. Autographed posters of baseball players I didn't recognize hung next to oil portraits painted by my grandfather, an accomplished amateur.

It was the second condo my father lived in since my parents had divorced. The first was a dark and musty cluster of rooms in the suburban town where my brother and I grew up. I hated that place and when I was there, I would shut myself in my room with my nose in a book, breathing in the faint comfort of paper, the smell of school.

My father moved into the second condo three years later, when I was a senior in high school and living full-time with my mother. This one stood on the edge of a golf course, next to a tiny lake that shimmered in the late-afternoon sun. I visited him there for the first time just after he arrived. I hadn't wanted to go. I was angry with him, a porous animosity that I had clung to since I was fifteen, when, on that cold November weekend, my parents sat my brother and me down on the couch to tell us they were getting divorced. They told us kindly, standing together over a basket of unfolded laundry on the couch. My father moved out the next day.

I hung back as my father, who looked happy if a bit uncomfortable, walked me from room to room—all of which, I noticed, smelled new. Too new, like floor polish and Clorox, like rug and gleaming kitchen metal. The condo smelled of the soft leather on the couch and the fresh coat of paint on the walls. It was an alien smell, an unwelcome one. It didn't smell anything like my father.

But what did *he smell like?* I wondered as I sat stiff backed at the kitchen table after the tour. Not right then. Of course I could smell the present. I could smell the damp pile of leaves on my father's lawn, the laundry detergent in his hugs, and the old fabric seat in his car. I could smell the soap-scrubbed present, the one wearing golf shoes studded in clumps of dirt. But our past?

There were physical reminders in his new home: the walnut bookcase that had once stood in our living room, next to the piano I halfheartedly played for years. There was the record player on which my father used to blast Led Zeppelin and Jimi Hendrix when I was in kindergarten, dancing a glorious mad trot while I stood on his feet, holding his hands and bouncing up and down. There was that Oriental rug that once lay in the hallway by the garage, and his massive collection of books on the history of war. There were pictures of my brother skiing on a steep mountain slope, my grandparents mugging for the camera in Florida, my father and Cyndi on a vacation somewhere warm. Everything seemed out of place, stone cold and silent, separated from our shared past with things unsaid.

"So what do you think?" he asked. He looked hopeful.

"It's nice."

"It still needs work," my father added almost apologetically.

Pause.

"Maybe you'll spend more time here?"

I nodded. "Sure."

But his condo smelled like paint and bleach. It was filled with memories that felt far away and empty. I sat at the table not sure how to relax. *This will never feel like a home,* I thought.

I returned to the condo in the week after knee surgery, my mind hazy from both pain and medication. The four years since my father moved in had dulled the potency of my anger, rendering it a tiny trickle easier to ignore. We had been spending more and more time together as the years progressed. I didn't hesitate to stay a few weeks recovering under his roof.

When I arrived this time, I didn't notice the smell of the condo—a smell that in the years since my father had moved in

had expanded to include the dark wood and char of the fireplace
and home-ground coffee trickling into the large pot he brewed
each morning. I didn't think about my past or my father's past,
one that smelled like jars of basil pesto or plates of lox and eggs
and onions, the extent of his kitchen expertise; like the troughs
of Grape-Nuts cereal he ate every morning.

I didn't notice that my father's plants, which he had main-
tained with precision since I was small, no longer boasted their
aroma of wood and leaf, their bright neon green, because I
couldn't move myself off the bed alone. I didn't notice that the
potent lavender shampoo was as odorless as a bottle of water be-
cause I was afraid of the shower, and whenever I sat on a rickety
plastic stool under the nozzle, my bandaged leg encased in plas-
tic bags, I could hardly breathe because of the fear of falling,
of moving, of feeling more pain. I didn't notice that the sheets
had lost their lemony clean or that the bandages on my scab-
encrusted knee smelled so ripe when the doctor changed them I
should have had to choke back a gag.

I thought that the veil separating me from my environment
would lift when my knee began to heal and I was no longer
under the numb influence of the pills I popped every few hours.
I thought that the pain and the drugs were what kept me from
engaging with my stepmother's plate of crisp-roasted chicken or
the mouthwash I swished back and forth across my tongue.

But then Cyndi made the apple crisp and I realized that
everything had changed.

My father sat by my side most nights. We watched movies
and news programs. He read; I slept. He brought cloves of garlic
and open bottles of cinnamon and clove, basil and oregano. He
held them under my nose and asked me to sniff.

"Anything?" he asked.

"No."

"How about this?"

"No."

I remembered the hours I'd spent peeling cloves of garlic in the restaurant earlier that summer, their aroma billowing up around me and clinging to my palms for days. But I didn't cry. I shook my head and looked down at my lap. My emotions had drifted off along with the smell of my father's aftershave.

I spent most of my time in bed staring out the window. I could see the small lake out back, which hung low in the dry weather. Green-gold reeds grew around its banks and ducks waddled to and from its shore. I sat with my leg swathed in thick bandages and a brace, my pelvis aching and my back muscles in constant spasm, and watched the leaves on the trees turn from green into deep shades of red and yellow. The seasons had changed.

For me, the slow drip of the summer turning into fall had always held the strongest allure of all the New England seasons. Autumn never failed to feel new, reminiscent of crisp notebooks and freshly sharpened pencils. Tart apples, hot cider, and the smell of pumpkin seeds roasting in the kitchen made *me* feel new. I had been apple picking every year in the orchards near my childhood home, breathing in the scent of wet earth and fermented apples left to fall. Halloween had smelled of chocolate and peanut butter, tiny twists of smoke from candles on porch steps, the staccato burst of fruit lurking under the caramel-coated globe. Autumn was when my family began to build fires in the fireplace, the sweet smell of smoke and burning wood inviting me in for warmth.

But without smell, the world around me seemed suddenly

strange and stagnant. It was as if I was watching myself in a movie, present but not wholly, interested but not engaged.

When my mother came to visit me in those weeks after surgery, she took me for rides in my wheelchair outside. She wore sweaters and jeans and tucked a fleece blanket carefully around my legs. I thought of how her hair usually smelled of rosemary and mint and how she used a drop of lilac perfume on the nape of her neck for special occasions. I had picked out that perfume for her after smelling more than a dozen scents—lemon, rose, clove, a muddled more—at a specialty shop near the Santa Maria Novella church in Florence when I was studying abroad in Italy.

My mother's feet crunched on piles of browned leaves and pine needles. These were perfect fall days that begged for the scent of earth and grass. But without the scent of rain or moss or bark mulch, my world seemed blank. I was reminded of days I had horrible head colds, stuffed up and unable to breathe, and was struck by the dullness of my landscape, which had suddenly been cast in two dimensions. This time, though, the air flowed freely through my nostrils and I sunk deeper in my seat with every passing minute. Autumn passed in a dim brown chill. What was once vibrant and colorful faded into shades of gray.

I didn't know how to explain it to my mother or my father, who both looked at me with eyes wrinkled in concern. *How do you describe the scent of nothing?* I wondered. It was strong; it was blank. It was completely overwhelming.

One afternoon while my father was at work my mother and her boyfriend, Charley, took me to a nearby farmers' market. They pushed me along in my wheelchair and we bought a pumpkin and some late-season tomatoes. Small kids shrieking and running among the piles of gourds stopped and stared at me, too

thin and too young in that big metal chair. I felt uncomfortable but tried not to mind the attention. I knew that my knee and pelvis would heal. I knew I would eventually be able to walk. It was the apple cider bubbling away in a pot on a table that upset me. I could see it: a metal crock, a thick trail of steam wafting from within. I could imagine its sweet fermented aroma—like Christmas in Germany, like fruit baking in the sun, like cinnamon sticks and clove buds—like a word on the tip of my tongue. But I sniffed and there was nothing. It may as well have been a pot of water, bubbling away as it waited for a box of pasta to be dumped within. It may as well have been empty. That's what finally brought tears to my eyes. My world was no longer as I remembered.

How will I cook? I asked myself over and over again. Silently. Never out loud. I wasn't yet ready for that.

After two wheelchair-bound weeks, my pelvis had healed enough for me to put weight on my right leg and I was able to hobble by myself from bed to couch on crutches. My skull fracture had mended enough for me to focus my eyes and read. I began to write e-mails to my friends and family across the country, thanking them for the bounty of colorful but scentless flowers that had filled my room for the past two months. I was happy to leave behind my state of complete dependence. But I still was not ready to articulate my fear. I wouldn't take a single step into the kitchen.

I returned to my mother's house in Brookline because it was close to the physical therapist's office, where I began to spend painful mornings bending my knee back and forth. I had to break through the scar tissue that had piled up, slick with disuse. I could feel it tearing, rocking my body with its red-hot burn, as

the therapist pressed back against my shin. I couldn't stop the tears, but I told her to keep going. It hurt, but it helped. This was recovery I could feel.

Back in my mother's house the once familiar rooms felt foreign and strange. I hardly remembered the days before knee surgery, when Alex sat by my side as I slept. Returning to the home where I had spent hours rolling fresh pasta dough to feed my family, my fingers caked in flour and egg as butter and onions melted in a pan to my side, was painful in its blankness. Sometimes I had to remind myself where I was. When I first reached my bedroom after climbing the steep staircase on crutches, it looked the same. It was the same square space. My cookbooks were still on the shelves. The desk was still painted white. But something important was missing—*was it the crooked window shade or the new lamp?* I stood in the doorway and inhaled deeply. It smelled thin, white, and utterly unfamiliar.

My younger brother, Ben, came home to visit from his college in upstate New York for a weekend. He is tall and funny, and I had fuzzy memories of him sitting on the couch near my bed in the days after the accident. One evening we drove back to our father's house for dinner, speeding up the highway to New Hampshire as the sun began to set.

"Do you smell that?" he asked, crinkling his face with a look of disgust.

"No," I said, annoyed. "Obviously."

"Oh, God, it's horrible. Foul. Like there's a sewage plant leaking . . ."

We were in suburban Massachusetts. I didn't think there was a sewage plant nearby. But I began to feel uncomfortable. Obviously I was missing something big. I began to think: *What if I*

was alone and I couldn't detect a horrible odor? Instead of sewage,
what if it was the smoke of a fire? A gas leak from the stove? By
the time we got to my father's house I was terrified that I would
be poisoned by rotten food. I would burn to death in my home,
unable to detect the scent of smoke in the next room over until
it was too late. "If only she could have smelled it coming," they
would say at my funeral.

We got out of the car and I limped with my crutches to
the door. Once inside I asked my father if there were any sew-
age plants between Brookline and Nashua. "Would something
pumping odor like that into the atmosphere be a health risk?"
And then I looked at my brother, who had plopped himself down
on the couch. He was laughing.

"There wasn't any sewage plant, you goon," he said. "I just
had really bad gas. I farted. I wanted to see if you really can't
smell." I saw my father begin to chuckle. I gave a weak smile. As
the sound of their voices bounced around the room I thought,
what a strange sound. It had been so long since I had last heard
laughter.

EVERY MORNING IN THOSE MONTHS, my mother would bring
me a steaming mug of tea as I sat in my bed, which still domi-
nated the living room downstairs. Sometimes the tea was laced
with milk and sugar and sometimes it was served plain. Occa-
sionally she would ask me if I could tell what kind it was, know-
ing that the taste of bergamot and chai, jasmine and chamomile
are indistinguishable without their strong and varied scents. She
would ask casually, accompanied with a careful smile as if to say
it didn't matter. And I would inhale, willing myself to register

something, anything. But there was nothing—just the wetness of
steam and the sharp heat of the mug.

"English Breakfast? Peppermint?" I had no idea.

Food, which only weeks before had been my consuming pas-
sion, had been reduced to a tasteless texture. I dreaded eating. I
didn't want to open my mouth. The necessity of smell slapped me
across the face with every bite. It forced me to feel what was gone.
I didn't yet want to face what I had lost. But I had to eat.

Without scent, the taste buds are capable of detecting only
salty, sweet, bitter, and sour. Umami, which was first identified by
Kikunae Ikeda in Japan in 1908 and is associated with a handful
of amino acids, especially L-glutamate, is considered by many to
be the fifth taste. It is commonly described as a savory taste and is
found in many protein-rich foods: from mushrooms to meat, to-
matoes to cheese and monosodium glutamate, or MSG. In 2009,
a study done by the Monell Chemical Senses Center in fact con-
firmed that there is a taste receptor genetically coded in humans
to aid in the detection of glutamate. But as I quickly learned,
every other element of the flavor of food put in the mouth is ex-
perienced by smell.

I could taste the sweet of sugar in a Popsicle, the salt on a
potato chip, the acid sour of a squirt of lemon juice in a cup of
water. I would inhale and exhale, just as Maws had taught me.
There was, after all, neurological reasoning: scent is perceived
from both the intake of air through the nose, called *orthonasal* ol-
faction, and in the slow release traveling through the back of the
mouth, known as *retronasal.* Both are important, each bringing
the perception of scent to the olfactory receptors through differ-
ent pathways. All were blank for me.

Ice cream was a thick and cold slush. Lattes were hot, some-

times even gelatinous liquid. I ate yogurt for its smooth chill and bread soaked in Tabasco sauce because I could feel the spiciness. Mealtimes were nonevents: when my mother cooked dinner, I could hear the sizzle and the clang from the next room over, but the scent of sautéing garlic and roasting meat fell upon a lifeless string of olfactory tunnels and nerves. And when I ate, a bite of steak may as well have been a chunk of cardboard warmed over.

Only a couple of months earlier I had spent long nights in a professional kitchen, awash in the scents of orange peel and clacking chicken bones. I had breathed in the heady aroma of salt- and oil-encrusted sardines, willowy braised leeks, poached eggs on garlic-skewered toast. A simple mushroom had inspired layers of flavor in my mouth. My clothes had reeked of butter. My hands were caked in the odors of thyme and stock. I had run back and forth from the walk-in refrigerator to the kitchen on strong working legs, holding bitter bouquets of arugula and tubs bearing butchered legs of lamb, pink flesh glistening and mottled with blood.

But now I wouldn't go near the kitchen. I wouldn't touch the stove. Even as I became increasingly mobile, nimble on crutches or hopping around on one leg, I hardly ever stepped foot into the room. I couldn't yet admit my terror.

ANOSMIA HAS A NUMBER of causes. Blockages can form like nasal polyps, small growths of inflamed tissue lining the inner nose, eliminating the pathway for aromas to the brain. Seasonal allergies can stop scent molecules in their tracks; an illness can strike, damaging the receptor cells of the nose. Or, like with me, there can be an impact, a head trauma, and suddenly the cocoa-

crusted scent of your favorite chocolate shop may as well be the musty stench of a high school locker room.

Anosmia can be sudden, stolen by a knock of the head. It can happen slowly, after years of damage caused by a virus or in the aftereffects of surgery. Congenital asnomics are born without a sense of smell. In the weeks after the accident, when I sat at my father's computer desk with my bandaged leg propped up to the side and Googled "loss of smell," I couldn't imagine that the congenitals feel their loss as acutely. Had they ever experienced the scent of fresh-cut grass on a spring morning?

Richard Doty, head of the Taste and Smell clinic at the University of Pennsylvania Hospital, and colleagues conducted a study on the effects of taste and smell disorders, including anosmia, on 750 patients seen over six years. The researchers reported that those without smell had trouble cooking and eating and struggled with mood changes and feelings of safety. Depression, Doty said, was common. I wasn't surprised.

I wasn't surprised either to read a study done by Daniel V. Santos and colleagues on 445 patients who were treated at a clinic in Virginia. Santos found that for those with impairment of the nose—whether anosmia or hyposmia—there is a higher risk of experiencing hazardous events day to day. He doesn't mean broken bones or slips and falls. Santos asked about specific hazards, ones that have to do exclusively with smell. Thirty-seven percent of smell-impaired participants, he found, had experienced a dangerous scent-related event, twice the rate of a fully-functioning control group. Thomas Hummel and Steven Nordin sum it up in the introduction to their 2003 paper, "Quality of Life in Olfactory Dysfunction," for the Sense of Smell Institute. "When the sense of smell is lost," they write, "it is not just that it becomes

a difficult task to differentiate between cardboard and a hamburger, but also a sense is lost which alerts us to dangers from fire or rotten food."

I could relate. Already I knew that fear. I examined every piece of food that I put into my mouth. That quart of milk: fresh or sour? That bag of spinach: new or old? I had only the visual to guide me. Without smell, I could not taste more than the salty, sweet, bitter, sour, and umami of the tongue. I hadn't realized what a role scent played in my mouth until it was gone. I hadn't realized the full extent of my loss until it was there, hanging over each bite of dinner, each sip of tea.

While at the Monell Chemical Senses Center I met Marcia Pelchat. She is a sensory psychologist who studies the science of flavor and food preference and often demonstrates the relationship between taste and smell with a jelly bean. Close your eyes and pick a jelly bean out of a bowl. Do it blindly, so you won't know the flavor before you put it on your tongue. Pinch your nose shut, so you can only breathe out of your mouth, pop the bean in, and begin to chew. What can you taste? Can you tell what kind of jelly bean you're eating? Most report nothing but a bland sweet. Now, let go of your nose and breathe through your nostrils again. Now there's something. *That's* how smell makes a difference in flavor. Pelchat conducted this experiment with Ruth Reichl, editor of the now-defunct *Gourmet* magazine, and Daniel Boulud, a well-lauded French chef in New York City, during an interview on WNYC radio in 2005. Her subjects wore clips over their noses as they put the unidentified flavors of jelly bean in their mouths. They chewed silently until, suddenly, they were instructed to remove the clips.

"Oh my God, amazing," said Reichl in a low, distinctive voice.

"It went from absolutely nothing to—the minute it came off, it was pure, devastatingly strong banana."

"Think of fruit," Pelchat said to me. By taste alone, fruit is sweet and sour, she explained, with the exception of bananas, which are solely sweet. "But we can distinguish lots and lots of different fruit *flavors*. We can distinguish the difference between peach and mango, apple and grape. Even more: we can distinguish between beef and lamb, the difference between a corn tortilla and a wheat tortilla. There are textural differences. But this is mostly smell."

In the days after the accident, everything in my mouth, nose clip or not, was absolutely nothing. I felt wild and alone. It was only after I began to research anosmia that I discovered it wasn't so rare. Everyone I talked to seemed to know someone who couldn't smell. And some surprising names turned up in the mix.

I called Ben Cohen, half of Ben and Jerry's Ice Cream Company, one afternoon. I had seen his name mentioned on various websites as I researched, unconfirmed rumors repeated frequently about his inability to smell. Was Cohen, who grinned behind a thick beard on the label of each pint of ice cream, truly an anosmic?

I could imagine. After all, Ben and Jerry's ice cream is not simply about flavor. Full of more hunks of walnuts and pebbles of fudge than any other brand, they have the monopoly on texture.

I ate a lot of their ice cream after the accident. I relished the texture then, which gave an otherwise flatlining mouthful of cold sweet a structural oddity. The lumps and globs held my interest. They kept some notion of enjoyment alive. But it didn't come as a surprise. I've known that pleasure since I was small, when I would excavate the knobbed rounds of cookie dough nestled

within their pints with my spoon until there was nothing left but a puddle of sweet vanilla.

On summer vacation weekends spent up north, my family would drive to the original Ben and Jerry's ice cream factory in Waterbury, Vermont. We would take their short, guided tour through the glass-encased mezzanine, past the production line and through rooms that smelled of baked cones and sugar. I watched the long rows of conveyor belts siphon pint carton after carton down toward packaging. My brother and I grabbed at the free samples, raising our hands to the air for Chubby Hubby, a malted vanilla cream swirled with fudge and chocolate-peanut pretzel chunks. In the factory "Scoop Shop" I always ordered my favorite: Half Baked, gritty with chunks of cookie dough and boulders of fudge brownie. I watched my father as he devoured his own cone—a waffle one filled with dark chocolate ice cream—in what seemed like only a few bites. I licked mine slowly. It melted in unmanageable rivulets down my wrist.

"Hello? Hello?" Cohen said on a grainy phone line. His voice was low and gruff. He sounded just as I thought he would: casual and carefree, like his picture on the pint. He told me to jump right in.

"I hear that you can't smell," I said.

He laughed. "It's true."

I felt a little sparkling thrill in the back of my throat, the kind that came when I received an A on a paper in school, when I answered a question correctly, when I was right.

"I have a poor sense of smell," Cohen said. "Actually, it's horrible. It's always been that way."

"You can't smell at all?"

Occasionally a scent or two will register, he explained. But only with enough decongestant.

I wondered whether his loss was due to inflammation or allergies, but Cohen didn't know. In fact he'd never gone to see a doctor about it, despite having lived without smell for as long as he can recall. "I can remember people shoving flowers in my face as a little kid, and I just didn't smell anything."

Like most anosmics, Cohen worried about rotting food and stinking clothes, leaking gas and fuel that he couldn't detect. "It's a lot better in terms of cleaning up after babies and dogs, though," he said with a chuckle.

But most important, Cohen's inhibited sense of smell affected the way he ate. Living with a blank smellscape—"I remember the first time I smelled an orange," he said. "I was in my twenties and I caught a whiff and it was awesome"—he needed other flavor cues to help him out. When he and Jerry Greenfield began making ice cream in a renovated gas station in Burlington in 1978, Cohen didn't want simple flavors. He wanted something more. He wanted chunks.

"I am very attuned to food textures," he said. "And I really wanted there to be textural variation."

"Did Jerry think that was odd?" I asked, thinking of the looks my mother gave me when I ate bread soaked in hot sauce right after the accident.

"Jerry thought it was kind of odd that I couldn't tell what flavor I was eating," Cohen said. "But there wasn't much weirdness beyond that."

Lucky man, I thought.

Before we hung up, Cohen asked: "Have you ever heard of the National Organization for the Smelling Impaired?"

"No," I confessed, embarrassed. I wondered how I could have missed something so big.

"Well, neither have I." Cohen laughed uproariously. "It doesn't exist. But if there was one, I'd totally join."

I WAS DUE to begin training at the Culinary Institute of America in December. Six weeks after the accident, however, I sat on the couch with my cell phone and the packet of informational material I had received to prepare for my starting date. My left knee and its thick metal brace rested on a pillow in front of me and I stared out the window as the heavy wind buffeted the trees out front. The familiar rhythm of Miles Davis's *Kind of Blue* played softly against the background patter of rain.

I'd thought about this call for weeks. I thought about it over every flavorless bowl of my mother's beef stew, alongside each bite of my favorite molasses cookie, the kind that now tasted like paper. I knew I couldn't cook. Not at home. Not in a professional kitchen. Not the way I wanted.

I knew it was time to make a decision, finally, when my father had come over a few days before. He looked grim and asked if he could sit with me on the couch. I was surprised to see that my mother, who generally cleared out of the room during his visits, sat as well.

"Molly," my father said, his voice low, "we need to talk."

"Okay." I looked at him. I knew what was coming.

"About your sense of smell . . ."

But I didn't want to hear it. I shook my head no. But my father wasn't looking. He charged on: "The outlook isn't good."

He had been reading all of the literature on anosmia that he

could find. He had placed a call to a Taste and Smell Clinic at the University of Connecticut. They don't know much, he said. But they do know this: the loss of smell often has no cure. Anosmia can be permanent. "We need to think about your future," he said.

Tears rolled down my face. My nose was wet, dripping. But I stopped shaking my head. I already knew.

I waited until I was alone to call the Culinary Institute.

"I need to delay my acceptance," I said to the woman who cheerily answered the line.

"No problem," she said.

No problem?!? Of course it was a problem. What would I do with the rest of my life now?

But I told her my name and scheduled starting date, calmly. I could hear her typing in the background as I spoke. I imagined the view from her window, high up in a stately old building on the campus I'd never visited in Hyde Park, New York. There were groups of young student chefs holding thick black cases of knives. They wore crisp white shirts and they laughed as they traversed the green.

It only took a moment to cancel my start at the school I had so desperately wanted to attend. I kept the phone to my ear for a moment after she hung up, the hard click vibrating through my body.

"Well," I said to my empty house. "That's that."

AS THE DAYS PROGRESSED, one at a time, slowly and alone, my body did heal. My scars did begin to fade.

I sat on the stationary bike at my physical therapist's office

three times a week, pushing the pedals back and forth before we did strength-training exercises on the bench. I had been helplessly fiddling on the bike for weeks and had not yet been able to bend my knee far enough to make an entire circle, too tight in scar tissue not yet ripped open for use. But one morning in early November I made a push, felt a pull but no sharp pain. My leg lifted those final centimeters, skimming the pedal like it was ice. It went all the way around and I looked up, surprised.

"You did it, Molly!" my bubbly young therapist called from across the room. "You're well on your way to recovery!"

Recovery, I thought. *What does that even mean?*

Though my knee was healing and I no longer received pitying looks from strangers on the street, I had never felt so broken. I didn't want to hear that I was better. Once my limbs were healed, I had nothing left to focus on but my nose. It was an invisible injury, potent and intense. It involved nothing concrete like crutches; physical therapy wasn't a possibility. But the absence—the monotone blank, the indescribable pale of a scentless landscape—was more painful than the nights I hyperventilated in the hospital after knee surgery. But this time, no one understood.

Without my nose, what was I?

"Beethoven couldn't hear," my father would say. "And he did it."

I nodded. I smiled, mechanical.

"You can be the Tasteless Gourmet!" he said.

With each passing day, I grew more and more frustrated. It was easier to live with the screaming pain of my knee injury. At least that was visible. At least everyone around me could understand. But now my friends and family were congratulating me

on my recovery and my health. My life, however—my day-to-day life—felt numb.

And I was angry. I was angry with my mother for asking me if I needed anything. I was angry with my father for looking at me with a glint of sympathy in his eyes. I was angry with my brother for simply existing—for eating with enjoyment, for laughing on the phone. I hated my friends for going on with their lives as normal. And I was angry with myself for caring.

One afternoon in October my mother and I went for a ride in the car. We were on our way to the supermarket and I wrote out a grocery list as we drove. When we came to a stop at a set of lights, I glanced up. It was the intersection of Route 9 and Warren Street, only a few feet away from the exact spot I had been hit. A ghost of my former self danced across the road. My mother took a deep breath.

"It was really scary, Molly," she said, looking ahead at the pavement.

"I know," I said.

I paused.

But did I know? I couldn't remember one second of the day that had so terrified my family, and driving through the intersection seemed to inspire more of a reaction in my mother than in me.

I wanted to alleviate the tension in the air. It made me uncomfortable. "It would have sucked if I had become a vegetable," I said, awkwardly. I tried to laugh.

My mom looked at me, as if to see if I were serious or not. "You're very lucky, you know," she said.

"I know, Mom," I said, softly. "I think about that every day."

"You do?" The surprise in her voice felt like a handful of needles pricking the base of my throat.

I nodded. I inhaled and then I exhaled slowly, just like the nurses told me to do after surgery, just like Maws had told me in the kitchen.

THE INVISIBILITY OF MY INJURIES wrapped me in what felt like a thick, impenetrable mist—just like the "fogbound horror" the novelist William Styron once described as his own crippling depression. A dark absence, a mysterious nothing.

Unlike the ripped tendons in my knee or the strawberry bruise on my neck, no one could see the injuries of my nose. I didn't limp or cry. I didn't cringe or shake or wither away. There was no pain; my behavior didn't change. There was nothing physical to show.

Not even I could see my injury. I didn't experience anything false. There was nothing obviously wrong in the way I perceived my surroundings. I didn't *feel* anything, not like those with the phantom limbs of amputees. I wasn't witness to a sight, not like the apparitions of those with visual hallucinations. No symphonies played unbidden in my head. This injury left me solely in possession of an absence. An important part of my world had become faded to blank.

My family tried, but they couldn't fathom my loss. I tried to explain the nothingness, but in order to do that I found that I had to describe what was now missing. And the language of smell, I quickly realized, is an absence in itself. How could I describe the indescribable?

Unlike the other senses, smell defies language. Its words are those specifically termed for something else, things perceived in other ways. Smell is a metaphorical sense, then, always in com-

parison to a concrete other, a more palpable here. Scents are often described in terms of taste (ripe or juicy, sour or sweet). They can be visual (bright, dark, green), tactile (warm, soft, cool), or come in sound (mellow, melodic, rich).

Diane Ackerman, author of *A Natural History of the Senses,* calls smell the "mute sense." She writes: "In a world sayable and lush, where marvels offer themselves up readily for verbal dissection, smells are often right on the tip of our tongues—but no closer—and it gives them a kind of magical distance, a mystery, a power without a name, a sacredness."

But even relating the experience of my own physical pain became difficult once it was gone. Only a few months after knee surgery I could no longer remember its immediacy, the scalding thrum of which had once circled my body like a vulture, vibrating in my muscle and bone. I tried to recall, but the memory turned out to be as fleeting as the relative duration of the sensation. And if I couldn't relate to my own pain, others had an even harder time. Harvard professor Elaine Scarry wrote about registering others' physical suffering in her book, *The Body in Pain.* "When one hears about another person's physical pain, the events happening within the interior of that person's body may seem to have the remote character of some deep subterranean fact, belonging to an invisible geography that, however portentous, has no reality because it has not yet manifested itself on the visible surface of the earth." Smell, like pain, is a primal, amorphous sensation, one of intensity and immediacy. I wasn't surprised to find that they each caused problems in language. Virginia Woolf once wrote, in her essay "On Being Ill," that someone who is sick "is forced to coin words himself, and, taking his pain in one hand, and a lump of pure sound in the other . . . so to crush them to-

gether that a brand-new word in the end drops out." She may as well have been writing about the words to describe the scent of the cologne worn by my first kiss, a young breath on a humid summer evening in Pennsylvania.

I spoke about language and the senses with Robert Pinsky, the baritone-voiced former poet laureate of the United States. Pinsky, a writer, translator, and poet, believes in the power of sound. He has called poetry a "bodily art form" and thinks writing poems is similar to composing music. "When I say 'chair' the little bones in your ear vibrate," he told me, his voice deep, his intonation practiced. "When I say 'chair,' I blow wind, *chh chh*. When I say 'very,' I let it vibrate in my throat, *vvvv*. It's physical. Words are an abstraction that we attach to physical experience."

"Smell is almost the opposite," he continued. "It doesn't involve category or generality. Smell is such a different sense, because the molecules come into the body, and then they go out. You experience it immediately by its nature. To describe a smell, words are abstract. Smell is so particular—it's the most particular configuration of molecules that makes coffee or body odor or acetone. No wonder it's figurative most of the time."

Pinsky, who teaches at Boston University, had spent some time thinking of examples of poetry that dealt in scent. He had found one by William Carlos Williams called "Sonnet in Search of an Author." He read it to me over the phone line, slowly, his clearly enunciated words vibrating the receiver at my ear. "It's a mock sonnet," Pinsky explained before he began, "a joke sonnet, but it's a beautiful poem." It describes two people—nude, "like peeled logs," in the forest. "A sonnet might be made of it . . ." Carlos Williams writes. "odor of excess / odor of pine needles, odor of / peeled logs, odor of no odor / other than trailing woodbine that /

has no odor, odor of a nude woman / sometimes, odor of a man."

As he read, Pinsky hammered down the word *odor* with each breath, over and over again. He said it with gravity, with precision, with rhythm. He explained that the poet used the word repeatedly in the poem on purpose. "The repetition is insistent that he smells it. And it is almost to say, to emphasize, that it can't be described."

When I asked Pinsky how he described scent in his own poems, lush poems as much physical as metaphorical, ones redolent with sound, he paused. "I am trying to think if I've ever had to describe a smell . . ." Silence. "You know, I'm not sure I have."

A poet laureate who couldn't recall ever describing a scent in his poetry? It didn't seem possible. But at the same time, it did.

I told him about the one mention of scent I had found in his work. It was in his poem "The Haunted Ruin," when he had described the smell of the computer, the semiconductor, a machine—"of breast milk / And worry sweat."

He laughed and sounded surprised. "You're right," he said. "Is that in *Jersey Rain*?" Yes. I had found it in one of his collections of poetry, one published a decade earlier. I could hear him pulling a copy off a shelf.

After a moment, he spoke. "You can definitely smell a computer," he said. "There are lots of little smells there. They are mostly ugly, but some have a little freshness to them."

Later, when I was away from my desk, I tried to summon a memory of that very scent. I closed my eyes and thought about the smell of wires and plastic, of late nights in college hunched over my laptop, of electricity and metal. It didn't come. Imagining aroma is difficult. Impossible for most.

Rachel Herz, a Brown University professor and author of *The*

Scent of Desire, once did a study in which she asked 140 college students to imagine a number of different physical sensations. They conjured the sight of a car, the sound of an alarm clock, the touch of satin, the taste of lemon, and the scent of chocolate. The ability to imagine smell, she found, was considerably weaker and worse than any other.

Although scientists have documented the overlap in brain activity when one imagines and actually experiences the sensations of sight and hearing, this is not true in imagining and experiencing an odor. "The parts of the brain involved in actually smelling pumpkin pie do not overlap neatly with the parts of the brain that are active when you imagine the aroma of pumpkin pie," Herz wrote.

I suddenly lived in an unimaginable world. One where my memories of scent were impossible to bring back. One where my loss was almost impossible to describe. I struggled with it. I avoided it. I didn't know who I was without my sense of smell. I had, as neurologist and author Oliver Sacks wrote in *A Leg to Stand On* about the aftermath of severely injuring his leg while on a desolate mountain in Norway, "fallen off the map, the world, of the knowable. I had fallen out of space, and out of time, too. Nothing could happen, ever, any more. Intelligence, reason, sense, meant nothing. Memory, imagination, hope, meant nothing. I had lost everything which afforded a foothold before. I had entered, willy-nilly, a dark night of the soul."

ON A MORNING in the final days of October, my mother loaded me into her car, balanced my crutches on the backseat, and took me to see an ear, nose, and throat physician, or ENT, in Boston.

It was time to get a professional opinion. I didn't want to believe my father's dire prognosis. I wanted to know when my sense of smell would come back.

I felt nervous as we drove toward the hospital. We had an appointment at the same hospital where I had spent those terrifying days right after the accident, the hospital that I could hardly remember. But it was a beautiful day, the trees lining the highway capped in leaves of bronze and gold. All I had to do to reinstate my starting date at the Culinary Institute of America was pick up the phone and call.

My mother and I took the elevator to the ENT's floor and checked in with a nurse. I could feel my heart begin to beat faster in my chest, thumping against my clavicle, as we sat quietly and waited for my name to be called. I stared blankly at a gossip rag, at the rug fuzzy with footprints, at the dull gray door. My mother looked at me and I smiled. I felt jittery but excited. I was ready to know.

When my name was called a few minutes later, my mother and I entered the small, windowless office together. We sat in chairs toward the back. We waited. When the doctor, a young man who exuded confidence, knocked and entered, he smiled and shook our hands. He sat and began to flip through my chart. He didn't look at me as he shuffled one paper after another. Suddenly, I felt very small.

"I can't smell," I told him. "Not since I was in the car accident."

He flipped through the papers again. I felt like my chest was slowly constricting.

"I've heard of this happening before," he said, finally. Shuffle, shuffle, shuffle; he tapped his pencil softly against his lap.

"I'm sorry," he said abruptly, absentmindedly, still looking down at his lap. "But your sense of smell is gone."

The silence hung in the room. I looked at my mother, who seemed stunned. She always knew what to say. But not now. I couldn't move, stuck in that chair in his bare white office. No tests? No questions? No medication? How is it possible that was it?

"What?" I finally spluttered.

"Yes," he said. "I've heard of this happening before in car accidents." He spoke so casually at first I wasn't sure if he was joking. "The impact destroyed your olfactory neurons. I've never heard of it returning."

I sat there numbly with nothing to say. My chest ached and I realized that I was holding my breath. I could feel the tears rising to my eyes. I didn't want to cry, though. I wanted to be angry with this well-coiffed doctor and his quick judgment. Where was his sympathy? Where was my hope? But instead my sadness bubbled up to the surface and spilled down my cheeks. The doctor looked up. He seemed surprised to see emotion.

My mother, who had jumped up to put her arm around my back, explained in a terse voice that I had wanted to be a chef. "She can't taste without smell," she said.

He looked at me for what felt like the first time and rubbed my arm softly.

"Keep your spirits up," he said. "Trust my opinions."

rosemary
and
a madeleine

IN WHICH I MAKE ADJUSTMENTS

I OPENED A NEW JAR of salsa while leaning against the kitchen counter one day soon after my visit to the ENT.

Pop.

I leaned in and inhaled. Air coursed up my nose, warm and blank. Of course there was nothing more. Unable to detect the scents of the tomato, garlic, or jalapeño, I wondered why I even tried.

But the scent of salsa had once meant something more than the lead to a crisp bite of a taco or the party companion to chips and beer. On dusky Sunday nights in the winter of my childhood, my father and I had watched movies. Not just any movies. We watched films handpicked from his extensive arsenal of VHS and laser discs—"the future of film technology," he used to

say—many times the same ones over and over. Sometimes it was a young Robert De Niro in *Midnight Run* or an even younger Mel Gibson in *Mad Max*. Usually, though, my father and I filled those hours with a bag of tortilla chips, a jar of chunky red salsa, and Bond. James Bond.

We would cocoon ourselves on the couch and watch *Dr. No, Licence to Kill,* or *Live and Let Die.* I loved *Goldfinger,* mesmerized by the scenes of beautiful women murdered by having their skin coated in layers of gold paint. I would drape an old crochet blanket—beige and slightly tattered, smelling faintly of our cedarwood closet—over my head as we watched. I felt protected by its bulk, but could still see the scary scenes from between its woven holes. Those evenings were always accompanied by a methodical crunch and the rustling of plastic bags. The chips and salsa were an integral part of the James Bond experience and, for years afterward, the smell of salsa brought me immediately back to it. Even after my parents divorced and my father left, I could pop open a jar containing some salty-hot variation on tomato, jalapeño, and garlic and I would be right back on that couch, under that crocheted blanket. I would be with a young Sean Connery, a Roger Moore, a happy young girl with her dad.

But as I ate in the months after the accident, salsa no longer brought me near the cedar-safe memory of my father, the delicious tingle of fear I had when watching James Bond. It was simply a jar of mush: sloppy, chunky, red.

I wasn't eating for sentimental reasons, though. I ate salsa—and I ate a lot of salsa—because I could *feel* it. The hot pepper kicked the back of my throat with blunt force, a tiny sign of life. It tickled my trigeminal nerve, which wraps around the face and into the mouth, transmitting sensory perception to the brain. The

trigeminal is responsible for the tingle on the lips and the tongue after eating a pile of spicy chicken from Atomic Wings or inhaling the menthol of Vicks VapoRub. It is the source of pain for the sensitive and a joy for those addicted to hot sauce, as well as for me, who had little else.

After many meals struggling to enjoy something, *anything,* in bite after mute bite, sometimes I just wanted to feel. I craved some kind of sensation in my mouth. I used Tabasco like salt; the Thai hot sauce sriracha like ketchup on fries. I couldn't detect herbs or spices or subtleties, but I could eat out of two jars of salsa blindfolded and feel the difference between spicy and mild. It all burned—painful, delicious.

On that October afternoon, I scooped the salsa into my mouth with a tortilla chip like a spoon, chewing straight-backed against the counter. I stopped attempting to smell. Sniffing felt monotonous, frustrating, and futile. My small but buoyant bubble of hope had burst in the office of that ENT. I needed different means with which to cope.

I had been forcing myself to concentrate on my other senses. As I ate, I honed in on the texture, temperature, and color of the food before me. I had always known that there was more to eating than flavor. I had watched Tony Maws work to keep his cauliflower florets a bright white, carrots their crisp orange, his sorrel sauce ablaze in greens. I had delighted in the pop of bubbly caviar atop a crisp blini, the smooth smear of sour cream. I had grown up eating bowls of homemade applesauce, redolent in cinnamon and steaming straight from the stovetop, with a big dollop of frosty vanilla yogurt on top. For years, in fact, that simultaneously hot and cold snack was the only way my brother would eat fruit.

But now I concentrated on the texture, temperature, and color so intensely that they took on a new significance. My eyes, my fingers, and the nerve endings of my tongue stood poised with meaning as each bite entered my mouth. I forced them to.

And I was surprised to find that it worked.

Suddenly the feather-light crack of my teeth on a wafer-thin Necco candy echoed in my mouth. The stringy heat of cheese pulled from that first bite of pizza, stretching against my teeth, soft against my lips, made me smile. I liked the pop of a ripe cherry tomato exploding juice against my tongue and contemplated the sensation of spaghetti in my mouth—slippery, smooth strands—the way I once did the lurking undertones to basil and butter. I stared at the rainbow of roasted beets arranged on my plate at the first restaurant I felt bold enough to go to with my family while I was still on crutches. They were luminescent in deep purple, fiery orange. I inhaled with my eyes.

At home I sought the crunchy: tortilla chips, popcorn, biscotti. I savored the jagged-edged crust of a sesame seed bagel. I ran my tongue along the tiny square indentations of a Triscuit as I let it dissolve in my mouth. I relished the thick feel of cream in my coffee and sticky spoonfuls of peanut butter straight from the jar. My mother made custard one night. She baked it in tiny porcelain ramekins in a *baine-marie,* a shallow water bath in a large pan in the oven. I told myself that it didn't matter that I couldn't tell whether mine was vanilla, butterscotch, or lemon. The soft, pillowy bites were fine.

And, slowly, I ventured back into the kitchen. Balanced on my crutches, I stood at the sink, by the oven, near the stove. I stood tentatively, hesitantly. I didn't cook. I didn't *want* to cook. But as thin threads of enjoyment began to weave their way back

into my mouth, I no longer feared the proximity. I breathed in and out over pots of low-boiling water. I wanted the caress of steam on my face, the thick band of damp heat up my nostrils. It was a different sensation now, and I pretended I could smell its warmth, conjuring images with each breath. Heat became the scent of two bodies under a mound of blankets on a winter night. Cold was the aroma of the chairlift, clanking as it took me to the top of a ski mountain in Vermont.

I daydreamed constantly. Over breakfast of a lifeless slice of toast, I imagined the bakery in France that I visited as a college student, where I opened the door to be struck by the scent of rich butter croissants. I imagined once again entering a coffee shop and breathing in the smell of its dark chocolate-like beans, the milk frothing sweet at the bar. I closed my eyes and tried to resurrect the scent of the wood-burning stove we used to light on winter weekends up north, of the salted brine to the beach in Hawaii, where my aunt and her family lived. I tried for fresh-cut grass, for the fluffy pink roses and lush basil plants in my mother's garden outside.

But the dreams remained fantasy, amorphous and unhinged. No matter how long I closed my eyes and imagined, I could summon nothing specific, nothing real, not the way I could recall the mournful tune of *Saving Grace* or the image of Monet's desolate haystack paintings on the dark canvas of my inner eye. I couldn't retrieve any memories of scents, and I knew that the people, places, and moments that had been fastened to each were likewise gone. Bereft, I watched them drift away. Where did they go? Those bright, vivid memories that came with a whiff of pastry or smoke, the background to every bakery or autumn I'd ever known. The ones that came with the smell of the crayons I used

to color magical landscapes with my grandfather in his studio. The ones that were perfumed with cotton candy and funnel cake, with fresh-turned earth or the shake of a pet dog just emerged from a lake.

I took myself completely off pain medication in the second week of October. The pills kept me lethargic, no longer in possession of my own body or of my own pain, and I couldn't wait to fully occupy myself again.

To celebrate, Becca scheduled a visit. Since I had last seen her I learned to operate my crutches without pain and regained most of the weight I'd lost. I no longer caught pitying glances from strangers on the street. Physically, I looked just as I had the previous May, when Becca and I celebrated our college graduation at a dinner with both of our families. Then, I wore a black dress, a pair of bright orange heels, and my hair tucked loose into a bun on the top of my head. We had sipped on rich glasses of burgundy in a restaurant that smelled of garlic and grape. "Cheers," we had said. But now I felt empty.

On the Friday evening that Becca arrived in Boston, we sat with my mother and Charley amid the flickering candlelight of their small dining room. We held glasses of wine, poured from a very nice bottle of red, one that they had been holding on to for a special occasion. We lifted our glasses, clinking them all around. Our collective laughter felt strange, unfamiliar and comforting at the same time.

I placed my nose carefully near the inside of the fluted crystal glass. I pulled it back and gave it a twirl with a flick of my wrist. The red wine moved in a jaunty pirouette around its inner curve. I held the glass away from me, admiring the deep color in the light and then drew it again toward my face. I inhaled

deeply. Once, twice, three times. Was there something there? I inhaled again. My breath came strong in the back of my throat and through my nose. I closed my eyes and pictured a dark red cloud floating above, listening for a whisper of scent. Its image swirled behind my eyelids and reminded me of the outdoors, of fruit on an overhanging limb, a jarring twang on the banjo I once heard on a camping trip in the woods.

I looked up to find everyone staring at me. My family and Becca were watching me closely, wondering if I could smell or if I could taste, wondering if I would hold it against them that they could.

I took a sip. I held it in my mouth for a moment and let it coat my tongue. I could only taste the sweet, the straight sugar of the fruit. I could sense the acidity, which gave a limp sparkle in the back of my throat. Nothing more. The glass held a strange echo of the familiar, but remained an oddly split unknown.

When Becca left on Sunday night for her long trek back to upstate New York, I sat on my bed and inhaled deeply. There was nothing but that all too familiar twang of loneliness residing in the back of my throat.

I GREW UP in a gray house with red shutters that sat across the street from a tiny apple orchard deep in Boston's suburban sprawl. I lived there with my parents and my brother, and then just my mother, until I left for college in 2001. This house was spacious and bright, too large even for our noisy family of four, and I was constantly on the search for new nooks and crannies to explore. My mother, a psychoanalyst, worked in an office at the far end of a hallway behind our garage. She

kept many of her books there, carefully organized on two large wooden shelves standing against the wall. Occasionally when I was restless in an empty house, I would sit at her desk and look at the cracked spines and grainy titles, their colors faded like construction paper left too long in the sun. I would pick up one or another, flipping through their pages, breathing in their musty, foreign smell—like that of the used bookstores I imagined existed in Paris or London or even New York, places I dreamed of going one day. My favorites included the seven volumes of Marcel Proust's epic novel *Remembrance of Things Past,* which occupied a place of honor at eye level. My mother had read them in college, and I liked to study her handwriting in the margins of the musty yellow pages, which looked careful and composed and nothing like her horrid scrawl of today. I often picked up *Swann's Way,* the first volume, and smiled over the price tag printed on its lower right corner: *$1.95.* But, even in high school, I never read beyond the first page. I was intimidated by Proust's language, which was beautiful but impenetrable. I always replaced it carefully on the shelf.

It was only later, when the books had been transferred to a shelf spanning the wall of my new bedroom after my mother moved, that I learned how special these flimsy, tattered volumes really were. My mother had bought them from the bookstore at Brown University in the fall of 1972, her sophomore year of college. I have pictures of her from that time, a skinny blond girl wearing bell-bottoms, a peacoat, and a wistful smile as she leaned against a tree on the Main Green. She bought them for a seminar on Proust, one that would concentrate on this roughly autobiographical tale that sprawls for more than three thousand pages. In that class, she sat at a long wooden table with a group

of students and her professor, a dynamic young man named Arnold Weinstein, whose lectures brought Proust's words alive. My mother became fascinated with the dreams in the novel because, she told me later, they implied the author's rich and hidden inner life. "That was the class that inspired me to become a psychoanalyst," she said.

I began to read her now odorless copy of *Swann's Way* one afternoon in the months after the accident. *Why not?* I thought. After all, one of the most iconic scenes in literature illustrating the connection between smell, taste, and memory takes place within the first fifty pages of the very first volume of her version of C. K. Scott Moncrieff's 1922 translation.

Here, the narrator describes a simple moment: arriving home on a winter's day to his mother, who offers him a cup of tea and a cookie, "one of those short, plump little cakes called 'petite madeleines,' which look as though they had been moulded in the fluted scallop of a pilgrim's shell." He raises a spoon filled with tea and cookie crumbs to his lips and is immediately ambushed by emotion, overtaken, as he says, by an "exquisite pleasure." It takes many minutes, many sips and crumbs, before he realizes why: a memory. The narrator recalls that when he was small and visiting his aunt in Combray, she fed him a nibble of her cookie dipped in a cup of lime-flower, also known as linden-flower, tea.

> But when from a long-distant past nothing subsists, after the people are dead, after the things are broken and scattered, still, alone, more fragile, but with more vitality, more unsubstantial, more persistent, more faithful, the smell and taste of things remain poised a long time, like souls, ready to remind us, waiting and hoping for their moment, amid the ruins of all

the rest; and bear unfaltering, in the tiny and almost impalpable drop of their essence, the vast structure of recollection.

Though the madeleine moment is today considered trite, detailed countless times by writers and even scientists, it remains effective. It's an important moment. Like Proust, we have all experienced the surprising clang of a scent that excavates a memory—a moment not wholly lost to time, one resurrected.

My mother's professor Weinstein went on to write many books. In *Recovering Your Story,* he tackles Proust. *Remembrance of Things Past,* Weinstein says, is "dedicated to the pursuit of ultimate richness and treasure: our own life." Most of us, he believes, are unable to retrieve the immediacy of our own living pasts. The heart of memories can fly away, even if we still possess the events, dates, and names stored away in the Rolodex of our brains. The important part—the emotional part—slips away unnoted and unnoticed, sometimes forever. Proust writes about how to bring that back. It begins with a cookie.

"As if to accentuate the grotesque disparity in this equation— the disparity between the whimsical, wispy, capricious puniness of taste and smell on one hand, and the galactic grandeur of our past life on the other—Proust wants us to realize that the immense edifice of memory (his exact words in French) rests on a 'droplette,' a *gouttelette,*" Weinstein writes.

Scent can excavate memories of one's past, of one's self, in an intense and personal way. Smells can grab at buried emotion and memories, at feelings long forgotten. These memories can come unbidden, lacking words or context. They can be specific, so specific that they squeeze you with their joy, that they pierce your skin with their pain.

Helen Keller put it eloquently in her essay "Sense and Sensibility": "Smell is a potent wizard that transports us across a thousand miles and all the years we have lived. The odor of fruits wafts me to my Southern home, to my childish frolics in the peach orchard. Other odors, instantaneous and fleeting, cause my heart to dilate joyously or contract with remembered grief. Even as I think of smells, my nose is full of scents that start awake sweet memories of summers gone and ripening grain fields far away."

I BEGAN TO COOK again one morning in November. It had been three months since I could smell.

Though I had been spending time in the kitchen with my mother and Charley as they prepared dinner each night, I had not yet attempted to wield the sauté pan myself. I told myself that I didn't want to cook. It was too dangerous to navigate the room on my crutches balancing fillets of salmon or pots of polenta. It was too expensive to buy ingredients that I would only destroy. I don't need it. I don't want it, I said.

But one dark November morning I woke to rain pounding on the windows and a sharp pain in my back. I hadn't been able to sleep on my side since the accident because I had to stabilize my knee in a position that locked my body upward and woke me up each morning aching after a too-still slumber. On this morning I lifted my knee gingerly out from under the covers and off to the side of the bed, which was finally back in my room on the second floor. I hopped on one leg down the stairs, balancing on my crutches and the rail, and sank into a large armchair in the living room. It was a typical beginning to another tedious day in an empty home. Everyone was already at work.

I sat wrapped in a blanket with a book propped open on my lap, but I couldn't concentrate on the words. The rain pattered thick and humid despite the chill and I felt restless. Bored. I hauled myself up yet again and wandered on my crutches— *click, hop, click, hop, click*—toward the kitchen. When I arrived I looked around, not quite sure of my purpose. Perhaps I would brew some coffee? My gaze settled on the oven.

I'm going to bake, I thought.

The idea sprang unbidden and took me by surprise. But why not? Baking was different from cooking. Baking required measurements and timing. It required temperature and science. It didn't involve tasting or improvisation. It didn't much involve smell.

I wobbled awkwardly between the fridge and the cupboard using just one crutch under my arm, clutching a dog-eared copy of *Cook's Illustrated* magazine in my free hand as I began to gather ingredients. With the slow whir of the electric mixer in my ears, I threw a cup of sugar and a couple sticks of butter into a silver bowl. Once pale yellow and creamy, I added salt, cocoa powder, and a teaspoon of instant espresso. The oven clanked as it warmed. I began to feel more confident in my movements. To the bowl I added eggs, vanilla, baking powder, and flour, pulverizing it into a thick glop. I threw in some ground almonds, some cinnamon, and—*why not?*—a dash of cayenne. *At least I'll be able to feel that,* I thought.

It took a while to figure out how to hold and carry baking sheets, how to portage dirty mixing bowls across to the sink and reach the spices way up on the top shelf. But soon it became a rhythm—the exact number of crutched steps I could take holding a bowl without losing balance, the length of time I could

stand comfortably on my right leg while my left hung bent above the ground.

An hour later the timer blared its metallic *ding* and I pulled two trays of cookies from the oven with a mitt. They lacked that familiar, cheerful aroma that I had always equated with the oven-fresh—the one of Nestlé, of my mother, of Christmas. But they felt adequately firm. They looked done. Ugly—the lumpy, mud-colored rounds lay unevenly on the sheet after my uncoordinated attempt to arrange them with one hand—but done. I took a bite of a hot cookie, which crumbled like gravel in my mouth. Later, I arranged them carefully on a plate for my family. Here was something I could share, something I could show. My family had cared for me wholly and tirelessly since the accident. This was one small thing that I could give back.

In the following days, I returned to the kitchen with new purpose. I filled the empty daylight hours with tufts of flour that rose from the counter like clouds. Beginning with an almond cake, a pumpkin pie, and a mountain of chocolate pecan cookies, I tried my hand at fresh pita bread and dimply rounds of whole wheat. I pulled a loaf of French lemon bread encrusted in a sweet maple frosting one evening just as my mother arrived home from work. "It smells delicious in here," she said with a sigh.

I found that if I followed recipes with precision, my baked goods would be deemed a success, scarfed up by the smiling mouths of family and friends. If I was experimental or sloppy in my execution, however, the results grew brittle and stale on the counter. I no longer had the ability to draw the line between bland and delicious, so I measured my cups of flour and teaspoons of salt with care. At the Craigie Street Bistrot, I had

been learning to leave recipes behind, to rely on myself and my senses. No longer able to trust my own intuition, I returned to the written word, the carefully recorded cups and tablespoons and ounces. While improvisation in the kitchen had brought excitement to the stove, a sexy creativity impossible while under the rule of recipe, at least my slow-rising loaves of bread brought the same enjoyment to the table in the end. *This will do,* I thought. *For now.*

I began to cook savory dishes, too. I attempted simple things, meals that I assumed wouldn't require me to taste so much as I went along. My head bent close to the stove, I watched the meat brown and listened to the sauce reduce with a burble. But I missed all reference to spice and herb, to nuance and depth. I couldn't balance the individual flavors in my mouth.

"Your cooking is . . . erratic," my mother said with a kind smile on her face one night over dinner. We were eating pasta with sheep's milk yogurt, Parmesan cheese, and a slew of slivered onions that I had cooked down to a sweet caramel brown. This was a dish that Becca and I had cooked weekly when we were in college, so charmed by its warmth, rich with onions in butter and tangy with dairy. I watched my mother take one bite before pushing it casually away to concentrate on her salad. "It needs . . . something," she said when I asked her what was wrong. I tensed in my seat. Suddenly, I was angry. "What?" I yelled. "What does it need?" The words exploded from my mouth. I pushed back my chair and grabbed my crutches. She apologized but I wouldn't hear it. I dragged myself back toward the stairs to my room, cursing under my breath.

■ ■ ■

IN THE FIRST WEEK of November I shed my crutches. My left leg had withered away in the months it lay dormant and my unused muscles screamed in anticipation, but my doctor had given me clearance to bear weight on my injured knee. My father took me to a medical supply store near his house to pick out a cane.

"I'll bet I'm the first person under the age of seventy to come here for one of these," I said, eyeing my options. I chose the simplest: black, curved like the candy we once hung on our Christmas tree, shiny with a painted metal finish. I tested it out with a slow walk around the store, leaning heavily, using both hands, terrified of falling over. The cane clicked each time its stump hit the ground. My father helped me to climb back in the car.

I met Alex at the front door when he arrived the following afternoon. I smiled, proud to stand on both legs, but embarrassed that my expectations had fallen so far. "I feel like a grandmother," I said, waving my cane, trying to shrug it off.

He laughed his familiar laugh. "You're fine," he said.

Alex had come over often since the accident. For this I was thankful. He provided respite to my loneliness, a companion for many of my long days at home. He made me laugh, reminded me to exercise the muscles of my smile.

Together in those weeks, we hadn't done much. We watched television or just talked while lounging comfortably on the couch. We ate burritos bulging with guacamole and beans from a restaurant down the block and carved warped little faces into pumpkins for Halloween. On an evening in October he tucked my crutches and me in the front seat of his car and we drove to see a movie at a theater one town away. We were running late and I worried we would miss its start. When we parked, Alex jumped out and slammed his door shut. I could see him stymie an im-

pulse to lope toward the theater a few blocks away. I was moving slowly, feeling guilty and trying to keep up. He gave an apologetic nod and I told him to run ahead with a point of my crutch. "No," he said, sweeping my arms over his shoulders and lifting my body up behind him. Careful not to disturb my injured knee, he held me stable, piggyback style, and carried me all the way to the theater, my face pressed into his neck, holding on tight. We fell into our seats laughing right as the film began.

On that November day—my first full day without crutches, a brisk almost-winter New England afternoon—Alex and I climbed into his car and drove toward the suburbs where we both grew up. We parked in a lot across the street from the Old North Bridge, its wooden limbs the site of one of the first battles of the Revolutionary War. On nice days tourists flowed over its small berth, but to us it was just a bridge, a high school haunt only minutes from his home.

Alex turned off the engine and turned to look at me. He wore a thick black coat and a snowboarding hat over his bright red hair, which he had recently cut into a Mohawk that I feared if unsheathed would draw more stares than my cane. "Are you ready?" he asked.

"Yes." I pulled on my hat and my gloves. I hadn't walked more than the length of my mother's small house in the twenty-four hours since I left my crutches behind and as I stepped out of the car onto the frozen ground, I felt my stomach clenched in fear. I had forgotten how to balance myself unaided. I couldn't remember how to bend my knee with each step.

"How do you walk again?" I asked with a nervous laugh, worried that I would fall on a patch of ice or that a gust of wind

would flip me right over onto my side, brittle like a stick. But Alex stood close by as we walked step after aching step from the car to the bridge, a distance no longer than a football field but one that felt as if it extended for miles.

We passed over the bumpy, ice-encrusted landscape. My leg, still encased in the thick metal brace that ran from ankle to midthigh, felt weak. My cane seemed too thin to bear the weight of my body, and I moved stiffly. When my feet hit a patch of ice, Alex held on to my arm and guided me to solid ground. We arrived at the bridge, which hung low over the dark flow of water, and paused for a moment at its peak. The final rays of light cascaded through the bare limbs of the willowy trees near the river. I could see the first dusting of snow limp on their branches. Standing with Alex as the cold air whipped around my cheeks, it was easy to imagine this was a different time.

My high school friends and I had often driven to this spot. We would stand on the bridge, laughing and joking and relishing the freedom of not being at home. We walked through the woods and threw rocks in the pond. We weren't particularly rebellious teenagers. We spent our time playing in the marching band at football games and watching movies at one another's homes. We took swigs of the vodka stored in one parent or another's liquor cabinets, giggling and unsure. But here we had just goofed around amid the scent of bark, of damp stone, of crisp running water.

Alex and I had come here in the beginning of our relationship, too, when we were shy high school juniors. In those bashful early days, we spent a lot of time wandering outside, the first blush of an "us" arriving alongside the scent of fallen leaves and

freshly turned earth. A favorite spot of ours was the local arboretum, a lush park in the center of town, where we would walk on the gravel paths in the afternoon or lay on a blanket in the grass waiting for the stars to emerge in the early-autumn sky. I remember the scent of that field, green and sweet, breathless as we moved toward our first kiss.

Standing there on the Old North Bridge six years later, it struck me how painful it was to be close to Alex again. Despite the pleasure of his friendship, which had only blossomed again in the aftermath of the accident, he was my ex-boyfriend. He was my first love. I missed our easy relationship, the one that ebbed and flowed through high school and college and made me feel that I would always be loved. I missed skiing with him in the winter, running on backwoods trails with him in the summer. I missed the way he put his hand on the nape of my neck from the passenger seat while I drove.

What I missed most, however, was something that no longer existed. I missed the smell of his favorite T-shirt, which I had taken with me to my first semester of college and worn every night to bed, cuddling in its known odor of home. I missed the soft scent of his skin, salty after exercise and sleek after a shave. I missed the familiarity of his embrace, of his home, of the haunts of our past—the kind that only came with that textured depth of scent. Without smell, without that present and its tie to the past, I felt like I had lost part of him. Perhaps the most important part. Alex wasn't Alex, really, without his smell. My memory of that person had been lost in the accident, too.

I looked back toward the car as we stood there silently. I measured the distance with my gaze. "I can't believe I walked here," I said, finally. "It looks like such a small distance."

"You did good," Alex said with a pat on my back. "You'll be running again in no time."

I STOOD AT the kitchen counter with a cookbook and a knife and my cane balanced against the counter a week after I began to walk. The pain had receded, and I hardly thought twice when I moved back and forth from the stove.

I had been helping to cook dinner for my mother and Charley every night, happy to do something productive even if the results were at times bland. On this night we planned to roast a leg of lamb, which sat fleshy and fine in the fridge. I laid a thick bundle of fresh rosemary on a cutting board before me. I would pluck the pointed leaves, just as I had done nightly for Maws, and then chop them in order to flavor the marinade for the meat. I moved along in my work, *pluck pluck pluck*, *chop chop chop,* my knife rapid against herb and wood. I let my mind wander. I thought about culinary school, about Alex, about the memoir I had begun to read that morning, one about a woman in New York who cooked her way through every recipe in Julia Child's first book. And then suddenly I stopped. I breathed in and out, slowly. There was something in the air. Something different. Something surprising and strange, something I couldn't quite process, like I had entered a waking dream.

There was a smell.

Inhale.

Exhale.

It was there. Definitely something there.

Inhale.

Exhale.

This scent was light but undeniable. It entered my nose with purpose on each breath. It was shocking, like a burst of neon light in a landscape of black and white, and I stood there silently, unsure of what to do.

Could I be hallucinating?

Inhale.

Exhale.

It was still there, smelling of the woods. Of the ground. Of the earth. It smelled dark. A dark forest green. It smelled wonderful.

I looked down at my hands, which still held a knife in one and a bundle of herbs in the other. *Of course.* This was a scent, a real scent, the scent of rosemary. I leaned down over the cutting board and sucked in air slowly again through my nostrils. The aroma saturated my nose, and for a moment I could hardly breathe. I felt assaulted. Surprised and overwhelmed.

"I can smell this," I said.

I looked around. There was no one in the room but me.

"I can SMELL this," I said, louder.

I inhaled and exhaled again. It was still there. I could smell it!

It was pungent, rich and warm. Like a friend I hadn't seen in years, this scent rang simultaneously familiar and strange. It tingled with possibility. I closed my eyes and breathed in again.

There it was. There what was? A thought? A memory? The aroma took me somewhere—somewhere as immediate as the sound of knife on herb. It took me back to my childhood: to a family vacation in Colorado, when I rode a horse for the first time on a trail littered in rosemary bush.

I put my hands to my face again and again. I could smell it

there the entire night. The lingering scent on my fingertips gave me goose bumps of pleasure. It reminded me of my family, of my past. It reminded me of the freedom of summer and the breath of vacation. It reminded me of James Bond.

WHY? WHY DID rosemary send me immediately back to that horse ride in Colorado? Why did salsa take me viscerally back to those Sunday evenings with my father when I smelled it before the accident? Why did the scent of sawdust ignite a memory of a rodeo out west and whiffs of cinnamon gum on a friend's exhale a middle-school crush?

It is not all romance and English literature. It is grounded in science as well.

The perception of smell is directly linked to the amygdala and to the hippocampus, located in the medial temporal lobes of the brain. They are both considered gateways to the limbic system, which processes long-term memory, emotion, and behavior. Although hearing, vision, taste, and touch likewise provide input, olfaction is the only sense so intimately and immediately routed throughout. No wonder, then, that smells "detonate softly in our memory like poignant land mines, hidden under the weedy mass of many years and experiences," as Diane Ackerman writes in *A Natural History of the Senses*. "Hit a tripwire of smell, and memories explode all at once. A complex vision leaps out of the undergrowth." Complex, indeed.

So smell is tied to emotion through the broad hand of brain wiring. But what does that mean about specific memories? How does this surprising little sense tie itself to a place, a person, a

day? It's through something much less romantic than Proust and his madeleine: learning.

Memories are tied to scents the same way that reading Proust over and over taught my mother about the symbolic value of dreams, the same way that I could eventually recall the definitions to Italian grammar words on my flash cards without having to turn them over to look. Smells are associated with specific events, people, and places because we learn them that way.

Trygg Engen, a professor of psychology at Brown University who passed away in 2009, was one of the first to theorize on odor memory and learning. It begins in childhood, he said, upon emerging from the womb. (Or even earlier. Studies have suggested babies are born with preferences for flavors similar to those ingested by their mothers while pregnant—even choosing chew toys scented with the aroma of alcohol over those with vanilla.) But babies, who have a fully developed sense of smell after only twelve weeks of gestation, are born without any preexisting knowledge of or opinions on scent, Engen believed. Emerging from the womb a blank slate, nothing is positive or negative until they learn it to be that way. The scent of a dirty diaper bears as much pleasure as a rose. Engen found that newborns responded the same way to the scents of foul onions and licorice, and that four-year-olds reacted similarly to the scents of rancid cheese and bananas. We learn smells through experience, often programmed into our brains while young, when we encounter most for the first time, when everything in the world seems large and intense. It's these memories that stick.

This slate is soon filled, however. It's filled with a love for anchovies like mine, a love that I learned while mimicking my father, who learned in turn from his father, who ate the strong

salted fish piled on slices of pizza with cheese. It's filled with a hatred for ripe bananas like my mother's, which is so virulent she cannot stand in the same room as a peel that is soft and fragrant and dotted in brown. I once met a chef in New York City who fell in love with her partner after learning that she, too, was fond of the taste of durian, the famously stinking fruit from Southeast Asia. "She just had to learn to appreciate its smell," she told me with a smile.

This is in part a mechanism of biology: if you eat something and become sick, the brain is programmed to remember the warning signals. I will never forget the slice of New York–style cheesecake, which I ate while on vacation with my family, only to spend the entire night helplessly huddled on the cold tile floor of the hotel bathroom, leaning over the toilet. It took years for me to bring myself to taste cheesecake again. Its creamy aroma, no matter how far away, nauseated me.

But how long do these scent memories last? Could Proust's protagonist really remember that specific cookie from that specific visit to his aunt's house in Combray all those years before? Engen was one of the first scientists to study long-term odor memory. In 1973, he asked a group of people to memorize a certain number of novel odors in his lab. Over the following days and weeks, he tested them periodically and found that their retrieval rate didn't lessen over a period of many months. They could remember far fewer of the smells than they could a list of novel words in the same time span, true. But, nonetheless, Engen believed that scent memory was long lasting. "The Proustian insight is validated!" he wrote.

Though it has since been found that if *another* new scent is smelled soon after the one to be remembered, the memory of

the first is significantly dimmed, Engen's findings have been fur-
thered by many more. Two decades later, William Goldman and
John Seamon asked a group of students at Wesleyan University
to recognize and recall a group of odors that they hadn't smelled
since childhood. Among them they smelled bubbles, fingerpaint,
crayons, and Play-Doh—important odors of young, impression-
able years, ones first encountered far from the sterile laboratory
environment. Later, the experimenters found that their partici-
pants could recall these childhood scents statistically higher than
average.

And it goes further: we remember smells from our past, but
smells also help us resuscitate memories. In 1999, John P. Aggle-
ton and Louise Waskett, two scientists at the Cardiff University,
tested the memories of a group of people who had made a visit to
a specific museum at least once, but as many as three times, six
years before. Not just any museum, however. They chose one that
dealt in a niche underworld: Vikings.

The Jorvik Viking Centre in York, England, dives into its
subject matter on more than one sensory level. Scents of burnt
wood, apples, rubbish, beef, fish market, rope/tar, and earth are
piped into different areas of the museum, depending on the ex-
hibit, to aid in education. Aggleton and Waskett, trying to re-
suscitate the specific, detailed memories from trips taken years
before, split their participants into three groups and had them
all fill out questionnaires. One group filled out the questionnaire
first while smelling these seven specific scents, and then again
while smelling a set of "control odors," or seven completely dif-
ferent aromas—common non-Viking ones like coffee, pepper-
mint, rose, antibacterial cleaner, coconut, maple, and rum. The
second group did this in the opposite order, and the third filled

out their questionnaires without any odor at all. And the results? Those who answered questions about that distant day while first smelling the common odors, and then again with the Viking odors, showed a steep increase in accuracy. The scent of burnt wood and apples resurrected a moment of the past. Proust would have liked that.

Others, however, disagree with this emphasis on Proust as seen through the lens of science. Avery Gilbert, a smell scientist and author of *What the Nose Knows,* says that Engen was wrong: odor memory is the same as all others, being faulty and decaying. Gilbert calls the scientists who put so much emphasis on his emotional connection to the past "Proust-boosters." "How can a work of fiction, no matter how well written, become the truth standard for scientific research?" he writes.

Perhaps it is ridiculous to put so much emphasis on the twentieth-century French novelist. He did, after all, deal in dream worlds and alter egos, concentrating on the cadence of language and not the accuracy of scientific possibility. But what's important is that these ideas, these theories and explanations swirling about the subject of scent memory have captivated many. Scientists have studied it—the length, the emotion, the accuracy of odor memory—for decades. They've written about it, spoken about it, and fought over it. And still we keep coming. We still read Proust. We still cite Proust. What is it about the memories excavated by an odor that keeps us so rapt?

I WALKED AROUND my house sniffing for days after rosemary shocked me with its wooded potency. I sniffed over every single item in the refrigerator, one at a time. Mustard, mayonnaise,

milk, Niçoise olives pitted in a jar. I sniffed over every bottle of shampoo in the shower. I smelled the blanket on my bed, the washing machine in the basement, the screen to the television overlooking the couch. I breathed in and out, carefully and conscientiously, waiting for the next scent to return. I continued to cook and to bake, leaning over the pots and the pans, my body taut with expectation. But as the inhales remained blank and the days passed numbly, I grew frustrated. Where the hell were they?

What came next I didn't expect.

I sat at the kitchen table reading a book and sipping a bitter cup of coffee one dark winter afternoon. When this scent arrived, it came slowly. Unlike rosemary, which assaulted me, sending me flying with its sudden strength, this smell melted into my consciousness. When it finally registered, I couldn't be sure it had ever been gone. But I paused, and looked around. What was it? Hovering and delicate, it wasn't the coffee steaming by my hand. It wasn't the book, or the table, or the lamp. Nothing burbled away on the stove. I closed my eyes. The more I concentrated, the stronger it grew. It was a toothsome, earthy scent. It was a strange scent. I wondered if I was going mad.

When I left the kitchen, it followed me to the living room. And then to my bedroom. It followed me to the shower, and then to the car parked in the driveway. I smelled it under my covers as I fell asleep that night. I smelled it over the oven as I baked a loaf of lemon pound cake to eat with tea the following day. I smelled it in the garden and on the front steps, in the basement and the linen closet upstairs. It lasted for weeks.

What was it? I could come up with only one answer.

"I can smell my brain," I told my mother.

I sat in my bed with a bottle of water and a stack of books to my side.

"What?" She laughed. And then she stopped. "Your brain?"

"Yes," I said. "I can smell my brain." She looked doubtful. I shrugged. I knew she wouldn't believe me. "Yes," I repeated patiently. "My brain. I can smell my brain."

"And what does your brain smell like?"

"It smells like the forest. Like the woods."

She looked at me like I was crazy. *Perhaps I am,* I thought. But that didn't take away the scent. And there *was* a scent. It came wobbly but present on each breath. It reminded me of the grass, of a garden after the rain. It felt organic and real and fluctuated in strength throughout the day. This smell didn't come from anything around me. That much was obvious. Therefore, I told my mother, it must come from within.

"It has to be my brain," I said. "What else could it be?"

I waved off her disbelief. I didn't mind the scent. I liked it, in fact. The constant aroma was reminiscent of the rambles I once took in the forest near my aunt's summer home in Pennsylvania, all leaf-burning horizon and black earth underfoot.

I liked the companionship, too. My little pet sensation, constantly nipping at my heels. The world no longer fell so flat with the blooming aroma of my insides. I kind of hoped it would stay.

I described it to my father when he stopped to see me one afternoon.

"I don't know that it's possible to smell your brain." He tried to explain. Miswiring. Misfiring. Phantoms.

"Whatever," I said with a flip of my hand. I didn't want his science, his doctorly lore.

My brother, Ben, at home for a weekend away from college, was more receptive.

"That's awesome," he said. "My sister can smell her *brain*."

After three weeks, however, the smell began to fade. It trickled away one breath at a time. Until one day, it was gone.

I ASKED FOR A JOB at the bakery because pastry dough had nothing to do with smell. I didn't need to taste the intricacies of flour, butter, or baking soda, I told myself again and again. Baking is about measurement. It is the science of precision and the art of decoration. "I can do that," I said to Bill, owner and head baker at a little pastry shop in Concord, Massachusetts. I hadn't worked since my time at the Craigie Street Bistrot, and now that I could walk, I needed a job.

Bill hired me as a favor. I had worked for him before. The summer before I went away to college I sweated out the early mornings unloading loaves of bread and refilling the cookies piled behind the glass case under his watchful eye. In those months I had stirred cauldrons of his special tuna salad, which smelled strongly—unappealingly, I thought—of curry and sour mayonnaise, and helped assemble towering sandwiches of apples and brie. I escaped the melting heat of summer in his walk-in freezer, which hung with the disembodied scent of winter, hectically piling bags of pecans in my arms. I had approached him in the first weeks I walked with my cane because I would soon move unhindered and I wanted a job. I wanted to be out of the house and in a kitchen again. He needed help for the holidays and this time he would let me bake. He would teach me how.

But honestly? I wanted to see if it would hurt. And I didn't mean in my knee.

I began one morning in late November. There was snow on the ground, and it took me a long time to walk from the parking lot to the bakery. I moved slowly, a slight limp favoring my right leg. I was still afraid of ice and, despite the six-pound metal knee brace that I wore twenty-four hours a day, I just knew that if I fell I would injure myself all over again.

I opened the creaking wood door of the bakery, which was on the corner of a historic block in the center of town. I felt dizzy and was worried my hands would begin to visibly shake. When I stepped inside, though, I was struck by the warmth. A handful of people milled about the small room, peering into the cases filled with breads and pastries. Coffee cups steamed. The brunette behind the cash register laughed loudly and greeted a man in a red sweater, clinking change and rustling paper bags. I stepped past the counter, through the arched doorway to the back. I glanced around, taking in the stacks of ovens, racks of colorful molded cookies, shelves of brown bread, and a cascade of metal mixers.

I shook hands with Bill when he emerged from the storage room downstairs, a well-worn Red Sox cap snug on his head. His shoulders were slightly hunched, his eyes creased in smile lines, and a pristine white apron hid his slight paunch. I began to work immediately.

I peeled and chopped apples for the Thanksgiving pies, refusing to think of those in my past, losing myself in the repetitive physical task. I rolled out dough for batches of Danish and turnovers, throwing about cinnamon and more apples with speed. I

baked pumpkin bread and coconut macaroons. I couldn't smell
a thing.

I arrived home that night tired and sore. I threw my clothes in
the laundry immediately. They must have smelled of butter and
grease, I was sure. I woke up the next morning and started again.

As the weeks progressed, I felt strange and uncertain in the
bakery. It was a warm shop, filled with light and shelves of crusty
bread. Pans of muffins and sheet trays of cookies were constantly
emerging from the ovens. Coffee brewed in massive machines
against the wall and Bill could always be found frosting a batch
of cupcakes or piping a design onto a birthday cake. But I didn't
know how to move, and my knee brace was always in the way.
I couldn't carry the heavy bags of flour upstairs from the base-
ment or tell when loaves of lemon poppy seed bread were done,
unable to detect their nutty scent. I had no idea if the milk in the
refrigerator was sour or if the caramel on the stove was scalding
without looking inside the pot.

"How did the cake turn out?" Bill would ask me every morn-
ing, a congenial smile on his face, after I had baked the day's
orders to his exact instructions.

"I don't know," I would say, always hesitant and stumbling.
"Will you look?" The cakes were beautiful. I could follow direc-
tions. But I felt like I was always missing something.

I tasted as I went along. Bread remained like a grainy sponge.
Coffee was bitter heat. Milk was a thick and clammy water. The
chicken sandwiches Bill served every day for lunch tasted like
cardboard. I dipped a spoon into the caramel sauce that tasted
only of sugar, painfully sweet. Nothing seemed right. I doubted
my every move.

And I was angry. It irked me that Bill's Red Sox cap was al-

ways on backward. I disliked the way the cashier looked at me
when she asked about the car accident. I hated the customers.
Middle-aged men and their cheerful little children, elderly grand-
mothers, and businesswomen in suits would come into the store,
exclaiming with pleasure. "It smells so good in here!" I wanted
to spit in their food. I wanted to smash the glass case of fruit tarts
that I painstakingly arranged every afternoon. And I almost did,
one day in December, the same day I would have arrived at the
Culinary Institute of America with new knives gleaming. Instead,
however, I walked into Bill's office and told him that I could no
longer bake. I needed to move on.

I ARRIVED AT the University of Connecticut Health Center early
on a frosted winter morning in the week before Christmas. I had
driven the two hours from my mother's house in Boston alone
but for the voices of NPR News. Dry heat shot up from the floor-
board vents of my car, and my left leg fit snugly by the door,
enveloped still in its oversized container. As I took Exit 39 off
that bleak, leafless interstate, I felt the anxiety wind itself care-
fully up the back of my neck as the hospital on top of a hill came
into view.

The UConn Taste and Smell Clinic is one of a handful of cen-
ters in the United States that diagnoses and occasionally treats
those with disorders of taste and smell. My father had assured
me that these doctors would not be able to cure me, that I would
leave the clinic experiencing the same scentless landscape that I
did when I walked in. But perhaps, he said, they could explain
what happened, exactly. They could tell me what to expect. What
would I do next?

As I waited for my name to be called in the waiting room, I thought about the sheet pans of cookies I had burned in the bakery's ovens. The bacon I had crisped to black soot. All the things I wouldn't have done had I smelled the beginnings of their demise. I wanted to know what to expect.

I had three days of testing scheduled. When the scrub-wearing nurse called my name I stood immediately. I was ready. "Let's go," she said.

In the following days, each of which were bookended by the long commute among the naked winter trees to and from Connecticut and Boston, I saw neurologists, dentists, ENTs, surgeons, and internists. I spent what felt like hours swishing clear liquids from miniature plastic cups around my mouth, each one a different strength of "bitter," "salty," "sweet," or "sour," to test my taste buds. I rated each of the seventy flavors on a scale of 1 (weak, a hint of salt lurking in the back of my mouth) to 10 (strong, almost gagging on the overpowering taste of bitter quinine). I breathed in deeply while puffing air from label-less bottles up my nose, trying to decipher which had the aroma of a strong chemical and which was odorless (virtually impossible to tell). I sniffed mystery jars of once-familiar food smells, touched my finger to my nose, walked a straight line, said *ahhh* as they peered down my throat, grimaced as they inspected my teeth and tongue. They looked at my cranial MRI and sinus CT scans, as well as the multitude of head x-rays from the accident. They drizzled numbing drops into my nostrils and then stuck a long device up to what seemed to be my brain, looking for obstructions.

One morning I sat on a stool in the office of a lanky, bearded doctor. He twisted open white plastic jars one at a time, their

mystery contents covered in thick cheesecloth, and then stuck them under my nose. I held one nostril closed at a time, testing each side of my nose in measured sniffs. Each jar held a common scent—wood chips, coffee, cinnamon, rubber, soap, jam—but they were all invisible to me. The exercise seemed to amount to little more than a frustrating parade of blank inhales.

"Are you sure there's anything in these jars?" I asked with a little laugh.

But then I sniffed over one of the final jars. It looked the same as all the others, clear white plastic, cheesecloth mesh. But this one held a smell. A familiar smell. It came blasting up my right nostril as I held the left closed with my index finger. I sniffed again.

"That's CHOCOLATE," I practically screamed at the doctor, who stood at eye level, a foot away.

He looked at me for a moment, confused.

"Chocolate?" he asked, incredulously. "You can smell that?"

"Yes!" I said gleefully. He had me sniff again with the same nostril. "Yup. That's chocolate."

He smiled and then had me sniff with my left nostril, now holding the right side shut with my hand. I sniffed. My shoulders sunk, defeated.

"No, I can't smell anything on that side," I said.

The doctor looked off into space, thinking. He seemed perplexed, yet the sides of his mouth were curved in a small but unmistakable smile.

"This is unexpected," he said. "Generally chocolate is not an odor that those who cannot smell first pick up on. Very unexpected. But no matter what, even if only through your right nostril, this is wonderful."

I beamed. A new smell! A great smell! I wanted to dive into a swimming pool full of chocolate and drown in its scent.

"The flavor of chocolate," the doctor reminded me, "is almost entirely dependent on smell."

I nodded. I knew.

On my final day at the clinic, I met with the center's head doctor, an older man who was cheerful and kind. "Recovery is possible," he said, going over the results of my tests. *Hyposmia on the right side and anosmia on the left side no doubt caused by the head injury she sustained in the auto accident,* they had written in my report.

"But it's unlikely," he said. "And if it happens, it can take years. We've seen people who didn't smell a thing for nine years."

"Nine years," I repeated numbly.

"It's possible you will recover," he repeated. "But it's not likely."

"But what about the rosemary? What about the chocolate? Some things have returned!"

He nodded. "I know. And that's a good sign. But I can't say what will happen."

"What can I do? I wanted to be a chef."

"Work is therapy, Molly," he said, kindly, looking down into my eyes. "Stay busy."

fresh bagels
and
a boyfriend's shirt

IN WHICH I IMPROVISE

I MOVED TO NEW YORK CITY on a frozen Saturday in February. Boarding the train in Boston early that morning, I lugged two large duffel bags as my mother waved good-bye from her car. When I arrived at Penn Station, I hailed a cab amid a swirl of snow and ice. The buildings loomed large from the taxi window, and the sidewalks teemed with people despite the unwelcoming weather. I stared at the city skyline like it was a painting as we drove over the Manhattan Bridge to Brooklyn.

We cruised up Flatbush Avenue, past small shops and squat buildings in the tumult of traffic. We took a right onto a windswept Fourth Avenue and then a left onto Sixth Street, which was lined with trees and brownstones. This was Park Slope, a quiet

neighborhood where I had rented a room in a three-bedroom apartment.

I dragged my bags up the stoop of the brick building on the corner, careful not to twist my left knee, which was still encased in a metal brace under my jeans, and rang the bell. My heart beat quickly and I could feel my face flush in anticipation. I had met my new roommates only once before and all of the pressure of beginning a new life in a strange city suddenly amplified this first moment at what would be my home. Jon, an international risk analyst with a halo of black curls who would occupy the room across the hallway from my own, descended the three flights to give me a set of keys and help bring my belongings upstairs. We smiled and shook hands, and I realized that he was the first person I had met in New York, the first new friend since the accident. He didn't know me when I was injured; he didn't know me when I was broken and depressed. I tried not to limp.

"Welcome," he said.

I plunked my things down in my room, which had bright red walls and an old wooden desk covered in dust, and sat on the full-sized bed that I had already purchased from the departing tenant. I looked out the window. I could see the bare branches of a tree, a naked street corner. The heater clanked uselessly against the wall.

I SPENT MY FIRST MONTH in the city wandering. I didn't have a job or a plan, only the vague notion that I wanted to write and spent hours haphazardly applying for positions at every publication I could find. I took the subway to Manhattan and walked to interviews in large warehouse spaces in Chelsea, in tiny dark

offices in Midtown, and in apartment buildings on the Lower
East Side. I interviewed for positions at culinary magazines, art
magazines, teen magazines. We'll call you, many said. But I had
no internships or experience behind me. My phone remained
silent.

And all the while I wandered. There were coffee shops in
the West Village, where hipsters drank cappuccinos and tap-
tapped on their laptops. I perched at low tables with a book and
a steaming mug and could imagine that the warmth of my coffee
held the scent of bean and milk. I spent afternoons at the Met,
where Monet's water lilies lost something without the familiar
background scents of marble and museum. I went to bars with
friends, where gin lacked an edge and I turned conjecture into a
game: Which well-suited man was the type to wear cologne?

The city was a blank slate without the aroma of car exhaust,
hot dogs, or coffee. Nothing was unbearable and nothing was
especially beguiling. Penn Station's public restroom smelled
the same as Jacques Torres's chocolate shop on Hudson Street.
I couldn't tell the difference between the bakery on the corner
and the cardio room at the Brooklyn YMCA, where I joined the
sweaty bodies racing on elliptical machines every morning.

I knew that New York possessed a further level of meaning.
Boston had smelled of Dunkin' Donuts coffee and the fresh con-
crete poured within the construction site near my mother's home.
It had smelled of the springtime lilacs in Arnold Arboretum,
the perpetually full Dumpster on the street near the local high
school, and the dark beer on draft at the bar next to Fenway. But
in New York I worked hard to ignore what I could not detect. I
kept busy.

One afternoon in March I took the subway, the twists and

turns of which I was just beginning to master, to Fourteenth Street for a job interview near Union Square. It turned out to be a long interview for a job I didn't really want, and I left with a headache and what felt like the beginnings of a cold. I walked a few blocks down to the Strand bookstore, which was stuffed with volumes old and new. I entered looking for distraction, wanting to lose myself in pages of prose. I had been in New York for a month and I still didn't have a job. My internal dialogue had begun to rise in pitch, staccato and loud. I reeled with the possibility of failure.

I was anxious about more than employment, though. A few nights before I had been on a date with a tall blond man who worked as a teacher in the Bronx. We sat over a bottle of wine and plates of pad Thai at a restaurant downtown talking about travel and music and books. And I had felt nothing. I told myself it was because his face was too smooth, his movements too awkward. I told myself it was because I still wore a bulky knee brace and my pelvis ached when it rained. But, quietly, I worried.

I'll never be attracted to a man again.

I knew that the sense of smell was linked to libido, to attraction, and to sex. I had heard about pheromones and had been subject to the advertisements of the perfume industry for years. I remembered the scent of Alex's shirt—a soft mix of Old Spice deodorant and sweat. Alex had moved to California the month before I arrived in New York. The last night I saw him before he left, we had hugged, locked in an embrace for a solid minute before I let go. I had inhaled and exhaled through my nose, but I had smelled nothing of the past, when I had loved to nestle my face against his and breathe in that human scent of his skin.

Unlike my grandmother Marion, who had still retained the

liquid drops of memory of her childhood as Alzheimer's over-took her body, the scents of my present had vanished along with those of my past. What could I do with this emptiness? Where else beside my depression would it lead? I knew that the sense of smell went deeper than the instant pleasure in the scent of a fresh-baked loaf of bread. I knew it influenced more than the conscious here and now. I began to wonder how much more I had lost. I began to wonder how much of my life—love and otherwise—had been tied to the perception of scent.

I browsed through the miles of books at the Strand, trying hard not to think of work or of men. I paused in the stacks to open a crumbly used copy of *Run River,* a bleak novel by Joan Didion, whose sparse prose I had always admired. I stuck my nose up close and fanned out the pages like a deck of cards. I breathed in and out, slowly, remembering happy afternoons spent in the library during high school.

For me, the musty aroma of old books—the combination of paper and ink and crisp cardboard bindings—had always hinted of the past, of the people who read them and places they went. The mildewed smell of libraries and used bookstores had been a comfort and a friend. Now, it was gone. I stuffed the novel back onto the shelf and walked out of the store, heading home.

"What if it never comes back?" I typed on an otherwise blank Word document on my computer that night.

HAD I THE courage to begin researching the extent of my olfac-tory loss as it happened, I would have known that the connection between smell and sex has been studied for generations. Even the ancient Greeks knew there was some kind of undetectable

communication between animals. They just didn't know what. But the modern study of the subject began in the late nineteenth century. It began with a moth.

One morning in May, Jean-Henri Fabre (1823–1915), a square-jawed botanist living in Provence, caught a moth. It was a female Emperor moth, also called a Great Peacock. It was a large one with a white fur collar and wings whirling with patterns of burnished browns and eyelike rounds staring out in blacks and golds. She had broken free from her cocoon on the table in his laboratory and Fabre, often considered the father of modern entomology, or the study of insects, imprisoned her under a sheet of wire gauze.

He forgot about her until that evening—an evening he would later dub the *Night of the Great Peacock*. Around 9:00 p.m., as he and his family began to get ready for bed, Fabre heard the yells of his son, Paul. "Come and see these butterflies!" Paul shrieked. "Big as birds! The room's full of them!"

As Fabre ran toward his study with his son, he was greeted with a cloud of moths. Giant ones. Peacocks, just like the one which had metamorphosized that morning in his lab. They had invaded the house and fluttered around to the delight of both the scientist and his small child.

"Candle in hand, we entered the room," Fabre wrote in *Social Life in the Insect World*. "What we saw was unforgettable." The study was full of moths, arriving mysteriously at his home as night fell. They surrounded the female's cage. "They rushed at the candle and extinguished it with a flap of the wing; they fluttered on our shoulders, clung to our clothing, grazed our faces. My study had become a cave of a necromancer, the darkness alive with crea-

tures of the night! Little Paul, to reassure himself, held my hand much tighter than usual."

Fabre kept his original winged female moth in the following days and kept many more moths in the following years. He watched as clouds of males arrived—together and silently—night after night. They stormed the study like a horde of princes at Rapunzel's castle, coming from miles away. They were there to mate, this much Fabre knew. But he wondered how these creatures knew where to go. There were no maps, no sounds or smells noticeable to anyone else. "What sense is it that informs this great butterfly of the whereabouts of his mate, and leads him wandering through the night?" he wrote.

Fabre tested many of his theories on the moths. Their signal, he thought, must be airborne because females still attracted mates when held in a porous but opaque container, though not when the air around them was completely sealed. He tried removing the males' antennae, but lacked conclusive results, and then tried drowning his study in the powerful stench of naphthalene, spike-lavender, petroleum, and a solution of alkaline sulfur—an odor mixed of rotten eggs, mothballs, and gas. But not even that masked the power of the female's signal. He played with the idea of electric or magnetic waves, "like a system of wireless telegraphy"—"I see nothing impossible in this; insects are responsible for many inventions equally marvelous," Fabre wrote—but in the end, he decided, the female must attract the men with a scent. Not an ordinary scent, however.

"I was now convinced," he wrote. "To call the moths of the countryside to the wedding-feast, to warn them at a distance and to guide them the nubile female emits an odour of extreme subtlety, imperceptible to our own olfactory sense-organs. Even with

their noses touching the moth, none of my household has been able to perceive the faintest odour; not even the youngest, whose sensibility is as yet unvitiated."

The moth's mating habits had everything to do with smell, he believed. He wasn't quite right. But he was close.

Fabre's observations became what was the first step in the still-going study of invisible chemicals—chemicals that bounce among members of many species and affect behaviors of all kinds, that allow an ewe to recognize her newborn, an ant to signal danger to its colony, and those male moths to be summoned to mate. Today, these chemical interactions are some of the most important ways of understanding how animals interact.

Pheromones.

It took almost half a century to come up with the word. That didn't happen until 1959, when a German scientist named Adolf Butenandt, who had already won a Nobel Prize in Chemistry for his work in sex hormones, discovered the first chemical composition of a pheromone. Butenandt had spent many years painstakingly testing the silk moth *Bombyx mori*. He went through more than half a million moths, trying to isolate the sex pheromone. Fabre had wondered for years how that feathery-winged creature could so silently summon her lovers from miles away. What kind of signal has that power? Butenandt found out. He isolated the specific chemical released by the female moth to attract the mating males. He called it *bombykol*.

But the actual term "pheromone" was coined by two others: German scientists Peter Karlson and Martin Lüscher. They came up with the word in 1959, timed with the release of Butenandt's paper. They knew that the behaviors influenced by chemicals would go far beyond those of the silk moth and, therefore, that

the phenomenon needed its own word. Karlson and Lüscher combined the term from the Greek *pherein,* to transfer, with *hormon,* to excite. *To transfer excitement*: it stuck.

Pheromones, they wrote in their 1959 article entitled " 'Pheromones': A New Term for a Class of Biologically Active Substances," are "substances which are secreted to the outside by an individual and received by a second individual of the same species, in which they release a specific reaction, for example, a definite behaviour or a developmental process." The scope of their definition is wide. And perhaps rightly so: pheromones have been found in algae and elephants, goldfish and lobsters. There are pheromones that signal fear and aggression. There are pheromones that elicit sex and those that signal kin and territory. There are pheromones that influence puberty and hormones and emotion. They dictate much in the life of animals. They skirt the line of smell and intuition, mystery and science, evolution and common sense. Invisible and potent, these naturally secreted chemicals function as a language of their own, silently curling their way around primal and sustaining acts of life.

The paths of these chemicals can be complex. Most animals react to a very specific ratio and combination. Many are still unknown. Today, the chemical composition of what, exactly, drives a male dog toward a female in heat remains elusive. But in 1996, for example, it was discovered that the female Asian elephant, that wrinkled mammoth who lives in small matriarchal groups, has the same sex pheromones—the one called "(Z)-7-dodecen-1-yl acetate"—as various species of insects, simply used in different ways.

Detection varies widely. Animal pheromones can be found in urine—think of a dog who sniffs or marks a tree—or are windborne, like the pheromones of the moth. Fish pick up water-

soluble chemicals as they swim. Male Queen butterflies deposit their pheromones right onto the antennae of their female companion. Male terrestrial salamanders drop theirs straight from their chin into the female's nostril.

But how do animals process pheromones? Does it happen in the nose? Is it as simple as a sniff?

The *vomeronasal organ* (VNO) is a tubular duct running separate from the olfactory system that plays an important role in the process for many species of animals. It was discovered by a scientist named Ludwig Jacobson in 1811. It's a sneaky little thing, like a second nose but not part of the nasal cavity. It's a cavernous, winding path filled with protein receptors primed to pick up chemicals and send their signals to the accessory olfactory bulb and, later, to the higher echelons of the brain.

In the past, scientists have believed that this pathway was the only place possible to process pheromones. They believed that it was the source of mystery, that it was the entryway to chemical communication. It's been found, however, that the traditional olfaction pathway—the basic sense of smell—is important as well. For example, in 1997 scientist Kathleen M. Dorries blocked the vomeronasal organs in domestic pigs with surgical cement. She and her colleagues then tested the reaction of the female to their sex pheromone, *androstenone*. They found that both the pigs with blocked VNOs and those with clear reacted the same way: excited, ready. The vomeronasal organ, Dorries concluded, wasn't completely necessary. It wasn't the sole pathway of chemical communication.

The animal brain, then, takes cues from both the VNO and the central olfactory system. Animals' worlds are defined by the nose and the brain, the chemicals and the aromas.

In those first months that I lived in New York I didn't know about those silk moths, who found their mates with little more than a puff of chemical. I didn't know about those pigs on a farm upstate, who snorted around the androstenone and were immediately ready for love. If I had, I probably would have been jealous. Those animals didn't have to worry about the scent of Old Spice, or a rank twang to a lover's BO. For humans, however, the concept of pheromones is both elusive and controversial.

ON AN AFTERNOON late in April, when the harsh winter chill had begun to lift, I met a man. We'll call him David. Short and stocky with wild curly hair, David had lived in my apartment the year before I moved in. He was a writer working on a book, now living in a one-bedroom apartment a few blocks away. On this day, he wore a bronzy linen shirt and gray pants. He had stopped by to pick up some of his old things that had been left in our hallway storage space.

When I answered the knock at the door, he smiled and shook my hand. His fingers felt warm; his palm, thick.

I leaned against the wall as he packed up nearby, chatting casually while he organized the muddle of artifacts stacked in the hallway, the ones that had been there for years now, he told me with a guilty shrug. There were boxes of books and plastic containers of clothes. There was a thick brown mask made of pottery and straw, which reminded me of the goods sold in the markets of Namibia I had seen years before. I asked him about it, and he told me stories of his travels and his years in the Peace Corps. He segued into stories of his work as a journalist and I listened hungrily, both intimidated and enthralled. He asked me

what I did and I swallowed, embarrassed, before admitting my struggles to find a job. I had just begun an unpaid internship at an art magazine, where I sat obediently opening stacks of mail in an office without windows. I felt young at work. I felt young at home. I was surprised to find myself telling David that I wasn't sure if I would ever find a career that I could like, certainly not a job that didn't involve the kitchen, that had nothing to do with food. He looked at me warmly, though, and smiled. He told me that I would be okay.

A week later we sat across from each other at a table in the dark corner of a bar nearby. His fingers rested lightly on the base of his wineglass as smoke from cigarettes curled up in the air nearby. Again, we talked about writing and travel. We talked about work. All the while I stared at his eyes, which were dark and a little bit strange. They were crooked, I realized. The right eye was level but the left tipped in a lazy slope downward—an asymmetry hinting of vulnerability, a body not quite put together correctly. In the past, I had fallen for athletic men who reeked of confidence. David was different, but I couldn't look away. His vulnerabilities reminded me of my own.

He kissed me on the stoop of my apartment, in the dark drizzle of a rainy Sunday night in June. He held my face with his hands. I couldn't smell his breath; I couldn't smell skin. But I felt something, then. I felt a lot.

AS AN UNDERGRADUATE at Wellesley College in the late 1960s, Martha McClintock lived in a dorm filled with dresses, long hair, and breasts. Among the women there, she noticed something interesting—more interesting than the catfights or makeup tips

commonly associated with large groups of girls. She noticed that, over time, her dorm mates' menstrual cycles synchronized. *Why?* she asked.

McClintock, who is today a professor at the University of Chicago and founder of the Institute for Mind and Biology, published a paper soon after graduation about this phenomenon. This mysterious menstrual overlapping among friends and housemates, she determined, was due to unconscious chemical communication. Human pheromones.

As her dorm mates interacted closely and regularly, information was relayed on a molecular level. Tiny blips of information, but over time this information grew to affect life under the skin. The women's reproductive systems aligned. The McClintock syndrome, as this synchronicity became known, was purported to be caused by the same type of chemical reaction known to happen in animals: silent, undetectable communication between members of the same species in a way that influenced behavior. But what chemical actually caused the women to synchronize? How did it work? Does it come through smell? Taste? Touch?

A generation later, many of these questions are still yet to be answered. They are stymied in part by a lack of funds. They are slowed by the sheer numerical density of the molecules released from human skin—a number, I've been told, that would take untold years to isolate and identify their singular effects as Butenandt did for the moth. (Can you imagine so many molecules constantly flying away from your own body, whispering secrets to your companions without your knowledge?) These questions are also plagued by doubt: the study of human pheromones has been viewed with apprehension for decades.

McClintock's first paper fueled enthusiasm for research on

this mysterious, elusive topic. She has been joined by many others. It is still going strong.

In 1998, McClintock published another paper on pheromones and menstruation, this time with scientist Kathleen Stern. In this study, they had a group of women apply samples of odorless compounds from the armpits of other females above their lips, where they would breathe it in without thinking. Some smelled samples swabbed from the armpits of women who were currently in the beginning of their menstrual cycle. These smellers experienced a surge of hormones, the scientists found, and a shortened cycle of their own. Other participants smelled samples from the armpits of women who were much later in their cycle—at ovulation. This had the opposite effect: the smeller's hormone surge was delayed. Her cycle lengthened. "By showing in a fully controlled experiment that the timing of ovulation can be manipulated, this study provides definitive evidence of human pheromones," the scientists wrote. I read this study, shocked to think that the scent of another woman, then, could change my internal clock and my capacity to reproduce. Or could it? Without a sense of smell, came that anxious little whisper, would I no longer react to the women in my life? To the men?

After all, scientist George Preti published a study in 2003 showing that the smell of male sweat, too, can influence a woman's reproductive clock. In this study, a group of women in the first seven days of their cycle were given samples of male sweat, inhaled from the top of their lips every two hours. Another group of women received samples that were blank. After six hours, their conditions were reversed. The scientists, who took small amounts of blood from each participant every ten minutes, found that the women who smelled male sweat experienced a precipitous in-

crease in a certain type of hormone—the luteinizing hormone—which regularly spikes in level just before ovulation. For them, it spiked at a 20 percent increase compared with the women smelling nothing. In 2007, Geoffrey Miller, an evolutionary psychologist at the University of New Mexico, in a study exploring the impact of ovulation on the tips earned by female dancers in strip clubs over two months, found that on average the most fertile dancers (the ones who were ovulating) earned $35 an hour more than those menstruating, and $20 more per hour than the others. Women on birth control earned significantly less overall, with no cyclic peaks.

So it does seem that there are invisible signals sent out and received by humans—ones that make changes, changes so silent it's possible to not even know they are happening. Changes that relate to fertility and growing new life, which, in their successes and failures, are quite dependent on the other humans involved.

But how does it work? What exactly is causing the change? If pheromones can influence a woman's menstrual cycle, does that mean they can influence other things? Do humans fall under the same categories as animals? Can I signal danger to my friends with my sweat? Did David kiss me because I unknowingly released something potent and primal from the follicles of my skin?

No one really knows.

"Despite what is advertised on various web-sites, and even suggested in certain scientific, peer-reviewed publications," wrote scientists Charles Wysocki and George Preti in a 2009 paper, entitled "What's Purported, What's Supported," for the Sense of Smell Institute, "there are no published, scientifically-constructed, bioassay-guided studies that have lead [sic] investigators through the complex maze of compounds found on the

human body to one or more elements that possess pheromonal activity."

The effects of pheromones in animals have been catalogued and categorized. They are often compared to the actions and reactions of humans, and many have attempted to find overlaps. Most, however, are hotly debated. As Tristram Wyatt, author of *Pheromones and Animal Behavior,* wrote in a 2009 essay ("Fifty Years of Pheromones") for *Nature,* "Controversy over mammalian pheromones has been almost as heated as the 'stink wars' between opposing troops of ring-tailed lemurs."

"Primer" pheromones are for the long term, like those studied by McClintock. They influence the body slowly, touching things like the rise and fall of hormone levels and the onset of puberty. "Releaser" pheromones are quick, eliciting immediate reactions like the flight of the upwind flight of male moths or the reaction of a male boar to a female in heat. This is murky water for humans. It may seem like the lightning flash of chemicals when two young lovers lock eyes at a party for the first time, but the only documented release behavior in humans as of yet is among babies, who react innately and actively when moving their heads toward their mother's breasts. "Modulators" are responsible for subtly changing emotions and moods and were introduced by McClintock's lab in 2000. Here, especially, little is known, but in Preti's 2003 study he also found that the group of women who had samples of male sweat presented on the top of their lip for a block of six hours claimed to feel calmer and more relaxed than when their lips were unadorned. "Signalers" give information: in animals, who is dangerous, who is my kin, who is healthy around me. Controversial in humans, it has been shown that mothers and babies can recognize each other by smell alone

on day one—but this is based on definable scent, not on hidden chemicals, and begs the question: How wide does one stretch the definition of pheromones?

Unlike animals, humans do not have active vomeronasal organs. A ghost of the pathway exists, extending from the roof of the mouth back toward the brain, but there is nothing functional within. This hasn't always been true: in the beginning stages of growth, human fetuses have been shown to possess an actively developing VNO. The volatile sensory nerve, however, disappears before birth. Perhaps thousands of years ago—before we developed tricolor vision, before we had language and emotion and still had to communicate so silently, chemically—it worked. But no longer.

The question remains, then: Can humans detect these chemicals through the traditional olfactory pathway? Like much having to do with pheromones, it's not yet clear.

There are those, like smell psychologist Rachel Herz, who have alternative ideas. In her 2007 book, *The Scent of Desire,* she proposes a theory: pheromones, she says, are passed through the skin. McClintock's female dorm mates synchronized because of touch, she hypothesized: "My explanation appeals to parsimony because it requires no 'smell' and obviates the problem of our not having a VNO or accessory olfactory system."

Richard Doty, director of the Taste and Smell Center at the University of Pennsylvania, is a leading skeptic. In his 2010 book, *The Great Pheromone Myth,* he argues that pheromones, by definition, do not exist in humans: " . . . evidence for the existence of human pheromones is weak on empirical, conceptual and methodological grounds," he writes. "While odors and fragrances, like music and lighting, can alter mood states and physiological

arousal, it is debatable whether agents purported to be phero-
mones *uniquely* alter such states."

But we do react to each other, in ways that can only be de-
scribed as pheromonic. And for me, in those first months in New
York, I wondered: Would I miss important, intrinsic relationship
cues without my sense of smell? Would I lose my ability to feel
close to my partner? To my family? Had I lost the ability to rec-
ognize my own children when, someday, I had them? Would I
lose my sexuality without smell?

Luca Turin, a scientist, smell expert, and author of *The Se-
cret of Scent,* writes: "Imagine you lose your sense of smell, just
like when you had that bad cold five years ago, but this time, as
occasionally happens, it never comes back. Food would become
unutterably boring: you might as well join Weight Watchers, eat
textured mushrooms and feel good about your bum. But sex
would still be OK, because your eyes, hands and ears ('I love it
when . . .') would still work. I rest my case."

I wasn't sure he was right.

DAVID AND I dated that balmy, sun-soaked summer.

He had been a resident of New York for years and introduced
me to many of the city's pleasures. We met at the Museum of
Modern Art after work on a Friday and walked among its cavern-
ous white-walled rooms. After a month of interning, I had been
promoted to editorial assistant at that fine art magazine—"one
of the only art history majors to get a job in the field," my fa-
ther had laughed—and I enjoyed rambling on about Warhol and
Redon, Nauman and Gorky. We spent evenings in Prospect Park,
where we picnicked with wine, bread, and cheese as darkness

descended. We went to movies at the Sunshine Theater on the Lower East Side and ate burgers at the bar near his apartment. We watched DVDs lying enmeshed on his couch, cooked dinner in his otherwise underused kitchen, and read in coffee shops on a Sunday morning.

And we slept together—comfortable, exciting nights in which our bodies fit so well together and apart. He traced the line of my still-red scar, which ran down the side of my left leg, softly with his index finger. I loved waking up with his arms around me. *Hey,* I thought to myself every so often, *maybe I don't need smell.* After all, I didn't need his.

There were some downsides to spending time with David: he called only when he wanted and never held my hand. I often felt young, too young. I wanted him to be both a mentor and a lover. We were casual, though my feelings grew stronger every day.

My job, too, began to overtake my time. I spent long days in the office, under the guidance of an intense though talented editor. I learned more than I could even hold on to each day, and therefore I also learned how to scramble. I learned to fact-check, to mark my corrections on raw magazine copy with a bright red pencil, to broker between writers and editors, and to smile quietly amid the hectic battle of deadline and production. I began to grow a thick skin. I fell in love with the possibility of words.

I worked in an office close to Bryant Park, where the onset of summer brought crowds of bare-legged women and a scentless explosion of flowers. As June melted into July, I didn't notice the stench of subway stations filled with rotting trash and sweating people. I didn't notice the fragrance of concrete sidewalks baking in the sun or the carts selling rich-smelling meats on top.

There was a change, though. A small change, almost too

subtle to notice, but succulent nonetheless. I walked outside my apartment one hazy summer afternoon, inhaled and exhaled, and noticed *something*. Something different. A change. A smell. *No, not a smell,* I thought. This couldn't be so defined. It was a change in the periphery of my breath, a noted shift in perception, but indescribable and indefinable all the same. It was more of an idea of a smell, an aura of scent.

As the weeks went by, I noticed this frequently—just a general sense of smell. I would walk from room to room in my apartment or office and note the vague alteration of aroma every day. Each time, I would turn to whoever was nearby and say, "What does it smell like in here?" He or she would often look confused, sniff, and say: "I don't know. Nothing much." I had forgotten that smells were everywhere. In every room, on every street, hovering above every person I knew. These auras were more painful than happy, though, remaining in their vaporous brevity unattainable and untouchable still, like the contrast of the grays in the black-and-white movie of my life had simply deepened their hue. There was no color. I wondered if I was simply making it up.

David and I saw each other, but less and less. Five months in, we didn't argue. There were no fights. We had hardly met each other's friends, and I knew we were both holding back. Sometimes he would disappear for days without a word. Sometimes I wondered if he was seeing someone else. I couldn't bring myself to confront him, though. It felt good when we were together. Losing my sense of smell didn't affect that. *I'm not wholly broken,* I would think with a smile. Until I met him I was afraid my heart would never flop giddily, butterflies would never flutter in the pit of my stomach, the light touch of a hand on my arm would never make me smile in such a way. I was afraid that I would never

want someone to take off my clothes or run his fingers over my collarbone again. David proved me wrong. I loved the feel of his hand on my cheek.

"I wear cologne," David said one morning in late September as he splayed out next to me in his bed. "I have for years." His arms arched upward, hands resting under that cloud of curly brown hair. Turning his head so that his face rested on the white pillow, he looked at me. "It's so strange that you don't know that."

There was the hum of an air conditioner, the warmth of his leg against mine, and the rasp of foot against the sheets. I tried to smile, breathing in deeply through my nose. There was nothing.

"You wear cologne?" I asked, hesitantly. "Really?"

"I do," he said. "Well, aftershave. Every day."

"What kind?"

"*Cool Water.*"

He looked at me and I turned my head away to stare at the wall. It was a milky off-white, with ripples of plaster visible just beneath the paint.

"What's the matter?" he asked.

"Nothing," I said, suddenly unable to hold back tears.

I used to know men who wore scent. Even on first introductions, one whiff of a Jean-Paul Gaultier, an Armani, or a Ralph Lauren, and I knew something about them. This was not necessarily a bad thing. Alex, I recalled, wore a Hugo Boss cologne in the latter years of high school, which I had loved. But it was *something*. Something telling. Wearing cologne says something about a man in his early thirties. It says something different than the raw, human scent of skin and soap. It wasn't what I expected.

I don't really know him, I thought.

▓ ▓ ▓

EVERY HUMAN HAS A SMELL. A unique smell. A smell shared with no one else.

This smell has nothing to do with what brand of deodorant or laundry detergent one chooses to use. It has nothing to do with perfume or shampoo or soap. It has nothing to do with how hard one pushed at the gym or how long it's been since the last shower. It has nothing to do with the existence of the vomeronasal organ.

This is a specific odor, a naked odor. This is the familiar smell of a boyfriend's T-shirt, a wife's bathrobe, a child's hair. It's the armpit smell, the neck smell, the smell of skin. It depends partly on diet and partly on bacteria, and therefore can change with location and culture. But mainly it has to do with genetics.

I first heard about this unique odor print at the Monell Chemical Senses Center. I sat in a conference room in the center, a light and airy room on the second floor, and spoke with Charles Wysocki, a leading researcher on the chemical senses and communication in both humans and animals. He began by telling me about a set of genes that regulates the immune system. It's called the *major histocompatibility complex,* or MHC. These genes also dictate a scent, one that is different for every person, overlapping solely for identical twins. Like the spiral patterns on the tip of the index finger, we each possess a unique odor print.

At one point in his career, Wysocki told me, he classified the scent determined by MHC as a pheromone. After all, it fit under the definition: it provides information to other member of the species. But, he explained, "I tend now to think that it might not be a pheromone, because it represents a mixture of potentially

hundreds of compounds, and is going to be different across different individuals."

But, he added, "that doesn't mean it's not providing information—it is. It's providing information about the individual, and that information may influence how an individual interacts socially with another."

The best example of MHC's influence comes from what is known as the "sweaty T-shirt study, " by Swiss scientist Claus Wedekind in 1995. In this study, Wedekind had 44 male students from the University of Bern wear the same 100 percent untreated cotton T-shirt for two nights straight. It was a Sunday and a Monday night, and during the day, they kept the shirts in open plastic bags. The participants were given odorless soaps and detergent to clean themselves and their sheets. They were told to avoid heavily scented foods and activities. On Tuesday, Wedekind then had 49 female students smell the sample shirts. The women rated the shirts based on pleasantness, using odor alone. All of the participants—men and women—had previously been tested for their MHC type. What Wedekind found was fascinating: the women were most drawn to the T-shirts of men whose MHCs were genetically different from their own.

Evolutionarily, this makes sense. If odor preference is influenced by the genetics of MHC and plays a role in selecting a mate, then two parents with different MHC types would make a baby with a stronger immune system. Similarly, being drawn to someone with a different smell and therefore genetically different immune system would help to avoid inbreeding.

Interestingly, Wedekind also found that women who were on oral contraceptives were *not* drawn to men with different odor prints. In fact, he found that the opposite. "This indicates

that steroids which are naturally released during pregnancy could change body odour preferences, leading to a preference for odours which are similar to those of relatives," he wrote in the paper "MHC-Dependent Mate Preferences in Humans." After all, evolutionarily, again, it would make sense for pregnant women to desire to be close to kin, for protection and care. Taking it one step further, Wysocki and colleagues found, in 2005, that body odor preference is influenced not only by kin, but by gender and even sexual orientation.

This scent preference isn't always conscious. There are areas of the brain at work in ways we can hardly know. In 2008, Johan Lundstrom and colleagues tested the brain activity of 15 healthy women when smelling samples of body odor belonging to strangers and friends, and then a synthetic material that had been made to have an almost identical scent. His results were wild: though these women could not tell the difference between the real and fake body odors by their nose alone, Lundstrom found, using PET scans, that they processed each type of scent in different parts of their brain. The true body odors activated areas of the brain known to deal in emotional stimuli and attentional efforts, whereas the synthetic used a region for high-odor processing, like labels. Somehow, somewhere, their bodies knew how to distinguish real and imposter human scent—potently, emotionally, importantly.

So, I thought, as I sat there speaking with Wysocki, *smell is a way of relating to people.* I knew this: I've talked with women who say that they can tell on a first date that they like or dislike their companion by their smell.

But I couldn't help but think: What about me? It was easy to ignore the possibilities of pheromones when the concept itself

is so riddled with the unknown. But this? This was just smell. Without the ability to smell, I *did* lose something more than the smell of bread baking in the oven. I lost something that had nothing to do with the existence, or not, of the vomeronasal organ, of scentless chemicals flying through the air. I lost a way of relating, of understanding, of processing my world.

"Without a sense of smell, then," I asked Wysocki, "I would not react?"

He paused a moment.

"Yes," he said. "That would be my prediction."

AS THE SUMMER heat grew and then faded into the burnished reds of fall, I pushed my relationship doubts aside. I didn't want to admit that something was wrong. But I wouldn't have to, I thought. After all, exciting things were afoot. The auras of scent hovering in the periphery of my perception had begun to crystallize, sticking me one by one with pinpricks of scent. Real, clear scent. I woke up each morning tingling with hope, with expectation, with the immediacy of this change.

I smelled cucumbers one day while chopping for a salad on the counter in my apartment. They smelled wet, cold, and slightly sweet, like wavy lines of a pastel green shimmering behind my eyelids. I yelled to my roommate who sat on the couch nearby: "Cucumbers, Jon! CUCUMBERS!"

He looked up. Concerned. "Are you okay?"

"I can smell cucumbers," I said, quietly this time, as I waved the vegetable back and forth under my nose like a wand.

Suddenly, I could smell the chocolate from a pack of M&Ms someone was eating on the subway several seats away. I stared

at them, goggle-eyed, for two stops straight. I couldn't believe the strength, the depth, of the scent and I fixed my gaze until the eater had finished, crumpled up the crinkled yellow wrapper, and walked away. One afternoon, a few weeks later, a whiff of perfume on Madison Avenue and Seventieth Street—smelling of grace, of wealth—stopped me in my tracks. Cilantro, the leafy green herb that I chopped to add to another salad, came on an evening in late June, pungent and cool and begging for guacamole. The jasmine of my morning tea arrived on an exhale; cantaloupe's summer-fresh sweet suddenly beckoned from five feet away. The spice of a man's deodorant—quickly, vividly Alex— appeared on the subway on a morning in July.

Slowly, painstakingly, almost secretively, individual smells had begun to return. They arrived alone, just like the rosemary and the chocolate of those months before. They arrived one at a time, confusing me with a combination of familiar and strange. Each scent brought color to my landscape. Each scent brought joy.

Not everything was returning, though. Like the sharp light of a streetlamp on an otherwise deserted street at midnight, these smells arrived singularly, spread apart, and glowing like mad. I could go days without smelling a thing and then—*pop!*—the scent of laundry or butter or soap would infiltrate my nose. I couldn't believe it. Against all the odds, I seemed to be recovering. I wanted to scream it out to my fellow riders crunched by my side on the subway. I wanted to hurl it at the ENT who had left me feeling so alone. *Look,* I wanted to say. *Cucumbers!* Their once common, negligible scent had returned—intoxicating, almost ambrosial. The scent of melon could bring me to tears.

And as these scents crept back, New York City, which had been a blank smellscape upon my arrival, began to pulse with

new layers of meaning. The park carried a twang of smoke, whiffs of tree and flower, the murky metallic ooze of a water fountain, drifting coal and grill, roasted nuts. The streets were filled with surprises—hot dogs! coffee beans!—and the taxicabs called to me with their old leather, new cigarettes, and remnants of *Chanel No. 5*, the signature powdery aldehyde of whomever just held my seat. A walk through Chinatown brought whiffs of salty leather handbags, raw fish on ice, deep-fried balls of sweet dough served in paper cones, and the faint trails of both orange rind and urine. My apartment came with lemony dishwasher detergent, damp cardboard, the deep green of basil. These smells reappeared quickly, raucously, reminding me of what had been gone: the shimmering cloud of garlic in the apartment of friends, the cold but floral aroma of a department store, like a skating rink just ironed smooth. Instead of retreating into my mind as I walked around the sidewalks near work, dodging tourists and businessmen with a practiced tunnel vision, I found myself often tugged out of my mind and into the world around me with the unexpected scents—some familiar, some not, but always in that moment, right there. I noticed more. I concentrated harder.

I went back to the Strand, which I had avoided since my blank trip back in March, and stood deep within the shelves of used books. I smelled them: cautiously, carefully, desperate for more. When I opened a stiff old book in the New York Public Library on an evening that August, its mildewed pungency sent shivers down my spine. Shopping at the farmers' market in Grand Army Plaza on a Saturday in September, I could recognize the spicy aroma of hot mulled cider from down the block. Autumn, I found, once again held the scent of roasted pumpkin seeds. Suddenly, the homeless man who cleared the subway

car with his stench contained more sadness than simply dirt and grime.

On a Sunday morning, I went for a walk with Jon along Seventh Avenue. Suddenly, there was a smell, strong and slightly sweet, a memory just out of reach.

"What is that?" I asked, inhaling deeply and looking around.

"What is what?" he asked, confused.

"That smell," I said.

"Oh." He pointed to the next block, where a line was snaking outside La Bagel Delight, a crowded store I had often walked past but never entered.

"Bagels," he said. "Fresh baked. It always smells like that."

It made sense: the warm, hearty scent combined yeast and sesame and, perhaps, early weekend breakfasts at my grandparents' house upstate. For the first time in more than a year, I understood why a line formed out the door so early on Sunday mornings.

THE OLFACTORY NEURONS are wily little things. They are tiny and delicate in their threadlike path from the nose to the brain, easily severed and subject to chance. But they have pluck; they're bold. The olfactory neurons are capable of tremendous growth. They can rise from the dead. And mine, it seemed, were on the move.

In the accident my olfactory neurons, which wind from the upper quadrant of the nasal pathway through the cribiform plate to the brain, were most likely severed with the impact of the crash. When I lay on a cot in the hospital in those following days, going in and out of CT scans and talking gibberish to my

mother, the remains of my truncated olfactory neurons receded. And then they died. For most of the neurons in the human body, that would be the end. But not in the nose.

The olfactory stem cells replenish constantly even in a healthy nose. They are some of the only neurons in the human body with the ability to regenerate from scratch. And they do so constantly, growing like the perennial flowers in my mother's garden but on warp speed. The olfactory neurons in rats, it's been shown, are completely new every thirty to sixty days. The rate in humans, many scientists believe, is slower, though no one is yet sure by how much.

As smells began to return, I felt supplanted into an alternate reality, one where the sensory world changed shapes, flowing like liquid before my eyes. I felt subsumed by the supernatural and crushed by my wild luck. It was only later, though, that I began to wonder what, exactly, was happening in my nose. The olfactory neurons are some of the only neurons in the human body capable of being replaced. Why?

I called Donald Leopold, a busy doctor at the University of Nebraska Medical Center who works with disorders of smell, to find out. He spoke to me breathlessly as he walked from one meeting to another, quickly throwing facts into the phone like tennis balls.

It is possible that the olfactory neurons die and regrow because they are exposed so intensely to the environment, he explained. These are the only cranial nerve cells that actually make contact with physical stimulus directly from the outer world, interacting directly with odor molecules on each inhale. They aren't in the possession of that buffer of skin. "The neurons wear down; they become fatigued," Leopold said. "We know that the

sense of smell is active in metabolizing pollutants and dangerous things that you smell. It's still just speculation, but maybe they are built to turn over because they are just doing a lot of dirty work. They regrow to protect you."

They do more than that, I thought. This ability—the intricate, innate program of growth—gives people like me the ability to recover. It is possible for the neurons to regenerate after a head injury. Or after the damage of a virus, or the complications of a surgery for that matter. After all, they've done it millions of times before.

On one of my many trips to the Monell Chemical Senses Center I sat at a table across from Beverly Cowart, who headed the Monell-Jefferson Taste and Smell Clinic. I asked her about the regrowth. Is it possible for all anosmics to recover?

Yes, she said, simply. It is. And then she paused. For almost a minute Cowart, a woman who appeared constantly on the verge of speech, sat silently. I waited.

"The striking thing about it is how long it can take," she continued. "I usually look at a two-year window. If you're not getting something back by then, though, I would advise you that it's very unlikely to come back at all."

"If I've gotten something back, even if it's just a little bit, does that mean the rest will return as well?" I held my breath. With the barrage of new scents during those months in New York, I had assumed that my full recovery was imminent. If I could smell some things, why not all things? My mind had whirled with possibility: maybe I could still become a chef.

"No," Cowart said. She explained that there are many obstacles for the damaged neurons in the brain. I watched as she counted them on her fingers. First, there must not be too much

scar tissue clogging up the Swiss cheese holes of the cribiform plate as the neurons begin their path back toward the brain. Next, if they get that far, the neurons must effectively reconnect to the olfactory bulb. And finally, the bulb must be healthy enough to sustain neural growth, allowing neural input to reach higher brain centers, where smell is actually perceived. In loss due to head injury, there is always the possibility that there was more central damage to the brain. It's impossible to predict, on this road paved with obstacles. And Cowart has seen it all—from absolutely no return to just a small seepage of scent slowly crawling back into perception, to a swath of recovered smells so wide that the patient can no longer recall what's missing.

I sighed.

Richard Doty, the head of the UPenn Taste and Smell Center and author of *The Great Pheromone Myth,* wrote a paper, published in 2007 by the American Neurological Association, about a study conducted on the predictors of prognosis. In it he discusses the results gleaned from 542 patients whose olfactory ability he first tested in his clinic, and then again, sometime between 3 months and 24 years later. He found that a third to a half of the patients tested regained at least *some* of their ability to smell. The rate of return depended on age. It depended on the time between the initial test and the initial loss. It depended on the amount of smell the patient still had when he or she walked in the door. The younger, the less time, and the more smell retrieved at the time of the test, he found, the better. I thought as I read: *Well, I'm young, within a two-year window of the accident, and could already smell chocolate and rosemary when I was tested at the clinic in Connecticut. That's good.*

But there's another factor too. Cowart has found in her clinic

that the cause of the original damage also plays a role in prognosis. "At least in this clinic," she told me, where she has seen thousands of patients with damaged olfactory systems, "it's clear that people with viral damage are more likely to regain their smell than those with head damage." With a virus, she told me, there is less risk for damage beyond the severed neurons. I shuddered to think of the other possible effects of the smash of my skull against that windshield. Like almost every day since the accident, I felt lucky. I wondered how lucky I could be.

"Is it ever possible to fully recover?"

Again, a pause.

"People do seem to continue to get better," she said. "But whether they ever actually get back to normal is questionable."

I WALKED OUT of the front door to my Midtown office building one evening in November. It was going to be a late night at the magazine, and I needed coffee. I set off down the block toward my usual caffeine haunt. But, then, suddenly, I stopped. There was a smell. Another one. A strong one. But this one was different—sticky, cold, almost crass. It reminded me of something vague but familiar, like the name of a friend I hadn't seen in years. I looked around, unsure. And then I saw it.

Trash. Ripe containers full of trash. There was a pile of garbage bags busting at their seams lying on the sidewalk nearby. I stared. They smelled bad. I mean, *bad*. Like rotting fish, like stagnant water on a hot summer day, like the slimy mouthful of an old mushroom you forgot to check. This was the first fully comprehensible "bad" smell I had perceived in more than a year. It was glorious. I took a deep breath and reveled in it.

As I again encountered foul odors, I became reacquainted with disgust. The subway was a bastion of scent, always promising a rich, cloying ride. Discomfort ran off the backs of passengers in smells that stuck to my face and my hair. I often had trouble recognizing these new smells. The words didn't return alongside them. It was sometimes difficult to identify anything. I mixed many things up, and I doubted myself constantly.

I met my mother for a long weekend on Martha's Vineyard. There, we drove down a thin gravel road with the windows open. I leaned my face out to nuzzle that touch of warm air.

"What's that smell?" I asked, suddenly struck by something buttery, something sweet. "Is it some kind of baked good?"

My mother looked at me.

"No, Molly," she said, bemused. "That's a skunk."

This confused me. I wondered what was happening beneath the surface of my skin. For coffee to smell like coffee after the neurons signaling its molecules have died and regrown, one would assume that the new neurons are attaching to the same spot on the olfactory bulb, so that they can send the same signals to the brain. How do they know where to go?

I once asked Stuart Firestein, the Columbia University neurobiology professor and leading olfaction scientist, about this over a tumbler of whiskey at a bar near Union Square. "There are lots of questions," he said, throwing his arm up in the air. "Does regeneration recapitulate development? Or is it different? Is regeneration the same process as development?"

"We do know that the replacement is very long term, very stable," he added. "But we don't know how."

How would smells remain the same? I wondered. How would the scent of cotton candy take you back to the state fairs of your

youth if it were different with age? "Presumably the neurons re-
generate and reattach to the same places in the brain." Firestein
shrugged. "There are many mysteries."

DAVID AND I broke up on the same apartment stoop where we
first kissed.

After the sound of his footsteps faded down the street, I
walked up the stairs to my apartment, collapsed on my bed,
and fell asleep wearing all of my clothes. It wasn't until I woke
up the next morning, the sun streaming through the curtain on
the window near my head and the ambient sounds of my room-
mates making coffee down the hall, that the cold waves of panic
began.

cinnamon gum
and
sulfur

IN WHICH I GET COOKING

I MADE TOMATO SOUP ONE NIGHT, months later. I wore sweat-pants and an old T-shirt, my hair in a knot on the top of my head. I had turned off my cell phone and powered down my computer. I stood over a large metal pot that bubbled on the burner, steam fogging my glasses, stirring with a wooden spoon. This soup, which I had been meaning to make for weeks, was a thick con-coction of canned tomatoes and chickpeas, rosemary and garlic, chicken stock and a pinch of sugar, salt, and pepper. It was a simple soup, a nourishing one. I had forgotten how much I loved the rhythmic lull of cutting board and knife, the burble and pop of dinner simmering on the stove.

This was the first Saturday night I had stayed home alone in many weeks and the first meal I had cooked for myself in

even longer. After David left, that spiked sense of panic had receded, leaving the depression to bloom. I was filled with a foreign exhaustion. A deep, dark lethargy. I slept long and hard, glacial nights without dreams. In the mornings, I had to force myself to move. This slow, creeping depression no doubt came in part because I was lonely. But mainly it came because I was scared. I was terrified of what I didn't know, of what else I had lost alongside my sense of smell. The professional kitchen, yes. David, of course. But connection, flavor, love? Only a year and a half before, at the Craigie Street Bistrot, I had known who I was, what I wanted, where I would go. I had been so sure of my passion. I had found my vocation. I was living my life. Now, without a map, I felt empty and confused. I began forcing myself to go out at night, to see friends, to act and interact. I distracted myself with films and restaurants. I wouldn't let myself think about the implications of my failed romance, the possibility of losing more. I wouldn't let myself think about my sense of smell. If I did, I would have to admit that the rate of olfactory return had slowed to a dribble. I hadn't smelled anything new in weeks, maybe months, and the scents already back had dimmed, pale in comparison to their raucous days of entry. I had no idea why.

On this night, however, I felt soothed by the mechanics of stirring and chopping, listening to the crackle of garlic in the pan, its warmth emanating softly on my face. There was something healing about the act of eating alone, of cooking just for myself. I concentrated on the stove and the sink, washing vegetables and wielding the slow crank of the can opener. I tried to concentrate on the smell of the fresh sprigs of rosemary and the knobby rounds of garlic, which I had chopped on the counter to

the background lilt of Bach, but their scents seemed muted, pale. The soup finished a light, easy shade of red. I pureed it in batches to break down the beans and turn its texture to smooth. I ate it out of a chipped white bowl at the kitchen table alongside a hunk of the sourdough bread I had picked up in the farmers' market that morning. I read a well-worn copy of a Wallace Stegner novel and sipped a glass of dry white wine—a Sancerre—which seemed to grow more aromatic and flavorful as the evening went on. I felt, for a moment, like I wasn't really alone.

I WROTE A LETTER to neurologist Oliver Sacks while sitting at a Park Slope café one humid afternoon in July. I had just read one of his pieces in the *New Yorker,* about a man who became hauntingly obsessed with piano music after lightning struck his face, and had called my mother to tell her about it. I was enthralled with Sacks's ability to show the mystery of the human body through its malfunctions.

"Why don't you write to him?" she asked.

"Who?" I said. "Oliver Sacks?"

"Yes."

"Why would I do that?"

"He might understand you."

I had been moved by Sacks's writing since high school, when I first picked up *The Man Who Mistook His Wife for a Hat,* his elegant collection of case histories about patients with conditions that ranged from autism to the inability to form new memories. It had never really occurred to me that the neurologist-author was more than a character in his books, a bumbling but astute celebrity scientist with a thick white beard. Could he explain what

was happening in my body the way he described the inability of Jimmie to form new memories in "The Lost Mariner" or the Tourette's syndrome of Ray in "Witty Ticcy Ray"?

But perhaps he could. Sacks had, after all, written about Stephen D., a young medical student who could smell abnormally well for a few days while hyped up on drugs, like a hound dog sniffing everything in its path. (Sacks later revealed that the story, "The Dog Beneath the Skin," was autobiographical.) "It was a world overwhelmingly concrete, of particulars," he wrote of that time. "A world overwhelming in immediacy, in immediate significance."

When my mother and I hung up the phone, I stared absently out the window for a moment. I *did* want to understand what was happening to me. The holes in my olfactory knowledge gaped like craters, and I had long been afraid to find out more. *Why not?*

"Dear Dr. Sacks," I wrote.

I stopped.

What did I want to ask? Questions twisted around in my mind, unformed and unacknowledged. I fully understood the importance of smell, but knew none of the specifics. I knew what scent provided through the lens of my loss, through each aroma that painstakingly crawled back into my nose. I knew that if damaged, the sense of smell could come back. That it could return in mysterious ways, ebbing and flowing with my emotions, turning around with words, flipping with color or sound. But I had been avoiding deeper scientific understanding for close to two years. I found in the numb months that I lived in an odorless, textureless world that I just didn't want to know. I found in the exciting, colorful months of return that I didn't care how or why. *Just keep*

coming, I thought. But when recovery proved to be less swift, less concrete than I had imagined, a more primal curiosity emerged. What was this mystery happening beneath my skin?

I could now smell the milk-white steam of my coffee and the floral haze of perfume emanating from the woman who sat to my right. But my sense was far from fully restored. I couldn't detect the intricacies of Syrian oregano or lemon thyme, the herbs that were once so relevant to my daily life. The potency of their aromas had faded to vague, vaporous ghosts of memory. They were ones no longer racked with pain, but I could feel the absence nonetheless. Each time I stepped into the kitchen it hung like an apostrophe over the stove. I could feel it in the buzz of my desire to cook, to no longer feel alone. I didn't miss David, but I did miss *something*. What was it? My wonder woke me up early, tapping me again and again with the inescapable hand of anxiety as I waited for understanding. *Why don't you find out?* It whispered. *Do you really want to know?*

I did.

I wanted to know why I could smell again when doctors had told me I would not. I wanted to know why the good smells came back first and why they all had muted when I felt so down. Why couldn't I recognize, or remember, or put into words what had once sprung thoughtless from my tongue. I wanted to know how my nose worked, and why it meant so much. If I understood, then I could move on. And if anyone could explain it to me, it would be Sacks, who was once deemed "the poet laureate of contemporary medicine" by the *New York Times*.

Dear Dr. Sacks. . .

I began to type.

"In the last few years," I wrote, "I have been witness to a

confusing neuronal phenomenon of my own—one that has been simultaneously frustrating and fascinating, depressing and hopeful . . ."

When I arrived home later that afternoon, I printed out the page, folded it into crisp thirds, and slid it into an envelope. Using the contact information on Sacks's website, I addressed it, stamped it, and walked down the block to the big blue bin outside the post office. I dropped it in.

MEANWHILE, I CONTINUED to keep pace with the ferocious speed of New York City. I wouldn't let myself rest, jumping between home, work, and friends. I moved quickly, restlessly. I rarely gave myself time to breathe.

But then again one Saturday morning, my kitchen filled with the scent of fresh-brewed coffee, I looked at the oven, the door of which I rarely cracked. I remembered the calm I once felt when cutting butter, sifting flour, and kneading dough. I remembered the slow rhythm to the mixer's whirl, the clank of heat from the stove. And I thought: *I will bake.*

I began again with bread.

I hauled out my electric mixer, a bright red one given to me by my mother before the accident but hardly used since. The kitchen flooded with morning light as the yeast bubbled softly in a bowl of warm water. I added careful cups of flour against the background hum of roommates showering, doors opening and whispering shut. I let my mind wander as I kneaded the dough, which morphed from sticky to supple on the counter with each turn of my palm. And as the bread baked, the kitchen filled with a nutty, sweet perfume.

I could smell the yeasted honey, the oatmeal whole wheat. Perhaps I could not detect its aroma in its entirety, I thought. But I could smell it enough to feel warm. I inhaled until I thought my lungs would burst.

I took a fresh loaf over to my friend Ben's house that evening for dinner. An aspiring chef who worked most nights at a high-end restaurant uptown, Ben and I loved to talk food. Along with his girlfriend, Philissa, we cooked and ate together often. At their table we devoured plates of duck breast sautéed in butter, delicate basil pancakes, and salmon cured by hand. There were buckwheat crepes and fennel salads and cinnamon doughnuts crunchy with a sugar coating, fried crisp in oil. But above all, there was laughter and companionship. At their table, I concentrated on the flavor I had only recently begun to retrieve. And while I doubted that I could taste everything, I did remember why I had valued the culinary in the first place: the togetherness, the happiness, the intimacy of place. Nourishment, I remembered, came from far more than taste and smell. Flavors were heightened with my happiness, pulsing with my friends.

"We should cook for more people," Ben said one evening. "Like a restaurant, but at home."

I took a bite of a basil pancake, which tasted of summer and herb.

"*You* should," I said, waving my fork in the air. "I mean, this is good. This is really good."

"*We* should," he said, pointing to my ravaged loaf of bread, which had emerged from the oven with a thick bronze crust and soft, air-bubbled innards. "You can bake."

I looked at him, my eyebrows raised. While I was still hesitant to attempt to cook savory dishes for crowds, ones that required

constant attention to taste, I felt comfortable baking. I didn't need a full sense of smell there. I only needed precision and patience. But did I trust myself to share my efforts beyond my inner group of friends?

"Seriously," he said. "We love to cook; we love to feed people. Why not run a little restaurant here for a handful of friends? Like a dinner party but bigger, an ad hoc experiment for food lovers at home?"

He looked excited. A homegrown restaurant? I smiled. *Why not?*

A month later I was awake at 6:00 a.m., the pale yellow dawn hardly visible through the kitchen window, my arms covered in flour, my oven filled with dough. My mixer stood ready. Steam from the teakettle left light clouds on the window nearby. A pan of focaccia bread, one that I had set to rise in the fridge the night before, lay on the kitchen table, dimpled and doused in olive oil and rosemary, waiting to be baked. I moved quickly, quietly around the room. I had twelve loaves to finish before noon, when I was due to arrive at the apartment where Ben and I would host the first meeting of our "supper club." There was much to be done.

Ben and I had sent out an e-mail to friends and acquaintances soon after our first conversation. We were startled by the response. It seemed that we were not the only ones who loved the communal aspect to eating. We were not the only ones who wanted the nourishment of friends, the comfort of home. We capped the first "underground" dinner—a five-course spread, complete with my fresh bread and home-baked dessert—at twenty-eight guests. *How are we going to pull this off?* I wondered.

We prepared for a week. Ben played with homemade stocks, soups, and pickled vegetables. He debated buffalo versus steak. Trout versus tuna. Grits and risotto, morels and portabella. I played with raspberry gelées and peppered biscotti, gingersnaps and shortbread each night when I arrived home from work. Ice cream bases were created on a tipsy Friday at midnight. *Biga,* the fermenting bread base often used for Italian bread that I stored in plastic jars, littered my apartment's refrigerator. I would bake individual chocolate cakes that oozed a dark molten dark center with the crack of a spoon against their flesh. I would serve them with scoops of caramel ice cream, just a touch of salt sprinkled on top. The hot and cold, salty and sweet: a dessert for those who could smell, and those who could not.

When I arrived at the apartment where we would cook that day, a small but open three-bedroom in Brooklyn, I could smell the neon-green pea soup already simmering on the stove. I could smell the grassy stalks of asparagus and the bright citrus to the oranges that had been peeled and sectioned on the table. We tasted one of the many loaves of bread that I had brought, carried in large shopping bags: cracked and crinkled, they had good crust and crumb. I felt confident for the first time in years.

"Here we go," Ben said, as our guests began to trickle into the apartment in ones and twos around 7:00 p.m. They were friends and friends of friends, ranging from teenagers to grandmothers, dancers and writers, businessmen and bankers, colleagues and comedians. Bearing bottles of wine they congregated in the dining room. Ben and I, sectioned off in the small kitchen by strategically placed tapestries, made our final preparations listening to the background sound of laughter and clinking glasses. Adrenaline coursed through my body. I remembered the mo-

ments before service at the Craigie Street Bistrot, when Maws
would stand at his station, knife poised, waiting for the first order
with studied calm.

"Let's do it," I said.

We raced through our work in the kitchen—grilling scallions,
searing meats, spooning a nutty brown romesco sauce, poach-
ing asparagus. Bent over the white dishes lined on an overturned
bookshelf, we arranged each course on thick white plates, which
we had rented from a party company the day before. The close
quarters, the heat of the oven, and the constant desire for speed
reminded me of Maws's lair. Against the hum of chatter and dish,
I concentrated on the immediate sizzle and sear, steam and boil.
I could feel the heat of the oven, an occasional flash of burn as I
grabbed pots and pans, the weight of plates in my hands as I took
them out to the smiling eaters. I inhaled and exhaled—smelling,
touching, working. Time flew.

I didn't watch as the guests dug their spoons into the rame-
kins of steaming chocolate cake that we brought out at the end of
the meal. Instead, I stood in the kitchen and I listened. I waited
for a reaction, something beyond the clink of spoon on plate.

The room was quiet. Very quiet.

"Too quiet?" I asked Ben.

"No," he said, peeking around the doorway. "I see smiles. I
see plates licked clean."

I MET OLIVER SACKS on the sidewalk outside the Cornelia
Street Café, a storied establishment with a bright red awning in
Manhattan's West Village, a few weeks after his letter arrived. It

had come in a thick envelope, tucked between bills and magazines in my mailbox at the end of August. I tore it open on the stoop of my apartment building to find two pages of scrawling, spidery handwriting within. Sacks was interested in my nose. He wanted to meet.

I arrived at the café at the appointed time, a light late-summer evening, filled with tingling anticipation. As I walked down the sidewalk toward the café, smelling the vagaries of the street, the smoke, the trash, the sweet waft of air, I knew I was on my way to an important place. After all, I had conquered my fear. I had asked for help. And not only that: my request had been granted. I was on my way to understanding the sense of smell, en route to the beginning. Sacks could tell me what had happened; he could tell me what to expect. He would, too. After all, he did it in his books. And he had written me a letter.

Sacks stood on the sidewalk with his longtime assistant and editor, Kate Edgar, and a portable seat cushion in his hand. He had a kind, round face and a thick gray beard. I noticed that he wore a light blue T-shirt from Columbia University, where he had recently been appointed a university "Artist," and the insignia across his chest was creased as if the shirt had just emerged from its wrappings.

I walked up to the scientist and introduced myself. "Molly," I said, shaking his hand, a huge grin on my face. He smiled back. "Thank you for inviting me," I said.

"My pleasure." Sacks, who was seventy-five years old, spoke with a soft English accent. He moved to New York from London in 1965 to work at Beth Abraham Hospital in the Bronx as a consulting neurologist. That was where he discovered the

group of Parkinson's patients who became the subjects of his book, later adapted into a film with Robin Williams and Robert De Niro, *Awakenings*.

I wasn't sure what else to say, so I followed silently as we descended the stairs into a dark basement room in the café. We were there to see a lecture. It was one of the café's "Entertaining Science" events, which Sacks had told me about in his letter. This one was called *Scents and Sensibility: How Your Nose Knows*. "You might find it helpful," he had written to me.

We took the stairs in single file. As Sacks rounded the corner to the basement floor he glanced back. "Well," he said, "I was very interested in your letter." He spoke softly, stuttering a bit. I had once heard him give an interview on NPR in which he described himself as almost debilitatingly shy.

"I'm not working on anything to do with smell," he said, looking back and above my head, squinting. I wondered if he was avoiding my gaze. "But I, I find it fascinating."

I suddenly felt cold. His words were so casual. I didn't want fascinating. Doesn't he *know*?

In the basement, Sacks sat on his cushion against the wall. He seemed a bit overwhelmed in the dark, loud room. The crowd surrounding us chatted, swelling with noise and inching closer toward this celebrity scientist. He leaned over the table to talk. He spoke softly, and I yelled so that he could hear my response. He told me that he had been so interested in my letter because his own eyesight had rapidly diminished in recent months. Sometimes he could see things that were not there. Pineapples and sea creatures, lines waving like flowers in the grass. *We're both living tales of loss,* he seemed to imply. *Ones that change the world around you.*

A middle-aged woman wearing a red blouse and slacks approached.

"I just wanted to tell you how much your work has affected me," she called out over the din.

He smiled gracefully. "Thank you."

As the lights grew low, I tried to think of something to say. But I couldn't. *He doesn't know,* it echoed in my head. *He doesn't know.*

A spotlight hit the stage. The first presenter mounted the stairs. Sacks leaned in toward me again.

"This," he said, gesturing with his hand, "should be interesting."

The lecture began with Stuart Firestein, the Columbia University biology professor and smell scientist. He was followed by Christophe Laudamiel, a top perfumer at International Flavor and Fragrances. They spoke about the complication and beauty of the nose. Firestein talked about the neuronal construction of the nostrils, sinuses, and brain. Laudamiel explained the molecular makeup and inherent appeal of fragrance. The word *mystery* was thrown like confetti. It was the first time I heard experts speak on the subject. It was the first time I sat in a room filled with people dedicated to the topic of smell. I listened intently, surprised that there was so much that they didn't know. I scribbled words with a ballpoint pen in the notebook I had cracked when the lights had dimmed, unable to see a thing through the café basement's dark glaze. I kept my eyes focused on the Power-Point slides flitting behind the speakers' heads, concentrating but overwhelmed by the sudden influx of facts, ones that tore at the soft tunnel of my ignorance.

I had been thinking about smell for years, but I didn't know

the purpose of an olfactory receptor. I had no idea the perception of smell was determined by genes. The names Axel and Buck were new. But Sacks's presence calmed me. He didn't know, but even the experts didn't know, not in that way, not in the way I wanted. Perhaps I would have to rely on myself.

Toward the end of the lecture, Laudamiel handed out samples of fragrances that he had created from scratch—different ones, nothing like the traditional scents sold in department stores. Laudamiel had been working on a series of scents based on *Perfume,* a best-selling novel by the German author Patrick Süskind, which had recently been turned into a film. It is a story of smell set in eighteenth-century France, one of intrigue and murder and mystery. It centers on a man named Grenouille who is born with no body odor but with an inhumanly keen sense of smell. Laudamiel had created the scents of specific scenes: of the cave where Grenouille hides, damp with stone, moss, and cold; of the best-selling perfume, *Amour and Psyche,* made by Grenouille in the book; of the scent of a young virgin girl, the one who drove Grenouille to such intoxication. For this scent, Laudamiel told members of the audience, many of whom tittered with amusement, he had used the chemical information gleaned from the belly button of an actual virgin, tested and determined at his Midtown lab. We smelled them carefully over thin white paper strips passed around the room. The details of these fragrances, which filled the room with a cloying aromatic glaze, were just a bit out of my perceptual reach. I inhaled and exhaled audibly and felt anxious and out of place. Only one sample stood out to me: *Paris 1738.* This particular fragrance was reminiscent of the streets of Grenouille's Paris, which Süskind had described in all their fetid glory in the first pages of his book. These streets were

foul with sewage and rank with wet stone. The sample reeked of
sweat and dirt and disgust, swirling with cassis and pyrozine. I
watched the faces of those around me when Laudamiel handed
out these samples to sniff. I heard the gasps of amazement as the
audience moved, simultaneously repelled and entranced.

When we left the café later that night, Sacks and I shook
hands while standing amid a throng of people on the sidewalk
outside. We spoke about the lecture, and promised to be in
touch. As I walked toward the subway, the fading light swal-
lowed by the fluorescence of city traffic and glowing neon signs,
I thought about Sacks and scent, about science and its mysteries,
about those who study them and why. I thought about what I
would do next.

I BEGAN GRADUATE SCHOOL in the fall of 2007. I would earn
a master's in journalism over the course of one year. Autumn
arrived alongside stacks of reporter's notebooks and mechani-
cal pencils, new faces and new friends and a constantly replen-
ished stack of library books to read on the long subway commute
between Brooklyn and school. I felt suddenly overrun and ex-
hausted. I felt challenged and inspired.

And, I was surprised to find, my nose went haywire.

I could smell the clove-tinted perfume of a woman in heels
who clicked past me on the street. I could smell the chlorine em-
anating from the pool at the gym from down the hall, thick like
carpet and cloudy with memories of summer camp. I took a stick
of butter out of the fridge one morning as I prepared a breakfast
of toast and held it in my hand for a moment, unable to believe
that it could so reek of sweet cream and salt.

My nose was suddenly registering so much, so quickly that at times I found it hard to concentrate. I sat near the water off Hunts Point in the south Bronx on a reporting trip for class and found myself breathing through my mouth because the air smelled so brackish that I felt sick. I couldn't think beyond the malodorous stench of the can of cat food my roommate opened in our kitchen each night. Whatever I learned from a lecture on the ethics of journalism was blotted out by the shower-fresh deodorant of the man sitting next to me in the auditorium.

More scent had returned in two months than in the previous two years combined. These scents weren't entirely new. Not like the bursts of that first fall and winter before. But these scents were stronger. More intense. They assaulted me with aggressive entrance. It was the opposite experience from that of the months after David left. "It's because I'm happy," I told my mother on the phone.

I was happy when I inhaled the scent of cleaning fluid—sharp and painful, like lemon juice on a scrape—as I tidied the bathroom one Sunday morning in September. I was happy on the bright afternoon that I sat on a bench in Union Square trying to read, but couldn't process a single word alongside the spicy scent of *pasta alla puttanesca* eaten by a nearby woman in large forkfuls from a cardboard container. And I was happy when I met Matt.

Matt and I were introduced at the end of the second week of graduate school. On that Friday afternoon, like many Friday afternoons that year, a large crowd of our classmates flocked to the bar. We would mingle over happy hour beers.

I saw him standing amid a group of fellow students on the sidewalk outside the pub on 108th Street, chatting in the dim evening light. He had short brown-blond hair, cropped close. He

wore a beige button-down shirt and jeans. He hung back a little, handsome and austere.

I joined them, and we passed introductions around like a hot stone. When Matt met my gaze, I smiled.

Soon we trickled into the bar to be swallowed by the mass of patrons, the taste of hops, the smell of smoke. I lost track of Matt in the flurry of sound.

Later, though, a new friend pointed at him from across the room. He leaned against the bar, talking to a swarm of faces I didn't know.

"He used to be a soldier," she whispered to me loudly.

"Really?"

I watched him for a moment. I was intrigued. Our country had been at war for years. I read about it in the paper every day. But I had never known anyone in the military.

"Someone said that he's been to Iraq," she added.

I had a hard time imagining that.

A few weeks later, at another party that we both attended, I asked him about it. We were perched on picnic tables outside at a beer garden in Queens, drinking pitchers of Brooklyn Lager, chatting among classmates and friends. Matt and I fell into easy conversation. We covered journalism and New York, past travels and future plans. We talked about smell and cooking. He had eaten chocolate ice cream for breakfast, he told me with a guilty grin. "I would also want chocolate to be among the first things I recognized when my sense came to," he said. We talked about his family in New Orleans, and his decision to join the army when he was eighteen. And we talked about the war in Iraq, an event that had defined Matt's life and never touched mine. He told me about the desert heat, shimmering off the sand during his two

yearlong tours of duty. He told me about the hours of hurrying, the days waiting, the tanks and the uniforms and the care packages from home. I leaned in close as he spoke. I could smell the alcohol on his exhale, a sudsy note of soap.

Later, he kissed me on the subway platform at Times Square as we waited for the trains to take us to our respective homes. I could smell his skin, which was warm with aftershave and a hint of sweat. I could smell his breath, which now held the spicy cinnamon of chewing gum. I could taste the heat of his mouth, the candy of my lip gloss. Our noses touched gently as we paused for air, his palm soft against the back of my head.

I FELT SURE that my sense of smell was tied deeply to the state of my emotions. When sad, I noticed my perception of scent dim, like stereo volume on low. When happy, new, intense smells arrived constantly in my nose, making me feel jumpy and quick, the world suddenly coming in exaggerated hues. But why? I had no idea. The smell experts at the lecture with Sacks hadn't explained it. I wasn't sure anyone would. All I knew was that my internal landscape fascinated me, moved me, drove me to wonder.

The tie between smell and emotion has long been known, potent since before the days of laureled Greek philosophers. It began, writes Patricia Davis in her book, *Aromatherapy: An A–Z,* with smoke. "When the twigs of certain bushes or trees were thrown on the fires as fuel, the smoke and aromas they gave off may have made people drowsy, or happy, or excited, or maybe even given rise to 'mystical' experiences. . . ." she says. "The 'smoking' of patients was one of the earliest forms of medicine, and as religion and medicine were closely bound up with each

other, the use of special smokes also formed part of primitive religions." In ancient Egypt, oils infused with scents like cedarwood were used to embalm the dead and help transport them to the afterlife—smell was equated with spirituality and the gods. The ancient Greeks and Romans used ample perfume; floral scents, specifically, were associated with a state of grace. In Greek mythology, the invention of perfumes was ascribed to the immortals. Today, scent as a mood modulator can be found almost everywhere: from massage parlors to department stores and in the advertised promise of perfume. In 2006, for example, the Westin Hotel chain began pumping the scent of white tea into its lobbies in hopes of inspiring a feeling of calm.

I've experienced a feeling of relaxation during a professional massage scented with chamomile and almond. When I was sixteen, I traveled to Nepal and felt an alert but deep calm while sitting in temples where incense burned lazy curls of smoke above my head. I cannot deny that the scent of a cake baking in the oven makes me feel happy no matter where I am, the safe pleasure of home. But could these scents really infiltrate my mind and manhandle my emotions without my conscious knowledge? How did it work? A long chain of scientists and amateurs have wondered just this.

The scientific validity of aromatherapy remains shaky at best. While there have been studies showing that the application of essential oil to the skin can cause a physiological reaction to take place in the body, there is little science to show that inhaling the scent of orange will cause the body to energize or that rose will relieve stress. But that doesn't mean that smell and emotion aren't linked.

Like the tie between scent and memory, this tie to emotion is

rooted in the structure of the brain. The olfactory system is only a small step away from the amygdala, which processes memory and emotion, and the hypothalamus, which deals, among many things, in autonomic reflexes. When looking at the results from studies using fMRI, the neuroimaging technique that maps brain activity by the careful recording of changes in blood flow, scent psychologist Rachel Herz has found that the amygdala, "the well-spring of emotion in our brain," is more highly activated when a person is recalling memory triggered by scent than by any other sense. It is also more active when recalling a scent related to a personally significant event, rather than a smell without personal meaning.

On the surface, the explanation is pretty simple, actually, one that goes hand in hand with the connection between smell and memory: learning. "Aromas work their therapeutic magic by evoking a learned association in the smeller," wrote Herz in *The Scent of Desire*. Similar to the connection between smell and memory, "this learned association can have real emotional and physical consequences, which in turn will influence moods, thoughts, behaviors, and general well-being. The scent of lavender encourages relaxation, and sniffing peppermint is revitalizing because of the meanings these aromas have acquired and the emotional associations they induce. We have 'learned' that the emotional association to lavender is relaxation in the same way that we have learned that rose smells *good* and skunk smells *bad*."

Herz has conducted many studies on smell and emotion. In one, published in 2004, she explored the difference between memories evoked by scent and those by sight, sound, touch, or simply a word. At the Smithsonian Institute in Washington,

D.C., she asked seventy people who ranged in age from seven to seventy-nine to recall a personal memory after hearing the name of each of three items: popcorn, fresh-cut grass, and campfire. They were asked to rate their memories based on emotionality, vividness, evocativeness, and specificity. Then, each item was presented again, this time by different sensory means. Visual, auditory, olfactory. Popcorn, for example, came first as an animated scene of an overflowing bowl of fluffy white kernels, then the sound of popping, and finally the scent—fresh and buttery. Each participant recalled the same memory after each example and again rated them on the same scale. Herz found that compared with sight and sound, the memories triggered by smell were rated significantly stronger both emotionally and evocatively. These scented recollections brought a great deal more to life.

But the association between smell and emotion can be much more concrete. Scent can change mood. Scientists William Redd and Sharon Manne projected heliotropin, a sweet vanilla-like scent, into the room where patients received magnetic resonance imaging (MRIs) as part of a diagnostic workup for cancer in 1993. These patients, lying in the claustrophobic chambers, alone with the possibility of their disease, reported reduced levels of anxiety compared with another group of patients who only breathed in the blankness of regularly humidified air. Vanilla, after all, is most commonly associated with the experience of baking, of dessert, of home. It produced a calming effect.

It goes both ways. In 1997, Robert Baron, a professor of management and psychology at Rensselaer Polytechnic Institute, found that patrons of a mall in upstate New York were more likely to pick up a dropped pen or give change for a dollar if in proximity to the "pleasant" ambient scents of Mrs. Fields Cookies, Cinnabon, and

The Coffee Beanery. In 2009, Rice University psychologists Denise Chen and Wen Zhou published a study saying that those who are better at smelling have a higher level of emotional competency. In this case, a group of female university students who could identify the T-shirt of a roommate opposed to that of a stranger by scent alone tended to score higher on emotional awareness and facial-emotion identification tests. Does better smelling equate with a more developed sense of sympathy?

But our emotional reaction to a smell is malleable. It can change because of placement, because of timing and mood. Studies have been done on how odor perception changes when labeled or given a suggested meaning. In 1990, Susan Knasko and her colleagues at the Monell Chemical Senses Center told a group of participants that there was an ambient odor—positive, negative, or neutral—present in a room. In truth, there was no odor at all, but they found that the participants self-rated their emotional state and physical well-being depending on what kind of ambient scent they believed to be present. With a feigned positive odor, participants reported a happier mood. With the false negative odor, participants reported a greater number of physical symptoms. It's as simple as context. "The instantaneous response to smell is an emotional response even when the scent is unknown," Herz would explain to me. "It doesn't have to be all good or all bad. It can be curiosity or suspicion in response to an unknown smell, so that you are aroused on some emotional level. It's the hedonic evaluation—*do I like it or not*—that comes with prior experience, and from interpretation and context."

As fascinated as I was by the link between scent and emotion, I wanted to know more. I smelled more when I was happy, less when sad. Why?

I sat in Tealuxe, a small café in Providence, Rhode Island, on a muggy August morning years after I first noticed the connection. I was waiting for Herz, who had been a professor at Brown University since 2000, to arrive. I had taken one of her classes, when I was in the midst of a brief but hopeful period in which I wanted to become a psychotherapist like my mother. I remember the uncomfortable hard-backed chairs in the lecture hall, which smelled musty, a mixture of stale coffee and feet. I remember the way my spring allergies peaked right before our final exam, clogging my nose and fogging my head. I remember the day that Herz lectured about scent and its relationship to child development. I had never thought too much about the nose and found it strange that this is the subject about which my young professor was so passionate.

"I love the smell of skunk," she had told us as she explained the importance of learning. "I would wear it as perfume if I could."

I ordered a cup of tea as I waited for her in the café. I chose Crème de la Earl Grey, a sweet brew that held blended blue flowers and a twist of cream. I used to drink it all the time when I was there as a student. The smell—burnt sugar, caramel—had once been viscerally tied to anxious hours of studying, hunched over unread textbooks and the hard black countertop. I inhaled over my mug. It smelled nice, sweet and cakey, like a liquid dessert.

Herz walked in a few minutes later. She has devoted a huge swath of her career to the relationship between smell and psychology. I asked her up front: I could smell more, and better, when I felt happy. Why? "The connection between smell and emotion is unique and entirely extreme," Herz said. And then she told me about her theory, which she calls the "depression-

olfaction loop" and first wrote about in *The Scent of Desire.* Already it has been found in numerous studies that patients who have been diagnosed with depression have a lessened ability to smell. Those with anosmia, as I knew all too well, were often depressed. So there is a correlation between the two states. "I decided that there is a feedback system there," she told me.

When someone loses the sense of smell, she explained, depression can set in because the input from the nose that once went regularly through the amygdala is gone. This has both a physical and emotional effect and can become worse and worse with time. Duke University's Susan Schiffman, for example, found that with age and the resulting loss of ability to smell, many become depressive, and even suffer from malnutrition.

On the other side, Herz continued, when one is depressed, the amygdala is not functioning normally. Because the connection in the architecture of the brain is so intense, then, this can affect the operation of the olfactory system. After all, German scientist Bettina Pause found in 2001 that a group of participants diagnosed with depression had a severely dampened olfactory sensitivity in comparison to a group of healthy participants. After successful treatment, however, the once-depressed group scored significantly higher on the odor tests. The connection between the amygdala and the olfactory system, she believes, are striking. "It is thus assumed that a dysfunctional state of the main olfactory bulb in depressive patients could account for a lowered olfactory sensitivity and moreover, for an intensified experience of sadness and fear, via a disinhibition of the amygdala," Pause wrote in the study paper, "Reduced Olfactory Performance in Patients with Major Depression."

"It's just a theory," Herz said. "Purely speculative." But she

has seen people who have lost the sense of smell fall into a deep depression. She has seen those who are depressed lose their ability to smell. There must be some kind of loop, she says.

It made sense to me.

IN SEPTEMBER, Matt and I strolled through Prospect Park in Brooklyn, navigating among the kids flying bright red kites, the scent of charcoal wafting off the grills. In October, we drove to West Point, the military academy fifty miles up the Hudson River where Matt went to college, for his five-year reunion. There, we watched cadets parade with crisp uniforms and serious faces. We drank pale ale in the stands of the football stadium, cheering Army vs. Tulane until the sun went down. In November we took the bus to Boston, where he joined my family for a champagne toast to Thanksgiving, my home thick with the satiating scents of roast turkey and pumpkin pie.

In December, Matt and I strolled through downtown Manhattan on a Monday night—arm in arm, our noses red with cold. The sun was fading and lights were beginning to glow from shop windows in every nook and cranny of the West Village. We stepped into a specialty coffee shop on Christopher Street. The bronzed wood store was filled with burlap sacks, glass containers of loose tea, and coffee beans that were so fresh they shone. It smelled thickly of cocoa and cafés. The scent was rich; a flick of my finger, perhaps, would indent the air.

"You must love coming into work every day," Matt said to the man behind the counter as he inhaled. "It smells so good."

The coffee-purveyor smiled as he ground us a pound of beans.

"We do love it, but not because of the scent. We can't smell

it anymore," he said. "You get used to anything. One week here and the smell is gone."

We left and took a turn down Bleecker Street. On the corner a man in a thick brown coat was wrapping a naked Christmas tree in mesh for a couple to take home. We walked by the forestlike stack of pine festooned with red ribbons. I took a deep breath. A new scent.

"Can you smell that?" Matt asked, sticking his face near the pile of branch.

"Yes," I said, smiling. "It's Christmas."

Our relationship grew slowly, carefully over the crusty edges of pizza in Brooklyn, hot dogs slathered in mustard outside a movie theater in Times Square, supermarket sushi on the steps of the school. He didn't know me "before." He didn't know me broken, unable to tell the difference between fresh and spoiled milk.

I began to cook more. I cooked savory meals, the kind that had scared me with their need for constant tasting. I cooked small things, slow things, never with much confidence. Sometimes they came out well—a red-wine Bolognese, which filled Matt's studio apartment with the scent of garlic and simmering beef, for one. But the successes were much fewer and far between. One night, for example, I decided to cook chicken. A roast chicken with garbanzo beans and a bright salad of peppers. I don't know what happened, but the flesh ended up rubbery and the beans burnt, leaving me so helpless and frustrated that we threw it all in the trash. I couldn't make myself try to resuscitate the dish from my mistakes, I wouldn't use the chicken to make stock, or stew. In fact, I told Matt, spitting out my words, I hated it. I hated that stupid, disgusting chicken that

I probably couldn't fully taste anyway. I stamped my feet, and Matt laughed. But then he opened the refrigerator and pulled out a small glass jar, hinged on top with a metal clasp.

"Here," he said. "I was saving this for a special occasion."

The jar was filled with a spread of some kind, something cloudy and light brown. He had brought it back with him from a recent trip to France, he said.

"Foie gras!" I hadn't had the rich duck liver pâté since my days at Craigie Street, when it had opened up new layers of taste.

I pulled myself together to roast a handful of asparagus I had picked up at the market that morning, which we then ate, plucking the stalks with our hands, our fingertips glistening in olive oil. I could taste the grassy, fresh vegetable, along with the sharply salted cheese I had grated on top. I toasted thick slices of bread, which we slathered with foie gras. It was thick and sumptuous. Could I taste it all? I didn't know. I tried not to care. After all, Matt didn't.

With Matt, I felt calm—like I didn't have to run, to constantly move, to keep too busy to think. I could breathe. I could smell him. I could taste him. Occasionally I worried. He and I were so different. He still simmered with the residual anger of two years spent in Iraq, at times blood-red and hot. I often retreated, emotionally impenetrable, far within myself. Was I missing something important? Were we safe from the dangers of undetected pheromones? From insubstantial odor prints or invisible signals? I had no idea. All I knew was that he smelled wonderful, like my favorite sweater combined with soap and shaving cream and the salt-airedness of his skin after a run. He tasted like mint, like caramel. I shoved my worry aside.

Early on a Monday morning in March, Matt and I rode our

bikes down the West side of Manhattan. Clouds filled the sky, blocking the already dim morning light. Snow still clung to the sidewalk's edge, and my fingers were numb beneath my too-thin red cotton gloves. We biked from Matt's apartment, a small studio above a dry cleaning shop on La Salle Street, through Riverside Park. I could see a halo of sun rising over the Hudson. There were a few walkers out with their dogs, but no more.

We were on our way to Penn Station, where we would take a train to Long Island. We had one week off school, a still-dark and still-cold "spring break." Though we would spend most of these ten days cocooned in the library, suffering over tattered copies of our master's thesis, we decided forty-eight hours could be used for rest. We would go to East Hampton, a small town in the heart of a ritzy beachside community, deserted in the bleak landscape of late March. We knew we would have the streets for our bikes to ourselves.

We biked down Eighth Avenue, zipping alongside taxicabs and SUVs. We rode rapidly, though, with the wind at our backs. I followed Matt as we weaved among cars and stopped at red lights. When we passed a large truck, double-parked on the west side of the street a few blocks above Times Square, Matt turned his head toward me.

"That smells like Iraq," he said.

I sniffed. The scent of diesel exhaust permeated the air. For me it was strong and unpleasant but exciting, too. It reminded me of the bus trips I took at school when small. The odor didn't leave my nose for a few windswept blocks.

Iraq, Matt had told me before, smelled strongly of fuel. It smelled of fuel and of flesh, burning oil, dirt, and disease. It was hot there, flaming hot and riddled with the sharp bite of sand

that frequently stormed around their heads. The heat only enhanced the stink.

All he needed, Matt told me later, on the train to Long Island, was a whiff of waste or fuel and he was right back in Kuwait, where he waited for the invasion of 2003, or in Ramadi, where he watched mortars fall for most of 2006. Burning oil. The stench of body odor long overdue. The second time he returned to war, he said, just one breath upon exiting the plane and he could remember things he had long repressed. The stink, he said, brought him right back.

I had no concept of burning oil. I could only imagine the smell of human waste baking in the sun. When I asked for more, he just shrugged.

"Indescribable," he said.

ALMOST TWO YEARS LATER, sitting on a train heading from New York City to Philadelphia, I would think about that conversation with Matt. I was on my way to the Monell Chemical Senses Center for my second round of interviews. A massive earthquake had rocked Haiti the week before, and I flipped through the newspaper, looking at picture after horrifying picture of corpses littering the streets, children with broken bones and dust covering every inch of skin. Every article written about the disaster, it seemed, mentioned the stench. Later, I would read a dispatch from Arthur Brice, a reporter for CNN: "Against the smell of death, many Haitians wear masks, bandannas or even small pieces of orange peel wedged inside the tip of their nostrils. Many journalists wear masks, but the masks don't eliminate the odors, just slow them down. You bring the smells back to

your hotel room, on your clothes, your hair, your skin. You want to wash them out, especially the smell of death, but you can't. It takes more than soap and water. The odors have soaked your memory." I wondered what horrific images, what traumatic recollections, would be tied to that smell for Haitians and aid workers in the years to come.

There is a dark side to scent. It's one far from Coppertone sunscreen and the beaches of youth, the velvety perfume of my mother's goodnight kiss. Smell can carry a sinister edge, an ugly underbelly. It can be vulgar and cruel.

"Smells plug us in," Jonathan Mueller, a neuropsychiatrist in San Francisco, told me. A friend of Oliver Sacks, Mueller has a private practice, which, according to his whimsical website that floats quotes from Nietzsche and neuroscientist Eric Kandel across the screen, deals in psychotherapy and pharmacology, disorders of anxiety and mood and pain. He works with brain injury and evaluates dementia. In addition, he works in smell. "Smells can beautify, to bring worlds of comfort and joy that are lost. They can also be emblems of death, terror, and loss of control. They can throw people days, weeks, months, or years after traumatic episode back into a horrific thing. The smell of smoke after seeing your house burn down. The smell of blood after a vehicular accident, and you wake up, taste blood in your mouth, and see your child dead by your side. They can open up cathedrals, 'immense edifices,' in the words of Proust, either in beauty, nobility and glory—or in torture chambers."

When I arrived at Monell, I asked Pamela Dalton, a cognitive psychologist, about the connection between scent and trauma experience. She has worked on many experiments exploring the subject. She told me that it only takes one moment, one sniff, one

experience to link a scent and a negative emotion in the brain.

Dalton did a series of studies on the subject—once purposefully matching a strong, heart-pumping sense of anxiety with a novel smell. To do this, a group of unwitting test subjects were given five minutes to prepare and then deliver a speech on an assigned topic in front of a panel of judges. Afterward, the subjects were told to count backward in set increments out loud from a very high number without the benefit of pen or paper. If they made a mistake, they had to start over from the beginning. This kind of social stress, Dalton told me, is prime fodder for a highly active autonomic nervous system: beating heart, sweaty palms. Fight or flight. And all the while, Dalton and her colleagues piped a novel scent into the room—subtle but perceptible, present but not distracting.

Three or four days later, back in the lab, the subjects sat alone in a room, told only to relax. Unbeknownst to them, that distinctive scent, light and hardly noticeable, infiltrated the room once more. The participants, the scientists found, began to show big spikes in heart rate, an increase in cortisol response. They reacted to the smell like *it* was a stressful situation.

Even though they were not consciously aware of the scent blown into the room, their bodies still knew. If the stress of public speaking could evoke a reaction, then, what about witnessing death and violence? What about pain or rape? What about war? "The phenomenon is real," Dalton said.

Dalton herself experienced scent-triggered post-traumatic stress disorder—known to most as PTSD, an illness of intense anxiety, a reaction spun from the experience of a moment devastating to your safety (physical, sexual, mental) or that of others near you—as a college student, decades before. Then, while

visiting a friend in an apartment building in New York, she was mugged by a man in the elevator. "He pulled out a knife," she told me. "I remember struggling with him. At one point I remember trying to scream." On the ride upstairs, which lasted only a minute and a half or less, the man grabbed her by the neck and held her prone until she gave him her wallet, her watch, the rings on her fingers.

A few months afterward, while visiting another friend whose child was putting together a model airplane, Dalton experienced a sudden onset of anxiety, of panic. "Out of nowhere my heart started racing," she said. "I felt faint. I thought I was going to pass out and I had no idea what was going on. I thought I was having a heart attack." It happened again, weeks later, when she visited her uncle on his sailboat, as he worked on the deck. Then she realized the common thread: scent. The scent of glue. Her mugger must have been a glue sniffer; the smell must have been on his hands. This specific scent triggered these symptoms of her fear.

"How did you recover?" I asked. "How do you erase a smell?" Dalton approached it scientifically.

"You can extinguish the effects by desensitization," she said. This can be done in a therapeutic environment on a large scale— for example, with programs like Virtual Iraq, an experiment in Virtual Reality designed by University of Southern California scientist Albert "Skip" Rizzo, which is gaining momentum in the United States. In Virtual Iraq, a three-dimensional program of exposure with funding from the Department of Defense, war veterans suffering from PTSD enter a three-dimensional world of armored vehicles and desertscapes, vibrating mock machine guns, and manufactured scents (among them burning rubber,

gun powder, body odor, and smoke) in order to habituate to the powerful sensory triggers tied to traumatic memory. Dalton, however, did it herself. "I went out and bought some glue. I would get myself calm and then I would bring the bottle a little closer . . ." She mimicked a sniff and a grimace, her arm extended straight out parallel to the ground. "And I would stop when I could feel my heart racing, and then I would take it back and relax again." Over and over, she trained herself not to react.

FAR FROM IRAQ, far from war, I stared at my cell phone for a long moment before I picked it up and made a call. My hand shook, almost imperceptibly, as I dialed the numbers. I held it to my ear as it rang.

"Hallo?" A French accent.

It was Christophe Laudamiel, the young perfumer with a bright red Mohawk who had spoken onstage at the Cornelia Street Café. Not long after my first meeting with Sacks, here I was, doing it myself.

I had made the appointment to talk with Laudamiel because the process of creating perfume fascinated me. Even though I hadn't worn it since those awkward years book-ending my bat mitzvah, when I thought that the scent of *ck one* was a portal to social acceptance and not simply the sweet, vaguely tropical smell reminiscent of green tea, I marveled at the art of fragrance. I called because I wanted to know about the perfumer's sense of smell. Laudamiel, I had read, was a phenom of fragrance, a creative wunderkind. The scents for *Perfume,* which I had attempted to smell at the Cornelia Street Café, simply brushed the surface of his potential. I wanted to know if he, like Grenouille,

was born with an unusual ability, or if it was something he had to learn.

"It's all about the training," Laudamiel told me. He compared the process of learning to smell to that of a composer, who goes through years of study before he or she is able to write symphonies. A musician must learn all the notes. A perfumer must learn all the smells. "A composer has learned to understand which instruments play what part in his orchestra, and how to fix the individual sections of trouble," he told me. "I have no idea what happens in music. But when I smell a fragrance I know exactly what to fix and where."

Laudamiel asked me why I was interested. I told him. I had recounted my tale of loss and partial regain so many times I was used to the response: the slightly strained silence, the effusive apologies, the not-quite-understanding-it sympathies. Laudamiel's reaction was different, though. He got it. Immediately. "What a tragedy," he said. "I would be lost without scent."

And then he offered to help. I was surprised—but I felt moved by his generosity, as I had with Sacks.

"Maybe I give you some tests?" Laudamiel said. "And, voilà, maybe we can help you to smell, to train?" I was doubtful that it would work, but he seemed convinced.

"Yes, please."

On a bright April afternoon, I found myself sitting in Laudamiel's office on the eighth floor of the International Flavor and Fragrance building, which overlooks the Hudson River in Midtown Manhattan. I sat across from him at his desk, on which he had balanced a box filled with glass bottles of scent. They were raw materials, the kind he used daily to create commercial fragrances.

I wasn't entirely sure what we were going to do, and I watched curiously as Laudamiel took small strips of white paper and dipped them into bottle after bottle of raw material, which had strange names, foreign names—ones like hedione, iso e super, and galaxolide. They were synthetic things, chemical things. Things that, Laudamiel explained, could be combined by the dozens, by the hundreds, to make a new fragrance, a popular fragrance, a lasting fragrance. Laudamiel handed the smelling strips to me, one at a time, and asked me to sniff.

"What do you smell?" he asked.

I *could* smell—vague, ephemeral odors, though, ones for which I had no words. Laudamiel guided: "This one smells of jasmine," he said, "and this one of musk." His face bent in a grimace when he opened a bottle of material that smelled like a pair of sweaty socks. But then he opened one of citrus and another of birch. "What do you smell?" he asked, again and again. My face began to turn red. Embarrassed, I could hardly tell. "It smells . . . sweet?" I would say, not even sure of that. It all seemed indefinable, ferociously dim. We went through twenty samples before the end of the afternoon and when I stopped sniffing, I felt deflated. I felt like I had failed.

"Now this is a start," Laudamiel said kindly. He had studied as a chemist in France and the United States before turning to perfume and was very interested in the science of smell, in the aberrations of smell, and in the ability to learn. He had even been working with the Sense of Smell Institute to create lesson plans to teach children how to smell.

When I left, Laudamiel handed me a collection of small bottles of raw materials, instructing me to smell them each day. Practice, he said, would strengthen my nose. It would train my

olfactory neurons to recognize more. I wanted to believe him. But I could hardly smell many of the scents he gave me. I wondered how smelling "nothing" could help me out.

I ARRIVED AT SACKS'S OFFICE ten minutes before our second scheduled meeting, the week after he returned from a four-month book tour. Though we had met before, I again entered nervous, uncomfortable around celebrity, unsure of myself.

Sacks sat in a rolling chair cushioned with two pillows in his office, which was a room filled with knickknacks and books, a compendium of whimsy and learning that fit well with the neurologist's public image. He wore a green sweater, pressed khaki pants, and a pair of gray sneakers. Behind me was a couch covered in pillows and a desk stacked with books on Darwin. There was another, larger desk by the door. A pegboard hung above, covered in pictures of the gray-haired scientist and friends.

Sacks was not working on anything to do with smell; I knew that. Nothing had changed. But this time, I expected it. The scents of Laudamiel's office still lingered in my nose and I had a lunch meeting scheduled with smell scientist Stuart Firestein for the next week. I had begun my exploration of scent. And Sacks, I knew, believed in the exploration. He defined it.

In the preface to *The Man Who Mistook His Wife for a Hat*, Sacks writes about the importance of turning a medical case history into a narrative: "To restore the human subject at the centre— the suffering, afflicted, fighting, human subject—we must deepen a case history to a narrative tale; only then do we have a 'who' as well as a 'what,' a real person, a patient, in relation to disease—in relation to the physical." In his work, Sacks doesn't solely exam-

ine the deficits, excesses, and distortions of the brain—he ex-
plores the meaning of the human body through its aberrations.
He writes stories, stripping the neurology down to what is most
important: identity. "The patient's essential being is very relevant
in the higher reaches of neurology, and in psychology; for here
the patient's personhood is essentially involved, and the study of
disease and of identity cannot be disjoined," Sacks writes. He calls
it the "Neurology of Identity." When I had sat across from him in
the Cornelia Street Café's basement room, twirling with anxiety
over my lack of understanding, my conflicting desires to know
and to not, I wondered where my own had gone. In the years since
the accident, I often asked myself: "Who am I without my sense
of smell?" I felt more confident just sitting in the presence of this
man who had dedicated his career to answering this question, in
many different forms, for himself and for others.

And Sacks was interested in my nose. As we spoke, he seemed
fascinated with the smells that came back to me first, and why
some were stronger than others. He spoke slowly and elegantly,
effortlessly combining science and psychology. While shy at first,
his slight awkwardness melted away to reveal a wild, almost
childlike enthusiasm. It was contagious.

"How interesting," he often said as I spoke of my returning
smell, jotting down notes on a legal pad on his desk. "Do you
have any strong childhood memories of cucumbers?" I tried to
think of one, as I didn't want to disappoint. Then we spoke about
the time that I smelled things that weren't there—skunk, per-
fume, rotting trash. Sacks asked about the month or so that I was
positive I could smell my own brain.

"What did it smell like?" he asked.

"Earthy," I said. "Like a garden, but without the flowers."

"It's interesting," said Sacks, "that the world can change, can be so different, when you no longer have the means to process it like everyone else."

I nodded. I had been reading about that, in fact. Tucked away in the library, I had begun to read about smell—the history, the psychology, the science. Every day I found myself held a little bit more in awe by the mystery, the grandeur, the complication of what we know, and what we don't. In the search for identity in smell, I had quickly realized, there is no normal. Even when healthy, I smelled the world around me differently than others did.

I smelled it differently in part because of gender. Scientists have found that women have a better sense of smell than men. Reproduction plays a role. Scientists have found that women have a heightened sense of smell during certain points of their menstrual cycle. Women are better at labeling odors than men, and they are more attuned to the kin recognition of their children. Almost everyone I'd met had heard of someone who experienced strange aversions or predilections while pregnant.

With age, too, comes a decline in the ability to smell. Threshold odor detection declines. Odor identification declines. The authors of a 2002 study published in the *Journal of the American Medical Association* noted that 24 percent of individuals between the ages of fifty-three and ninety-seven have an impaired ability to smell—62.5 percent of those over eighty. Even before the accident, my only living grandmother, my father's mother, Ruth, did not smell the world in the same way that I did.

Later, I would learn about the genetics. I met Charles Wysocki, who does work on a phenomenon called *selective anosmia,* or odor blindness, a few months later. Almost every single person is unable to detect the smell of something that others can,

he would tell me. This is due in part to gene mutation, the creation of less efficient olfactory receptors, or the natural absence of an important protein. We are simply genetically predisposed to smell the world differently. The classic example is with androstenone, a pheromone found in boar saliva, as well as both male and female human sweat. This steroid smells different to different people, described like stale urine or a sweet floral but never in between. And for others it is completely absent. A fraction of the population cannot smell androstenone at all.

Once, at a conference held in New York City about the use of smell in art and design, I listened to Rockefeller University scientist Leslie Vosshall as she stood onstage and spoke about the differences we all have in our ability to smell—genetics, perception, learning. She mentioned androstenone. She mentioned cilantro and skunk—both scents that receive wildly different reactions, perhaps genetically based. Chandler Burr, the perfume critic for the New York Times, sat in the audience. Toward the end of her talk, he raised his hand.

"So if we all smell differently," he began, and then paused. He started over: "If we all saw colors differently, then we wouldn't be able to understand art like painting, or if we heard differently, like music. Schoenberg to you would sound like Radiohead to me. Are you saying we could *all* smell completely differently? Mint to me could smell like horse manure to you?"

Vosshall nodded. "That is what we're studying. There are many examples of disagreement. Does it smell good or bad? Some of the disagreement is cultural, yes. But I think it's possible that we all smell differently."

But Sacks and I, sitting in his office that mild February afternoon, were not examples of healthy bodies experiencing the sen-

sory world with a naturally implanted diversity. We were victims of internal damage. Of bodily decay.

"I have problems with my eyes," he explained. Over a number of years his vision had rapidly decreased. Then, he told me, he barely had any depth perception at all and, unless looking at a paper or book a half foot from his face, could not focus on what was around him.

"Just this morning," he said with a laugh, "I got out of the pool, where I swim every day, and walked back toward the locker room. I looked at the wall and was surprised to see a new painting of a woman, in dark blue. It was a large painting and I wondered when they had time to hang it up without my notice. But then, as I got closer, I realized that it wasn't a painting at all. It was a real woman, sitting on a bench. The world isn't as it should be for me anymore."

Sacks's visual hallucinations, though, fascinated him. Small, often geometric shapes danced frequently before his eyes. "Sometimes squares, sometimes triangles—always moving, slightly, like daisies in a windy field," he said. "My favorites are the miniature pineapples. Or the tiny sea urchins."

"Why do you think you see pineapples and tiny sea urchins?" I asked, intrigued. *What an odd thing to see,* I thought. I wonder what that says about his subconscious. I wonder what smelling my own brain said about mine.

"I have no idea," he said. "But I'm going to get some brain scans next week. I'd like to figure myself out."

I paused for a moment. "Me too."

I stayed for a little over an hour. Before I left, Sacks reached over his desk and picked up two rocks that were perched on the shelf above. One was bright yellow, the other a deep purple.

Crystallized and bumpy, they were unlike anything I had ever seen. He held out one, the color of a canary.

"Do you know what this is?" he asked.

"No, I don't think I do."

"Smell it," he said. "We'll see if you can."

I put my nose close to the rock that he held in his outstretched palm. I took a deep breath. Inhaling and exhaling through my nose. "No," I sighed. "Nothing."

"It's sulfur," Sacks said. "It smells strongly. I put these two rocks there on the shelf when my vision first started to go. I wanted to make sure I could still tell the difference between purple and yellow."

"And can you?" I asked as we walked toward the exit. I glanced up and noticed the words "Tiny Sea Urchin" scrawled sideways in black marker on the large dry-erase board behind the door.

"Well, no. But I can tell them apart with my nose now," he said. "We're on opposite sides, you and me. It's all I've got."

pink lemonade
and
whiskey

IN WHICH IT STARTS TO COME TOGETHER

I COULD SMELL THE WAITING ROOM.

It smelled of lavender shampoo, of scrubbed tile floors, of bodies just in from the cold. There was a hint of laundry detergent, a puff of stale bread, the Clorox-clean odor to every hospital I'd known. The scent rose and fell with the movement of each patient, vibrating with a familiar Sunday-morning scent of newspaper print and a photocopier's inky heat. A rose-saturated perfume, reminding me of my grandmother. Orange peel, mint-flecked tea. A bit of sweat—sour, like the gym. These smells came together like a painter's palette, a muddle of deep dark brown smeared on canvas. I concentrated on my coffee, which steamed straight hazelnut from the Styrofoam cup in my hand.

I was sitting in the waiting room of the University of Penn-

sylvania's Taste and Smell Center, a row of small labs and offices dedicated to the evaluation of patients with chemosensory disorders. The clinic, which stands kitty-corner to the department of Otorhinology: Head and Neck Surgery on the fifth floor of the university's hospital, was founded in 1980 by Richard Doty, editor of *The Handbook of Olfaction and Gustation* and author of many books, including *The Great Pheromone Myth*. He is an enthusiastic gray-haired scientist with laugh lines and a firm handshake. Doty and a small handful of assistants operate the part-time program, where they evaluate up to ten patients a day on three or four days of every month.

I came to watch.

I had taken the train from New York City at 5:30 that morning, dozing over my computer and my notebook, which was half full of my pencil scrawl, the beginnings of my research on smell. I walked the almost mile from the station to the hospital as the sun rose, puffing white clouds of steam into the air with each breath.

This was my first trip to the clinic—the first of many. Fresh off my meeting with Sacks, I had e-mailed Doty after reading about his work. I knew, objectively, that my injury existed far beyond myself. But I wanted to put it in a broader context. I wanted doctors. I wanted patients. What was it like to treat a disease with no cure? Was I the only one haunted by my loss?

Doty had responded almost immediately. "If you wanted to come up during one of our clinic days, this might be quite insightful for you," he had e-mailed me back.

On this first day in the clinic I felt shaky. I felt unsure of myself, of even how to introduce myself to the day's patients—six of them, ranging from middle-aged to teenaged, sandy-haired

women and tired-eyed men—who trickled in around me one by one. I shrunk into my seat, one of nine in the windowless waiting room, spread around the small space like an open parenthesis. I waited for Doty to emerge from behind his thick office door.

I wasn't sure what to expect, but I knew what I wanted. I wanted to witness loss like mine, the kind that hung invisible but claustrophobic, the kind that had influenced every aspect of life. I wanted to know that the sense of smell was not about only me. I wanted to meet others who had gone through the same thing. I wanted it to be about them.

I was in the right place. Every patient in the waiting room that morning had a lost or distorted sense of smell. Just a droplet of the estimated 1 to 2 percent of American adults—approximately three million—with a disorder of this kind. I would soon learn that their olfactory problems stemmed from all sorts of sources—viral infection, allergies, head trauma, age. Some had arrived with an understanding of their etiology; others came fuddled by mystery. Though the clinic prefaces each visit with doubt—"We only evaluate; we don't treat," I heard the secretary say on the phone—these patients were all there for answers. They wanted cures.

The morning began promptly at 7:30 a.m. when Doty, wearing a white doctor's coat and a Winnie the Pooh tie, opened the door to his office and called me in. I felt the stares against my back as I entered his cluttered workspace, where I could smell a vial of vanilla extract perched on a shelf. I took a seat near his desk, which was almost blotted out under piles of papers and books. I glanced at a few titles: *Olfaction and Taste III, The Evolution of Consciousness, Who Cut the Cheese?*

Each clinic day for Doty starts with a series of interviews.

The patients enter his office one at a time. The origins of most disorders can be determined from history, Doty explained, and he takes time to talk about each patient's past. Head trauma or virus, toxins or chemotherapy, surgery or allergies. They cover it all. Then they discuss the present. Doty hears about problems that range from a simple absence to a persistent unpleasant taste in the mouth, from ghostly apparitions of scent to distortions without apparent cause. Doty lets his patients know what to expect at the clinic: a long day of tests—ones that range from the specificity of taste on the tongue to the threshold of odors in the nose, from measuring the airwaves of the nostrils to scratch-and-sniff recognition. "It's a fact-finding mission," Doty told me before we began.

We agreed I would observe his interactions with patients throughout the day, assuming each allowed my presence. I sat off to the side, pen poised, as each patient entered the office. Many came holding copies of their CT scans and MRIs, purses and papers clutched nervously on their laps. I stood and smiled as Doty introduced me and asked permission for me to sit in. I felt relief when each allowed me to listen, surprised that they didn't seem to care. Most appeared pleased to have a witness to their story. I listened as they explained losses and irregularities in faltering, hopeful tones—problems of taste and smell that had been present anywhere between months and years. For many, seeing Doty at the clinic was the first attempt to solve their olfactory problems. For others, after dismissive appointments with primary care doctors and ENTs, the visit was a desperate last try. For all, the inability to smell had sapped the texture from everyday experience.

Doty listened, flipping through reams of papers holding medical histories and answers to the patient questionnaire. I watched him engage each visitor in friendly banter while they navigated their stories of loss and confusion, moving seamlessly between topics: anosmia to ancient art, distortion to NASCAR, sinusitis to Vietnam. He showed compassion to those who were upset and joked with the uncomfortable to lighten the mood. He took everyone seriously.

One by one, I met others whose loss rivaled mine. I met a middle-aged woman with salt-and-pepper hair who had arrived in the office holding a paperback book and a banana. She couldn't smell normally and didn't know why. "Car exhaust, coffee, laundry detergent: they all smell like skunk," she said.

I met a retired teacher who constantly smelled the odor of burnt toast and an aging art historian with a gentle smile who could smell garlic but not perfume. She may have reduced olfactory abilities due simply to her years, Doty said. "As we go through life everything takes a toll. Little islands of damage accumulate unnoticed until something innocuous lets it go, like a waterfall."

I met an eighteen-year-old boy who had been in a car accident that had hurtled him face-first against the windshield from within. The force of the collision, two years before, had almost completely detached his nose. His lower jaw had been disconnected, his upper fractured in a number of places. The bones around both of his eye sockets were broken, and his sinuses? "Like dust," he said. It was only months later, when the metal plates were supporting his skull and he could walk without pain, that he realized something else was wrong. Cologne was a mono-

tone nothing. Milk tasted like water. Aside from their color, flow-
ers were bland. "Hey, what's going on?" he had asked his mother
one afternoon. "I can't smell nothin'."

I met a woman whose ex-husband, she told Doty through a
sudden onset of tears, had hit her—"on the head, so the bruises
wouldn't show"—for a decade. She couldn't smell and now, after
a divorce and years spent caring for her own ailing mother, she
was there to finally care for herself. Doty spoke with her kindly,
warmly, even offering to drive her downtown to meet her daugh-
ter after work himself. When she stepped back out into the wait-
ing room, he closed the door and looked at me with downturned
lips. "The nerves in your brain are like Silly Putty," he said. "A
really hard hit and they will snap."

In these meetings I listened to Doty voice cautious thoughts
on the cause of damage: virus or trauma, polyps or allergies or
the side effects to various drugs. He spoke of prognosis: "With
complete smell loss, we see around 11 percent recovery; with par-
tial, it's around 23 percent," he explained. He was careful not to
give too much hope.

And as I listened to the patients, who each arrived at the clinic
filled with the day-to-day reality of their loss, just as I had arrived
at a different clinic those years before, I felt a sorrow mixed with
the low thrum of guilt. My recovery, spun of youth and luck, was
far from normal. The scent of the waiting room, pale as it was, lay
warm in my nose.

Later, I wandered through the various testing rooms of the
clinic where each patient had their nostrils and tongues prod-
ded, pricked, and doused. The seven tests at this Taste and Smell
Center include swishing solutions of salty, sweet, bitter, and sour
on the tongue and a scratch-and-sniff test called the University

of Pennsylvania Smell Identification Test (UPSIT), which Doty had developed soon after opening the clinic. I watched residents pipe little droplets onto specific points of the tongue. I watched technicians conduct electromagnetic surveys of the nasal cavity, pressed together with a patient in a small dark room as the machine clicked like a cricket. I watched odor memory tests and odor threshold tests. I watched the patients with the identification test spread wide on their laps as they scratched, sniffed, and repeated.

By 4:00 p.m., when Doty began to wrap up the barrage of tests and interviews with a final one-on-one meeting with each patient, I was so tired that I could hardly keep my eyes open. Again, I sat in the corner of the office to watch. There were statistics. There were test results. Doty confirmed the loss of scent, the function of tongue, the unrelenting allergies. Though I knew when I arrived at the clinic that little could be done for those with olfactory disorders, I found myself surprised all the same when patient after patient left the room without a cure, without a follow-up appointment made. Some patients left happy to have a clinical diagnosis: the complete loss that comes with anosmia, the partial of hyposmia, the ghostly apparitions of phantosmia. They were happy to have a concrete case, to have been given a name. They tucked Doty's official letter of results and recommendation carefully into their bags. Others, I found, were frustrated. Angry, even, that there was no treatment, that they had no plan.

When the young man who had been in the car accident entered the office for the final time, Doty spoke calmly. "The tests show, like I'm sure you already realize, that you have lost all olfactory function. There is nothing left."

He nodded. I shifted in my chair.

"There's not much we can do about this," Doty continued. "To put it in perspective, about 10 percent of those with head injury regain their damaged sense of smell. But that usually begins within a year of the accident. I'm afraid you don't have much hope."

The young man looked down at his hands.

"And, you know, sometimes I baby the people who come into this office," Doty continued. "I say, there's hope, you'll be fine, there's always hope. But for you, son, I think we need to be really pragmatic. You've gone through something traumatic and emerged alive and well. Think about the big picture. At a young age you have survived something large. Think about what you can do with that. Let's put it in perspective."

Doty spoke seriously but respectfully—talking man to man, and not doctor to boy. They were both silent for a moment. I kept my pen hovering over my notebook. The room seemed to tingle, like static electricity.

"You can cry in your milk," said Doty, finally. "Or you can deal. It's a choice you'll have to make."

The boy looked up. I thought I saw a smile flit across his face. "I'll deal," he said.

RICHARD DOTY BEGAN with mice.

A PhD student in clinical psychology at Michigan State in the late 1960s, he worked with a professor who kept a colony of rodents in his lab. There were more than fifty different species of mice there—big and small, black and gray and white. Doty, who once told me half facetiously that he prefers the company

of animals to people—"for the most part"—was immediately entranced.

"I was interested in the differences of the worlds of all sorts of animals," he said one afternoon from behind a mound of papers at his desk at the University of Pennsylvania Hospital. He smiled. "I really fell in love with those mice, though."

More important, he fell in love with the way these mice experienced their environment, one that they processed in ways very different from our own. One dependent on smell.

"These animals lived in a world that we don't relate to," he said. "We don't *know* the experience of how a bat uses sonar to see the environment. We don't *know* the experience of animals that depend on smell." It was a world he wanted to understand.

Doty spent years studying the mating behavior of mice and then dogs as he moved from Michigan to California, earning his living by teaching at the University of California, Berkeley; San Francisco State University; and the University of San Francisco. In these early years, he lived in a room on a hill overlooking town, broke but happy, frying steaks and drinking beers on his deck. In 1973, however, he headed east. He began at the Monell Chemical Senses Center, where, for the first time, he began to work on the human nose, as director of the newly minted human olfactory program. Human olfaction was—and still is—a small field. In 1980, Doty and a group of colleagues opened the Taste and Smell Center at the University of Pennsylvania with funding from the National Institutes of Health. There, Doty became intimate with the dysfunction of the nose—and its possibility. He became the gatekeeper of the lost and found, director of a world based on an absence.

The convergence of medicine and smell has been studied for

hundreds of years. Nonetheless, it's a field that today still seems to be in its infancy. "Smell is the orphaned sense," Doty told me. "It's been forgotten by medicine."

In the ancient world, aroma was strongly correlated to health. Stench came with disease, especially before the rise of universal hygiene, and these rank odors—of body, of decay, of death—were often seen as the cause rather than the result and strong, pleasant scents were used to combat illness.

As a result, herbs, plants, and flowers distilled into oils as well as spices were traded internationally in part for their health benefits. Widely used despite the fact that the specifics of the medicinal properties of these fragrant materials could not be known—indeed, are still debated to this day. Pliny the Elder, a prolific Roman naturalist and author, wrote of the use of scent as curative in his book *Naturalis Historia* around a.d. 77. Thyme aids epileptics, he wrote. Pennyroyal protects against heat and cold, as well as lessens thirst. In ancient Greece, soldiers carried olive oil perfumed with myrrh into battle to help treat their wounds. The Persian physician Ibn Sīnā (also known as Avicenna, who lived from 980 to 1037) is credited with perfecting the technique to distill essential oils, while incense and herbal medication has been in unbroken use in China since thousands of years before Christ. Aromatherapy, certainly not developed solely to modulate mood, first came to wide appeal in Europe when the French chemist René-Maurice Gattefossé burned his arm, healed it with lavender oil, and then began the research to write a scientific paper published in 1928 that culled the term *aromatherapie.*

In the late 1300s, the Black Plague hit Europe and its smells filled the cities with rank odors. Puss, boils, waste, decaying flesh. Scents were used for both protection and prevention, writes

Annick Le Guérer in her book *Scent: The Mysterious and Essential Powers of Smell.* Agreeable scents were used in order to stop the contamination or spoilage of perishable food—in essence, masking the rot with the spice cabinet. Incense and herbs were the principal weapons against bodily and atmospheric pollution. While the connection between scent, bacteria, and illness would not be made for hundreds of years, society avoided foul smells in order to remain healthy. They quarantined illness, rubbed food with spice, breathed in man-made scent. It was the only way, they believed. Incense was burned and "plague waters"—strong fragrances made to be poured onto handkerchiefs, including the original *eau de cologne*—were inhaled to ward off sickness. In many cases, the poor could not afford the time or materials to ward off foul smells or clean their own bodies of odor, and scent became a mark of class, as well as health. As Constance Classen writes in *Aroma: The Cultural History of Smell,* "Put succinctly, putridity engendered putridity, with smell constituting the primary agent of contagion."

Scents and their effects remained mysterious, partly due to the simple lack of understanding of how the nose worked. For hundreds of years, the theory touted by Galen, the ancient Greek physician, held fast. Like Hippocrates before him, Galen believed that the body contained four substances, which he called humors: black bile, yellow bile, phlegm, and blood. The fluid in the nose, he believed, represented a purging of the brain, which percolated through the base of the skull out the nose. Galen likewise believed that odor molecules entered straight into the brain through pores in the bone at the top of the nose, to be processed in the ventricles of the brain. It wasn't until the mid-1600s that it became known that glands release the mucus of the nose. It

wasn't until the 1860s that the existence of olfactory neurons was widely accepted.

But then, as now, smell was an important part of the medical profession and could be used in diagnosis. Neuroscientist V. S. Ramachandran writes in his book *Phantoms in the Brain* about a medical professor who taught him to identify disease by smell alone—"the unmistakable, sweetish nail polish breath of dia- betic ketosis; the freshly baked bread odor of typhoid fever; the stale-beer stench of scrofula; the newly plucked chicken feathers aroma of rubella; the foul smell of a lung abscess; and the am- monialike Windex odor of a patient in liver failure. (And today a pediatrician might add the grape juice smell of *Pseudomonas* infection in children and the sweaty-feet smell of isovaleric aci- demia.)"

According to Doty, the first description of anosmia was by the Greek philosopher Theophrastus in the third century b.c., who said that it is "silly to assert that those who have the keenest sense of smell inhale most . . . it often happens that man has suffered injury [to the organ] and has no sensation at all." Galen himself supposed that the loss of smell could be for one of three reasons: too much mucus in the nose, blockage of the bone to the brain, or disease of the ventricles.

It wasn't until the late nineteenth century that disorders of smell were tackled in earnest. One of the first doctors to concen- trate on the lack of smell was William Ogle. In 1870, he published a paper titled "Anosmia, or Cases Illustrating the Physiology and Pathology of the Sense of Smell," in which he detailed three case studies of patients. "This I do not merely because such cases are comparatively rare; but because I think they may perhaps throw some light on the physiology of a sense which has been less stud-

ied than any other," he wrote. But even that didn't make much headway within the scientific literature so dominated by sight, sound, and touch. In 1822, the English writer John Mason Good summed up the prevailing scientific views well: "The evil here is so small that a remedy is seldom sought."

Today, there is only a small number of taste and smell clinics in the United States. Most are run in a similar fashion to Doty's in Pennsylvania. They are there for research, for information, to learn. Treatment is not common.

That isn't for lack of trying. Some treatment options by doctors in the field have been found to help. For his patients, Doty commonly recommends taking over-the-counter drugs like alpha-lipoic acid, a compound that occurs naturally in the human body, which has been shown to aid in recovery in studies done on patients who lost their ability to smell through upper respiratory infections. Studies have been done on the potential of zinc, without viable or concrete results. Vitamin A, for a time, was thought to be a potential help—a theory since deemed unfounded. For patients with problems such as sinusitis or nasal polyps, Doty can recommend other doctors who will prescribe steroids or even conduct surgery to reduce blockage and to clear inflammation.

Others have taken a more radical approach. Robert Henkin, a doctor at a private clinic in Washington, D.C., has generated debate within the field. Believing that many dysfunctions of the nose are a result of the mucous glands in the olfactory epithelium, and not the movement of the olfactory nerves, he has published studies on the benefits of transcranial magnetic stimulation and drugs such as theophylline, a medication often used for respiratory disease, one with side effects similar to overdoses of caf-

feine. He claims theophylline can cure, though his results have not yet been replicated, and the drug is not approved by the FDA to treat anosmia. "Henkin did bring attention to the field," Doty once told me. "And he's certainly a creative man. But he's quite controversial." Mick O'Hare, an anosmic from the United Kingdom who recovered after being treated by Henkin, however, did not care. "I know my recovery could have been a coincidence, but I am ecstatic that I can once again appreciate every smell, however nasty, and every meal, however ordinary," he wrote in an article for *New Scientist* magazine in 2005.

I spoke with Henkin on the phone. He believes there is a huge problem in the way taste and smell clinics are run today. They are too focused on research, he told me, his words loud and angry. Henkin prides himself on following up with his patients. "This whole concept is missing—there is no systematic way to see patients," he said. "They see them once, and never again. They say: Your smell is gone; your nerves are done. That's it."

Doty has hope, however. He believes in the future of olfaction. It's a science that can be conquered, he says, and when it is, it will improve the study of medicine for future generations. He has found links between Parkinson's and Alzheimer's disease and smell in his research. There have been links to schizophrenia and epilepsy. Computerized "noses" have been developed to help diagnose diseases like cancer and diabetes. There are even scientists working on techniques to use a small and specialized piece of the olfactory system called ensheathing cells, which are necessary to guide the regeneration of the axons of the olfactory neuron, to help cure human patients with spinal cord injuries. "This type of work is where the future is," Doty said. "This is where we can make our mark."

In the first years after my accident my world had shrunk into the distorted sensory present, dependent on the minute and invisible, the tiny cues and individual neurons in my own brain. It never occurred to me that I was, in effect, part of something so much bigger. The scope of the nose and the systems underlying its health—and dysfunction—shocked me with their grandeur. As Lewis Thomas, the former dean of Yale Medical School and celebrated author of *The Lives of a Cell,* once said: "I should think that we might fairly gauge the future of biological science, centuries ahead, by estimating the time it will take to reach a complete, comprehensive understanding of odor. It may not seem a profound enough problem to dominate all the life sciences, but it contains, piece by piece, all the mysteries."

MILLIONS OF PEOPLE in the world have a lost, distorted, or severely muted sense of smell. It is an underreported disability, an invisible but pervasive absence. I visited the Taste and Smell Center, on and off, for two years following my first trip. The anosmics that I met there are aberrations to the rule: most people never seek treatment. Their preface is ubiquitous: I'd rather see and hear than smell.

After all, many anosmics told me, it's an easy absence around which to navigate. One does not *need* to smell the earth freshly churned by cleats at a child's Saturday morning soccer game. No one *needs* to reflect on the powdery vanilla of a birthday cake just out of the oven. But the absence of smell runs deeply over time. And if I learned one thing at the Center, it was that this could come with disastrous effects—ones that amass slowly, painstakingly, over years.

I knew that smell, central to both identity and experience, can leave a deep hole in the perception of the world when it has melted away. The absence of smell, for me, was a vicious, monotone thing. At the clinic I began to see how for others, too, it could leave depression and anxiety, disordered eating, and a lack of sexual desire. Memories are flung to the wind and familiarity, ungrounded. Something much deeper than the thick salt-fat scent of a chicken roasting in the kitchen is lost without the ability to smell. It could be a memory of childhood, a cue to hunger, a feeling of home. It's an indefinable, often un-word-able, but nevertheless integral measure of self and identity—past, present, and future.

I wondered how many people, really, were struggling just the same. I began to search for and contact anosmics outside of the clinic. I found them online—on Facebook, where groups like "Anosmics of the World, Unite!" had more than five hundred members. I found them on community listservs, like Yahoo!'s Anosmia group, where messages were sent between those with lost or distorted senses of smell from around the world every single day. I found hundreds of people. Thousands, even. It struck me that I was never alone. The majority of people like me, however, feel as if they are.

I met people who were depressed. The texture of their worlds had vanished. Thabiso Mashape, an anosmic in South Africa, missed the scent of the air, "just taking in the intoxicating freshness of life," he wrote me. Joanne Cordero, who was hit by a car as she walked home from Penn Station in New York City, felt vulnerable and isolated. "I miss the smell of my children, my dog, hugging someone and smelling the warmth of life," she told me. "Mood, memory, emotion, mate choices, we communicate

by smell without knowing it. I have burned dinners, sat next to drunks, been around fire and smoke and felt insecure. I don't go to restaurants; I don't want to pretend or waste money on food I can't taste."

Fear came into focus. Lacking access to clues for coming danger like the smell of smoke, of fire, of natural gas or exhaust, it was impossible for many to feel safe. "I lived in a place with a gas oven," Andy French, a music marketer in Los Angeles, told me on the phone. "I was worried that the place would blow up because if there were a gas leak I wouldn't be able to tell." He had his roommate check his clothes to make sure they didn't smell. "I was so paranoid sometimes I would take three showers a day. I just had no idea if I was going to be offensive.

"Everything in life has these cues, and then they are taken away," he said. "It makes everyday life more complicated."

I also met congenital anosmics, or those born without any sense of smell at all. Some of these men and women felt a loss, a lurking danger, like something important was gone. Others did not seem to care. "To me, the world is complete," wrote Katie Bouchillon, a thirty-five-year-old anosmic from Louisville, Mississippi. "Upon learning this about me, a lot of people ask me if I can taste. I can certainly taste. When you are born without a sense of smell, eating is different. I do enjoy food for the sweet, bitter, or salty, but to me, food is more complex than that . . . I love the color, the texture, the sound, and the flavor of food. I make gumbo, and homemade tomato gravy. I love to watch how the roux darkens as it cooks to just the right moment before you add the other ingredients."

I met people who learned to cope. John Pfund, an anosmic in Memphis, began to enjoy food again a year after he lost his

smell. "I can actually tell by the texture and feel whether a certain dish is delicious or awful . . . it's another sense based on texture and mouthfeel, kind of like how a blind person's hearing must be enhanced."

And I wanted more—more stories, more contact. With each conversation or e-mail exchange, another person struggling silently felt a little less alone. And so I continued to visit the clinic. There in the waiting room, where five or six or seven patients congregated for eight-hour days, I found a togetherness that existed nowhere else. As Doty once said from his office desk, "There's more therapy in the waiting room than in here."

One afternoon in the clinic, months after my first visit, my companions ranged in age and occupation—from twenty-seven to fifty-five, from a corporate lawyer to a photography agent. We sat in the waiting room, some with folders of medical records and x-rays balanced on their laps. Others answered questionnaires on clipboards. Jackets littered the still-empty seats, and the clacking of the secretary's keyboard from the other side of the room filled the air. We sat quietly, waiting for the heavy wooden door at the end of the room to open and Doty to emerge.

Across from me sat Bobby Smith, a colonel in the army who had driven to the clinic from his home near Washington, D.C. He was not in uniform, but in slacks and a sports coat, and looked grim and determined. Smith hadn't smelled a thing in over eight years. No one had been able to tell him why.

On my right slouched Matthew Smythe, a twenty-seven-year-old insurance broker from Philadelphia who had severed his olfactory neurons in the head trauma of a car accident eight months earlier. He had the day off from work and wore a green crew-neck sweater, jeans, and sneakers. He missed the scent

of his six-year-old daughter and he had trouble remembering events—Christmas wasn't Christmas without the scents of peppermint, pine, and turkey.

Robbi Robinson sat across from him. A lawyer who had been out of work for months due to a vestibular illness, she lurched forward each time she stood up from her chair, grabbing the side of the nearby file cabinet for balance. "Whoa," she would say. She had no idea why she couldn't smell and felt hobbled by the mystery.

Debbie Bondulic, who sat to my left, was a photography agent in Manhattan who had driven to the hospital early that morning. She had cropped brown hair, bright red glasses, and a thick novel balanced on her knees. She couldn't smell anything except in sudden ten-minute spurts every few days. Instead of enjoying the moments of returned smell, she felt burdened; they only reminded her of exactly what she was missing. "I wouldn't say I'm unhappy," she told me. "But without that ability to smell the baguette in that French bakery, I mean, what else is there? I've lost an important way of creating happiness in myself."

Many occupied themselves with a thick packet of scratch-and-sniff trials. The minutes passed slowly. The system to schedule tests, orchestrated by clipboards and paper surveys, left a lot of time for sitting in between. The waiting room was almost always full. I chatted a bit; I got up to watch Smythe's tongue be doused with tiny drops of solutions of salty, sweet, bitter, and sour that he had to identify by taste alone. By 11:00 a.m. everyone was restless.

"Do we get time off for lunch?" asked Robinson. "I'm hungry."

"Nope," said Colonel Smith. He smiled. "They're locking us in here until the end of time."

"Oh dear," she said. "I might have to eat the scratch-and-sniff test."

"Maybe they'll let us run out to the cafeteria," Robinson added hopefully.

"I could really go for some soup," the colonel said. He still liked soup, he told me later. There was something about the heat coupled with a chunky texture that he enjoyed.

"I'm thinking five-course 'haute hospital' for lunch," said Bondulic with an impish grin. "We're waiting here for so long. They should serve us. First course, caviar . . . second, perhaps some foie gras . . . a nice French onion soup . . ."

"Go on," the colonel said. "I like how you think. Next course?" he prodded.

"Lobster," she said after a moment's pause. "With melted butter, because I can taste that really well."

The colonel nodded in approval. "How about steak?"

"Sure. Would you rather have a main course of steak?" she asked.

"Can I have both?"

"Ah, a man with an appetite. Of course. Steak and lobster coming right up."

"You still like steak?" Smythe asked from across the room. He leaned forward, his elbows on his knees. "I used to love steak." He sighed. "Any kind of steak—flank, porter—put some herb butter on there and, damn, I'm in heaven. BBQs? Grilling? God, I loved that. Now steak is just a mealy, grainy, and flavorless texture. I can't handle it."

"For me it's red wine," said Robinson. "I used to drink a glass of red wine every night. But now all I can taste is the tannins. Acid."

"I never had a sweet tooth before," continued Smythe. "But now that one of the only things I can taste is 'sweet,' I find myself eating a lot of desserts. Bingeing, even. It's shocking to me. I can eat a whole quart of ice cream in a sitting. Something about the cold and the sweet together."

There was an echo of *me too*s in the room. A pause, and then a collective laugh.

"I guess we are all here for the same reasons," said Robinson. "Well, this can be fun," she added. "Let's talk about why we're all here. It's not often that you'll be in such a small, close group of people who are all having the same problems you are. Right?"

"Yeah," said Smythe. "I lost my smell in a car accident." He had been on his way to work one morning when he was pulled over by a cop.

"Why were you pulled over?" asked the colonel with a wink. "Don't blush! Narcotics? Stolen vehicle?"

"Well," Smythe said, "I may or may not have been accused of excessive speed." But as soon as the cop stopped behind him on the side of the road, another car hit them both. Smythe slammed his head on the front steering wheel. The cop was pretty banged up, too.

"Did you still get a ticket?" asked Robinson. She looked shocked.

"No, they let me off easy," Smythe said, laughing.

"And how about you?" Bondulic asked, tapping my knee.

I smiled. "I lost my sense of smell in a car accident, too."

"Just like me," said Smythe. I nodded.

"Well, I wasn't in a car accident. My smell just disappeared about eight years ago. I thought Doty here would fix me. But that doesn't look likely, huh," said the colonel.

"My smell is lost because of sinus problems," said Bondulic. "I fixed my deviated septum and lost my ability to taste. I could stick a cup of coffee up my nose and there would be nothing."

"Yeah," said Robinson. "My smell has been gone for a while. I'm not sure why. I just know I could taste the baked beans on the Fourth of July, but then on the fifteenth—my birthday— there was nothing."

"Nothing?"

"Nothing. It made my birthday dinner very bland."

Bondulic missed cooking. She described with wild hand gestures the dinner parties she used to throw in her apartment. But now she needed someone else around to taste as she cooked, otherwise the seasoning is all messed up, she said. "I never did cook with recipes. Maybe I should start."

They were laughing then, comparing stories about dinners with friends. "I hate when someone asks me how I enjoyed my meal," Smythe cried out. "My favorite response is I don't freaking know. How am I supposed to know? I can't taste!"

Robinson got a kick out of this. She looked giddy. The laughter was verging on raucous.

"And I don't even know when my trash is rotting!"

"Or when my dog had an accident in my living room!"

"If my toast is burnt or not!"

One of the doctors stuck her head into the room to see what all the commotion was about. When she saw the laughter, she smiled and walked away.

I MET VITO RIZZO, a slight, sixty-year-old communication and computing expert at New York University, at the clinic one morn-

ing in May. He was the first patient of Doty's day and entered the room quietly to perch in the chair next to me with his shoulder bag hunched up on his lap.

Rizzo had lost his sense of smell three months before—the effect, he could only imagine, of a vicious head cold. But unlike my loss, when my world faded to a monotone but innocuous black and white, Rizzo's had taken on a sharp hue, one that veered toward the surreal.

He hadn't lost everything. There was still *something.* Just one thing, though. And he smelled it all the time. He smelled it with his nose over a pot of his wife's famous Bolognese sauce and he smelled it when there was nothing there. "It's constant," Rizzo said. He spoke calmly but looked nervous. Doty flipped through his medical records, which, I noticed, had been typed onto the sheet rather than scrawled in ink like those of most patients.

"I didn't realize how much you smell until it's only one thing," Rizzo said.

"Is it a recognizable smell?"

"Well," he said, drawing the word out slowly. "Yes."

He seemed to be struggling for description.

"Actually, it reminded me of my mother."

I looked up from my notebook. His mother? I thought of my mother: rosemary-mint shampoo, Tiffany's *Eau de Parfum,* mushroom-rich chicken Marsala cooking on the stove.

"My mother passed away in 2004," Rizzo continued. "She died around four in the morning, in my sister's home. I went there early that morning." He paused. I wondered where this story could go. "I found her and I grabbed her. She was already decomposing and her skin was cold. It was turning green. And there was this odor."

Doty remained silent.

"That's what I am smelling now," Rizzo said. "Dead tissue. Flesh. It's the smell of death."

Phantom smells, ghostly odors with an undeniable presence but no discernible source, can be benign, like mine—the scent of my brain, that earthy, woodsy scent that I grew so attached to in the weeks after my accident. But they are often foul. Phantom smells, like the limbs of amputees still cramped and broken after removal, can be painful and strong, infiltrating every breath and distorting every mouthful of food.

Rizzo, who was born in Sicily and grew up loving the food of his childhood, could no longer be in the kitchen when his wife, Vita ("Yes," he had laughed, "Vito and Vita, I know"), cooked his favorite foods.

He wasn't alone.

Dianne Knibbs works in the culinary center of the University of Michigan. She was beset by phantoms soon after she lost her smell in 2008. Hers were not static, not like Rizzo's. Hers changed regularly over the course of the following six months. "Some of them are nauseating, some are comforting, but all of them are totally unfamiliar to anything I've ever smelled before. Sometimes they get more intense with heat (opening an oven door) and sometimes humidity (being in the shower). But they always seem to be there."

Valdene Mintzmyer, who is forty-nine years old, lost her sense of smell after a bad cold. When it began to come back, weeks later, it began with phantoms: insecticide, rotten apple, a scent that she deemed "poopy gasoline," which smelled like just that. A vegetarian, she often smelled meat when none was present, strange scents that were reminiscent of her childhood. "A few

months later, at Thanksgiving, I just couldn't go to my family dinner, because I knew everyone would be saying how wonderful the food is, and I would be tasting 'poopy gasoline.' I skipped the holidays that year."

When the olfactory system is damaged, many things can go wrong and, unfortunately, they often do. Phantoms, though most disturbing in their haunting, emotional, and almost primal auras, are only one of the many possible disruptions to the nose. Problems can begin at a surface level: a blockage in the nostrils, too much mucus in the nose. They can take place a few inches away, as in the shearing of the olfactory neurons. Or they can come much higher up, in the processing of the brain.

Take the basic path of perception. Each encountered odor molecule travels up the nostrils to be captured by the tiny receptors at the top of the nose, igniting bursts of staccato signal to be fired toward the brain. The signals come via neuron—the same neurons that regenerate, the ones that were severed in my accident—like notes on a page of sheet music. Each and every signal from each and every neuron is important to create the coherent whole. The difference between the smell of sweaty socks and Parmesan cheese, after all, is only one carbon atom of change. The signals create a pattern—of perception, the symphony read by the brain.

But in the process of regeneration, the neurons can be tangled. They can be caught. Some can retrace the path to the brain effectively while others are stopped along the way. They can be stymied by scar tissue, by bone, by internal damage to the tissue of the epithelium. When the pattern is disrupted, things can go very wrong.

The cause of phantoms hasn't been fully explored in the sci-

entific literature. It's possible that they are caused by neurons misfiring to the brain. It's possible the brain is retrieving signals never sent. These apparitions of aroma are often compared to the phantom limbs of amputees, who can feel the arm or leg they no longer possess, clearly and strongly, often held at painful angles with no option for relief. A lot of time and energy has been spent understanding these ghostly appendages, now commonly believed to be caused by a cross-wiring—a reorganization—in the somatosensory cortex, a section of the brain responsible for movement and motor information.

Phantom smells, however, are only one way in which perception can go wrong. If only some of the neurons make their way back to the olfactory bulb, the first stop in the brain, in the process of regeneration, the signals sent to the higher regions of processing can be muddled. The resulting scent is often strange and unpleasant. Shocking, even. These are distortions, the internal warping of once familiar smells.

Linda Woodard, a former anosmic, for example, lost her sense of smell in the early 1990s after a respiratory illness. She was thrilled when odors began to return. She was one of the lucky ones able to experience regeneration. The first scent to come back was garlic. But garlic, she soon realized, came frequently. Too frequently. Woodard smelled garlic in place of almost everything. Her entire environment was distorted to garlic's thick scent. "The worst was a summer-fresh ripe peach," she said. "When it approached my mouth, and all I could sense was garlic, I couldn't eat."

What can be done? For the phantom limbs of amputation, V. S. Ramachandran, an expert on the plasticity of the human brain, discovered through experimentation that by using a mir-

ror placed in strategic points, an amputee can trick his or her brain into relieving the pain of the physical apparition. "The brain should be thought of not as a hierarchy of organised autonomous modules, each of which delivers its output to the next level, but as a set of complex interacting networks that are in a state of dynamic equilibrium with the brain's environment," he wrote in a 2005 paper titled "Plasticity and Functional Recovery in Neurology." But for smells this cannot yet be done.

Donald Leopold at the University of Nebraska Medical Center once performed a procedure that offered one solution. A drastic solution. In this procedure, he physically went in to remove the olfactory nerves and olfactory mucosa and, as a result, effectively wiped out the entire sense of smell. Leopold no longer does this procedure, he told me, because "the risks outweigh the benefits." He is working on a slightly different, less risky procedure, though also suggests just waiting it out, as phantoms are known to fade with time. But for some patients, like Rikki Worthen, the possibility of the operation was more attractive than living with the pain of the surreal. Worthen, an anosmic who dreads the fact that each day the scent of her children's hair has morphed to burnt coffee, told me: "I still can't help but wonder if being totally anosmic would be better. Living in a twisted world of smells and tastes is still really hard on me emotionally. Hopefully one day I will adjust."

For most, there is little hope of a remedy.

At the end of Rizzo's day in the clinic, I sat in on the exit interview. He and Doty spoke about the test results. Rizzo could taste, but could barely smell. And the phantoms? He should wait those out, Doty said.

"But what can I do?" Rizzo asked.

Doty suggested his usual: alpha-lipoic acid; take spices out of the cupboard and practice. "It's only been four months," Doty said. "There is still light at the end of this tunnel."

"If nothing happens, though, what's the recourse?" Rizzo asked.

"If nothing happens over the next year—well, it is what it is," Doty said. "Olfaction is dynamic, but generally after a year, maybe a year and a half, it's dead." The hard syllable of his final word seemed to echo in the room. "Hopefully in the next decade we'll have a better idea of how to fix problems like yours."

EIGHT MONTHS LATER, I met Rizzo at his Manhattan office.

It was an evening in the first week of December and Rizzo had a small Christmas tree hung with New York Yankees paraphernalia sitting by his desk, blinking colored lights. On the wall I could see the framed certificate announcing his retirement as a master sergeant from the army and a small postcard of Palermo, Sicily, where his family is from, taped to the cabinet by his head. Pictures of his daughters, both in high school, were displayed on his desk. "They're good kids," Rizzo told me, proudly. "I want to do well by them."

"How is your smell?" I asked gingerly, afraid that it was unchanged. I had almost skipped washing my hair that morning, worried that my shampoo would smell to him like rotting flesh. But I asked, holding my breath, hoping for good news.

He gave me a small smile. "There have been improvements," he said. "That foul smell?" I nodded. "That's gone."

The death phantom had floated away. But that didn't mean Rizzo was free. His sensory world remained distorted, surreal.

He was still haunted by a foul odor. Not the same odor. This one was "indescribable, unpleasant," Rizzo said. But rather than hover perpetually, irrespective of the environment, this smell replaced many aromas that were once familiar: the barbecue he grilled at his vacation home on the Jersey Shore, the smoke from the vendors selling kabobs on the streets outside his office. "Dog poop and hot dogs smell the same," he said with a sigh. "It's very disturbing." Rizzo couldn't bear the scent of popcorn or cologne—"I was on the elevator with someone who must have been wearing perfume," he said, "and I felt nauseous." He even stopped smoking pipes, which he once did every night.

And lurking behind the distortions, behind the phantoms, the absence remained. Rizzo regularly drove past refineries near his home in New Jersey, the ones that had smelled so strongly of his time in the army when he was deployed to Saudi Arabia. Now he detected nothing. He brought his face down inches from the water near his home on Cape May, trying to breathe in the ocean to no effect.

In the aftermath of his visit to the clinic, Rizzo had followed Doty's advice. He was taking 200 grams of alpha-lipoic acid, twice a day. He was practicing with bottles of spice from his cupboard. "But I don't know if that's doing anything," he said.

Later, Rizzo and I ate dinner at an Italian restaurant around the block. It was a nice restaurant, with waiters in white-collared shirts and black aprons who spoke with Italian accents.

The combination of distorted reality and striking loss have affected Rizzo's ability to eat. He's had to leave dinner parties because the scent of the food made him feel ill. He's spent many nights making his own dinner because he couldn't bear the scent of his wife's cooking. "My family understands," he said. "But it's

hard." He still can't distinguish between vodka, amaretto, or sambuca—which, as a former bartender, leaves him depressed. He can't touch chocolate, not even the Hershey bars he once loved.

"I feel like I'm being punished," he said. "I feel like I've been cursed."

Rizzo does remember the way food once smelled. The way it tasted. He's ecstatic that the experience of eating some foods is returning to normal—like tomatoes, green pears, and pink lemonade, which he drank as an experiment at a picnic ("not the regular lemonade, though," he said with a shrug). After months, he was finally able to eat the Bolognese sauce his wife makes. "I used to swim in her sauce," he told me. "She was so happy when I could eat it again."

"But my life has changed," he said. "I've accepted that."

Over a plate of rich, earthy stuffed mushrooms ("I can taste the bread crumbs," he said, "and the olive oil, but not the mushrooms"), and a glass of white wine ("it tastes good," he said with a relieved smile, "but nothing like wine"), we spoke of his phantom. He still struggled with the memory.

"That was scary," he said. "That was really scary. The dead tissue, the dead flesh smell. Even in my hands"—he lifted his palms up to his nose, and sniffed long—"I could smell it."

His regular doctor wondered if the smell was psychological, he told me. Could it be mental trauma rather than physical? Rizzo didn't believe it, shaking his head as he spoke. But he was concerned.

"Was my mother calling me?" he had wondered. Early on a Sunday morning, overwhelmed with the putrid smell of flesh, he got out of bed and drove to the cemetery where his mother was buried. He stood at her grave, but found no answers.

He found answers nowhere, he said. He didn't find them from his ENT, who told him there was no hope for his sense of smell. He couldn't find them online, and even Doty, who sent him away with suggestions but nothing concrete, had left him feeling alone.

Rizzo was coping, he told me. He was patient, he was glad to be alive, he was grateful to be able to function. But he couldn't ignore the pain and discomfort that came with such an absence, and with such a haunting presence.

"I want there to be more attention on this," he said, forcefully. He wanted information. He wanted recognition. "This isn't something that will kill you. It's not cancer. But it changes your life. I want someone to say that this is a disease."

When we left, we paused at the entrance to the restaurant and shook hands. I thanked him and was surprised to hear him say how grateful he was to have met me. I blushed.

"You've recovered," he said. "You've really given me hope."

BUT HAD I? One evening during a three-day visit that I took to Philadelphia to observe at the clinic, I decided to take Doty's smell test, the UPSIT, myself.

Doty pioneered this scratch-and-sniff odor identification test, which is now widely used to determine the ability of patients to perceive and recognize specific familiar scents, in 1984. Each page of the test—forty of them, all different colors—contained one question. Each question consisted of a scent, hidden behind a surface removable with a scratch. Next to each square of smell were four multiple-choice options. The goal: to correctly label each scent. I opened the booklet at 9:30 p.m. in my hotel room

downtown after a long day at the clinic. I used the hard back end of my eraser-less pencil to free the odors and then, page by page, I leaned in and sniffed.

I could smell every single one. All forty of them. But when I tried to match the smells to the words that should define them, I ran into trouble. A lot of trouble.

I sniffed and looked at the multiple-choice answers. I stared at them until my eyes glazed over. I found that I could hardly recognize any of the scents. I could perceive them; I could smell them all. But the words I once knew floated away from consciousness.

Cherry or honey? Skunk or clove?

Leather hit me over the head. That one was potent, recognizable. Gasoline I could feel. *Good old trigeminal,* I thought. A few of the scents were unmistakable: watermelon, chocolate. But most were much more confusing—wintergreen? Whiskey? Musk? I guessed on many of them.

Why can't I do this? I felt unglued.

After I finished the test, I lay back on the bed. What was going on? I thought I could smell.

I arrived at the center at 7:00 a.m. the next day and handed the completed test to Doty's secretary. I watched as she graded my answers. It only took a minute.

"How did I do?"

She looked uncomfortable as she handed me the results.

Twenty-eight out of forty.

I must have had a strange expression on my face, because she immediately smiled very wide. "You can smell a little bit," she said, cheerfully.

I tried to explain. "But I could *smell* every one!"

"Talk to Dr. Doty," she said with a wave of her hand.

I handed him the test when I walked into his office a few minutes later.

He looked at me with the same expression that he used with many of his patients, one with which I had become so familiar, one filled with patience and a little bit of sorrow.

"So it's not all back," he said.

key lime
and
lavender

IN WHICH I TASTE

MATT AND I MOVED into a dim one-bedroom apartment in Manhattan's East Village in the winter of 2009. It was on the sixth floor of a walk-up, unreachable without the clump of boot on stair, out of breath as I rattled the lock and key. The apartment was a sublet and we would only live there for three months, but we were happy to take it while we searched for a permanent place of our own. Matt had just begun work as a newspaper reporter across the Hudson River in New Jersey, while I freelanced from home. Our bedroom window looked out over the concrete yard of a public school, where the joyful shouts of kids ricocheted across the street in regular twenty-minute blocks throughout the day.

Small and gloomy, what the apartment lacked in light was

compensated for in smell. Some strong, others weak, and all of them old, the odors came accompanied by the musty damp scent of the radiator, which hissed constant steam in the air. It felt strange to live in someone else's space: the drawers were filled with a stranger's perfumed clothing and the closets with leather shoes that didn't fit. There were corners of patchouli and lemon-scented cloth, different brands of dish soap and books I wouldn't read. Matt and I scoured the apartment listings online, searching for something permanent, ready to make one our own.

During that cold, steam-insulated winter, Matt left early each morning wearing a blazer and a tie and came home late at night, tired and hungry. I worked in the dim light of the kitchen while he was gone. Through the window by my side, next to the mugs of coffee that I let grow slowly cold, I could see pigeons and flurries of snow. The solitude made me uncomfortable at times, and I escaped to the crowded coffee shop down the block until it was time to come home and cook. Matt and I ate dinner at 9:00, at 10:00, or a bleary-eyed 11:00 p.m.

I roasted chicken and potatoes, moist and salty with crisp-bronzed skin. I made salmon with lentils, salads with pine nuts and Parmesan cheese. I braised short ribs in a spicy tomato sauce until the tender meat fell off the bone, served over a thick puddle of cornmeal polenta. I baked pork chops in a crust of bread crumbs, parsley, and Dijon, which we ate alongside cauliflower, thick slices that I roasted until caramel brown. Simple, hearty fare: meals that kept us warm.

On weekends Matt and I saw friends over pork dumplings in Chinatown, over dark rye beer at parties in Brooklyn. We

frequented the Polish restaurant around the corner, where we shared pierogi thick with cheese and fragrant with butter, sauerkraut ripe with vinegar and caraway seed. We went on early morning jogs alongside the frozen East River, our feet in tandem with the rhythm of run, the perfume of boats and brine. We took walks through the snowy streets, passing cafés that smelled of warmth and coffee, and alleyways that reeked of refuse. I concentrated on the sensory details of New York, which felt intimate and intense: the scent of both diesel exhaust and sweet-roasted nuts; the heat of the crowded, delayed Q train; and the echoing clank of recycled bottles picked up off the sidewalk before dawn.

And all the while I worried.

I often failed to recognize the scents of the city. Painfully aware of this after the test at the clinic in Philadelphia, I tested myself again and again, whenever I caught a scent, however slight, in my path. I challenged myself to sniff and remember, to recall and identify as I walked around my world. There was that sticky sweet at the food cart near Times Square (soft pretzels), the strong citrus of the market in Chelsea (grapefruit), and the woodsy dust at the butcher shop (cedar chips, floor). But I couldn't tell what that savory scent outside the subway station was, the sour one by home, or the cool, wet one that I smelled on an unseasonably warm morning sitting by the window as I read a book. The odors whipped past in twists and turns just out of my perceptual reach. I would ask Matt: "What *is* that?" He would tell me without second thought: *it's meat from that kabob vendor; it's trash from that Dumpster; it's the rain.*

I retreated to the kitchen. I wanted the smell of basil on my

fingertips, the scent of fry oil in my hair. I rolled my own sheets
of pasta for a lasagna that I baked with spinach and ricotta
cheese, filling the kitchen with the saucy scent of tomatoes and
garlic. I braised chicken, baked tofu, and seared cuts of lamb.
Pots of rust-red chili flavored with just a bit of dark chocolate
simmered on the stove, and I leaned over to inhale the almost-
imperceptible bittersweet of its steam. I could recognize these
smells. I could see their source. I felt comforted by their defin-
able presence.

I baked, too: banana bread, zucchini muffins, and ginger
cookies redolent with spice. I had promised an old friend that
I would make a four-tiered cake for her wedding, which was
scheduled for that summer, and I practiced with dozens of layers
that came out of my oven tender and moist, a bite of almond and
a bit of lemon on the exhale. I whipped gallons of rich vanilla
frosting in my mixer, the aroma of butter and sugar a reminder
of what had once been gone, of what I had missed in the com-
pany of that same whir at the bakery near Boston those years
before.

I moved easily in the kitchen. I felt better there than I had
in years. I once again began to trust my intuition at the stove. I
allowed myself to experiment—concentrating still on tempera-
ture, texture, and color, but taste and smell as well. There were
still mishaps. But I allowed myself small whispers of thought:
perhaps through my own trial and error, my own practice and
my own doubt, I could still cook.

In the meantime, I cocooned myself among tastes and smells
that I knew. I spent entire days looking forward to dinner, to the
moment I would begin to chop onions and garlic, bring pots of
salted water to boil on the stove. I concentrated on the details of

perception, the inhale and exhale, the nuance of herb and spice. I became obsessed with flavor. More so than I already was.

I knew the connection between smell and taste. I knew that I could taste the salt of my pasta, the sweet of my cakes. I could taste the sour to the lemon in my tea and the bitter to my coffee. I knew that only with smell was flavor born. Scent, the kind that came from the back of my throat as I chewed, the unpoetically named *retronasal olfaction,* allowed me to glean the sweet-garden flavor of tomato sauce, the almond marzipan in the layers of cake. Smell gave me the jasmine to my tea and the layer of vanilla in my latte. I had already spoken with Marcia Pelchat, a sensory psychologist at Monell, who demonstrates the basic nature of flavor with jelly beans and breath. "Most people are unaware that the nose plays a role in flavor," she had told me. "So when people have a cold they say that they can't taste anything. But if you put sugar or salt on their tongues, they can taste it. What they're missing is the olfactory component of food."

I walked to the farmers' market in Union Square every Saturday, drawn by the promise of fresh eggs and tiny new potatoes even in the harsh winter cold. I went alone, wanting to take my time, stopping at each stall to touch the bulbs of dust-crusted beets or to taste the pickled okra made locally by hand. I walked past plastic-wrapped cookies and vacuum-packed meats. I stopped to smell the hot cider, which steamed in a pot on a portable burner, and then the green tea, which reminded me of home.

On a snowy afternoon in February I stopped at one of the stalls in the market selling apples. Their tables, lined up under a small tent, were covered in boxes of fruit: greens, reds, knobbly

big yellows. The air smelled of the faint acid tang to the fruit, some of which had been sliced and laid on a tray for sampling among the crowds, and the smoke wafting up from a cigarette nearby. I began to load apples into a sheer plastic bag. I packed in a lot. For these, I had a plan.

That evening, as I had yelled to Matt when I headed out the door, I would bake an apple pie. I would use an assortment of apples, mixing colors and textures. There would be cinnamon and hints of both lemon and orange. A crust of butter and shortening would hug the pan, emerging from the oven flaky and bronze, steaming scents of fall.

On my way home, my shoulder sagging under the weight of my bounty, I took a Macintosh out of the bag and took a bite. The apple was tart and sweet and juice ran down my hand. My naked fingers soon grew numb. It smelled like orchards, like my kitchen in college during the hours I assembled my pies; it tasted like all the autumns of my childhood rolled into one.

But as I walked, I realized that I could smell something else. It was familiar yet unknown, something biting and faintly metallic. Perhaps it came from the trash can, overflowing on the sidewalk nearby. Perhaps it was the exhaust from a taxi speeding past. Like many new smells—smells that were there but not, recognizable but unknown, perpetually on the tip of my tongue—I just couldn't figure it out. *Perhaps,* I thought, *it is simply the scent of cold.*

I MET ELAINE KELLMAN-GROSINGER, the chief flavor chemist for Citromax, a small, family-run company that for generations has produced lemon oil from Argentina, in the lobby of her

Upper West Side apartment building one morning before she left for work. Grosinger had invited me to spend the day with her at her office, a formidable warehouse-like building off the highway in New Jersey.

Grosinger is a flavorist. She is an inventor and scientist, a taste maker and trendsetter, the closest to Willy Wonka I may ever meet. Chemists like Grosinger create the flavors added to a huge number of processed foods, the kind devoured daily by consumers all over the world. They duplicate flavors found in nature and make up some of their own. Flavorists work to entice the buyer, to entrance the palette, to fool the mouth. "The consumption of food flavorings may stand as one of the modern era's most profound collective acts of submission to illusion," wrote Raffi Khatchadourian in "The Taste Makers," an article published in the *New Yorker* in 2009.

On that day, Grosinger, whose official title is Director of Research and Development, stepped out of the elevator at 8:30 a.m. wearing black pants and high heels, blue eye shadow, and a bright purple coat, one that appeared to be made out of fake alligator skin. With platinum blond hair down to her shoulders, Grosinger wasn't at all what I imagined. She didn't look like a chemist to me.

"Molly?" she asked with a smile that expanded the width of her face. We shook hands.

"Call me Ellie," she said warmly. We took the stairs to the basement garage, climbed into her car, and began driving west. Destination: Carlstadt, a small town across the Hudson. After all, New Jersey, as I had read in Eric Schlosser's *Fast Food Nation,* produces two-thirds of the flavor additives in the United States.

The flavors made by chemists like Grosinger are both natural and artificial. They are added to sports drinks and yogurts, fruit rollups and frostings, some types of juice and much more. They are an integral part of diet sodas, vanilla soymilk, and my mother's favorite brand of margarine. They are added to the big-brand products, household-name products, but hardly ever developed by the companies themselves. They are created using volatile chemicals and mathematical formulas, beakers and pipettes. They come from complicated mixtures of chemical compounds, ones with foreign names like benzaldehyde, cis-3-hexenol, and linalool. They are determined by computers and machines. But first, they are determined by scent. Grosinger works on the thin line between a chef and a perfumer, a chemist and an artist. The results hang in the balance between taste and smell.

Like most in this small industry—there are fewer than five hundred flavorists in the United States—Grosinger didn't originally set out to become a flavor chemist. "I stumbled into it," she told me with her bubbly laugh as we drove through the Lincoln Tunnel toward Carlstadt. She was a science major in college and then went on to begin a PhD in genetics. That career path didn't last long, however. "It wasn't my passion," she told me. Also, with a laugh: "I hated working with fruit flies."

In 1981, Grosinger began looking for a temporary job in New York. She needed something to tide her over until she could figure out what to do next. When she interviewed at International Flavors and Fragrance, one of the largest producers of flavors and fragrances in the United States, she loved it there immediately. "Every lab smelled like something else," she said. "It was the most interesting industry." When they asked her if

she wanted to train to become a full-fledged flavor chemist, she said yes.

At IFF, Grosinger tasted and smelled hundreds of chemicals—natural and artificial, ones that reminded her of peaches and cloves, ones that were like rubbing alcohol or liquid sugar. She smelled them again and again, memorizing them, writing them down, describing them with terminology she learned by flash cards. She had to. The only way to make a flavor, which can be constructed of hundreds of disparate chemical ingredients, she told me, is to understand every individual element. It took years.

But when she finished, she entered into an exploding industry, one that now has a strong grip on the taste preferences of everyone who eats packaged food. The average American eats 31 percent more packaged foods than fresh food, and more packaged food per person than those in most other countries in the world, reported the *New York Times* in 2010.

We stepped out of the car in the parking lot behind Citromax that morning at nine.

"Do you smell that?" she asked as we walked toward the door. I did. There was a strong smell of early spring, the fresh scent of recently mowed lawn. "That's a good smell, that grass smell," she said. "We use it in the lab."

I couldn't imagine where.

The practice of adding flavor to food began thousands of years ago. Spices, the trade of which first developed in the Middle East around 2000 b.c., were used to defend against spoilage and to improve taste. They came from the bark and buds, fruit and roots, seeds and stems of both plants and trees. During the Middle Ages, spices were imported from Asia and Africa, traded

from the Middle East to Rome, and sold at steep cost. In Rome, writes Jack Turner in *Spice: The History of a Temptation,* spices were an expensive taste. The most common, and one of the only spices available to the majority of the population, was black pepper. A pound of cinnamon, however, cost the equivalent of six years of work for the common man. Thus spices—and, therefore, flavor—became a sign of luxury and power. "For most of their history spices spoke unequivocally of taste, distinction and wealth," Turner writes.

Other means of flavor came with geographical variants: lemons, which first grew in Asia, were not known to those in ancient Rome; vanilla and chocolate, which are made from plants native to the New World, didn't arrive in Europe until much later. Processed sugar was not introduced into the European diet until the seventeenth century, according to Mark M. Smith, author of *Sensing the Past: Seeing, Smelling, Tasting and Touching in History,* which was a momentous shift, "changing what people tasted and the way they tasted."

Today, bottles of spice from around the world line the kitchen pantries of most homes in the United States. But flavor chemistry, the first threads of the industry now known today, didn't begin until at least the seventeenth century, when oils, extracted or distilled from fruits and vegetables, roots and herbs and plants, began to be used. These flavors were natural flavors, made from known ingredients, and were used usually by pharmacists to mask the unpleasant aftertaste to medicines like lozenges and syrups. It wasn't until the nineteenth century and the rise of organic chemistry that the modern practice of flavor chemistry commenced. In 1832, benzaldehyde, the simplest aromatic aldehyde, which smells of almonds, was one of the first volatile molecules identified as

having a flavor. In 1874, two German scientists created vanillin, the first flavor synthesized in the lab, which they extracted from coniferous trees. Then, flavor was added to products like gelatin, soft drinks, and ice cream, which had only recently begun to be commercially produced, according to Joanne Chen in *The Taste of Sweet*. "New varieties emerged in the years that followed, and Americans embraced them as unique and sophisticated—bubble gum, cola, tutti-frutti."

The industry changed in the middle of the next century with new technology: the gas chromatograph, a machine that separates a compound into its individual flavor components, using glass or metal tubes, releasing them one by one in vapor form. Flavorists, then, were able to smell each part of a whole, one volatile component at a time. This aided in identifying specific components of otherwise impermeable flavors that once were only replicable by trial and error. After all, an important part of a flavorist's work is to duplicate the flavor of items found in nature or, today, to duplicate the flavors found in products already on the market. Before the gas chromatograph, chemists had to rely on guesswork, matching and mismatching chemicals, one at a time, never entirely sure, to reach their goal. This could be tough: a real strawberry, one that grows delicately on the vine, for example, contains more than three hundred different volatile molecules. It's impossible for the human nose to pick up on every single one. In fact, researchers have found it to be almost impossible for individuals (both trained and not) to pick out and identify more than four individual scents within a larger whole.

In the 1970s, the gas chromatograph was coupled with another machine: the mass spectrometer. This changed the process of creating flavor yet again, as the mass spectrometer could

give a specific chemical reading of each point of the flavor, printed off in graphs from a computer interface. Scientists no longer had to rely solely on their noses but could have a list of the chemical components of each flavor. It wasn't perfect—"the mass spectrometer isn't as accurate as a human nose," Grosinger told me. But it was a start. Later, this was joined by headspace technology—portable devices capable of measuring the volatile molecules in the space around an item, able to catch olfactory moments in time, like the scent of my apple pie the moment it exits the oven.

At Citromax, I followed Grosinger as she walked inside the lobby and up the stairs. We entered the flavor lab, a large rectangle of a room on the second floor. When I stepped through the sealed glass door, I was immediately hit by smell: sweet and cloying, like caramel candy. Grosinger turned back toward me and smiled.

Inside, I saw two long counters jutting into the center of the space, each stacked with shelves holding dozens of small brown bottles. The counter space held glass beakers and tiny pipettes, metal scales and plastic jars. I could see a sink, a stove, and a refrigerator standing against the wall. A few women wearing white lab coats worked around the room.

"Those are the chemicals we use to make our flavors," Grosinger explained, pointing to the bottles on the shelves. Those containers were filled with the raw materials of the flavor world—some of the more than three thousand components used in the industry. There are liquids and powders, solvents and sweeteners, and the caramel coloring needed to add to a cola. These chemicals are guarded from the light with their opaque bottles, their tightly sealed lids. It seemed strange that

flavor—a term with such broad scope, with such powerful individualities—could originate in those containers, which looked so uniform, so tame.

Around the room I could see brand-name products, too. Cardboard boxes full of them sat on the shelves. Mainly beverages, familiar ones like sodas, teas, juices, and waters—ones that came in bottles and in cans, ones that I had sipped at my desk, at the kitchen counter, over dinner at home countless times. Grosinger and her small team had been hired to invent the flavors for many of these drinks. They had been hired to duplicate the flavors of many more, ones that were already on the market, produced by other brands. Citromax only creates sweet flavors, mainly because their facilities in New Jersey are too small, Grosinger told me. "You need to have separation of your plants. You don't want your lemon flavors to taste like garlic."

But before we had even entered the building, I promised not to name any names. The flavor world operates under strict secrecy. The mystery is due, in part, to the fact that most flavors cannot be patented. Even within the individual flavor companies, formulas are kept hidden from the majority of employees. But I wondered if the secrecy was also in place in order to keep reality one more step away from public consumption. Large food and beverage companies, producing products with household names, could not want the consumer to know that their sports drinks, their granola bars, their yogurts contain flavors made from chemicals, from machines, from faraway labs. They want to preserve the mystique. "Consumers don't get that there are ghostwriters out there," Grosinger said. "They wouldn't have a clue that there are people like me sitting in a lab."

Grosinger began to introduce me to her aromatic raw mate-

rials, one at a time. She opened bottle after bottle, waving the caps under my nose so that I could smell. Aroma, she explained, is tantamount to the creation of flavors. She assembles most of the ingredients that she will use for each flavor, which can be anywhere from a few to a hundred, with her previous knowledge and her sense of smell. Only later, when all of the elements are combined, will she taste. "Sometimes you pick up more with just your nose."

But taste and smell work in different ways, combining in a unique manner, one that Grosinger needs to address with every single flavor she produces. To create a successful flavor, she needs to think about the way the product smells before it's placed in the mouth. She needs to know how it tastes on the tongue, how that couples with the smell in the back of the throat. After all, taste and smell are important together and separate, providing important feedback both individually and in combination. Different areas of the brain are activated for the perception of taste and for the perception of smell, but when perceived *together*—the scent of chocolate combined with the taste of sweet on the tongue, for example—an additional, new area lights up as well. "These findings have caused some to believe that flavor is in itself a separate sense, the sixth sense, one all its own," Johan Lundstrom, a scientist at Monell Chemical Senses Center once told me.

Likewise, it's been found that there is a difference in the way the human brain processes scent *orthonasally,* or through the nose, and *retronasally,* which is through the mouth. Inhaling through the nose over a fragrant cup of coffee or exhaling through the mouth while chewing a bite of pizza both would send the odor molecules to the same receptors at the top of the nose, but each pathway actually causes the brain to light up in a

different place, implying that there is a difference between smelling the external world and smelling the food that one ingests. Inhaling the scent of a chicken roasting in the oven for dinner is not the same as experiencing its flavor in the mouth.

I smelled Grosinger's ingredients one by one. She began with benzaldehyde, a component of bitter almond oil, an ingredient widely used. I sniffed. It smelled sweet and familiar, its name just out of reach.

"What does it remind you of?" Grosinger asked.

I looked at her blankly. Just like during the scratch-and-sniff test in Philadelphia, I couldn't think of a single word. I began to feel the familiar rise of panic. I tried to keep my breath slow. Normal.

"Cherry?" she suggested.

I inhaled again.

"Yes!"

A memory crystallized. It *did* smell of cherries, of ripe summer cherries, spitting the pit out into the palm of my hand. Of cherry sno-balls in New Orleans, of the cherry cola from the corner store I once loved to drink flat and warm.

"What else?" she asked.

Again, I froze.

"Uh . . ." I could smell *something,* that familiar something, on the edge of my consciousness. My frustration began to grow.

"Like some type of candy?" she nudged.

Only one word came to mind, like a broken record: cherry, cherry, cherry, cherry.

"Uh . . ."

"Marzipan?" she said.

Of course. There it was. It smelled of the thick almond paste,

marzipan, which I had used again and again that winter to make dense, nutty cakes that came out of the oven smelling of almonds and lemon. Benzaldehyde smelled like baking, like dessert. I smiled.

"As soon as you said it, I could smell it," I said.

"Suggestion is a powerful thing."

Next came isoamyl acetate. I sniffed.

"Sweet," I told Grosinger, and she shook her head.

"There's more," she said. For just a moment, a half-second blip, I considered throwing the bottle of chemical across the room, over the shelves, on the floor. That would give her more. But instead I sniffed, drawing blank.

"How can you so easily tell?" I asked.

"Practice. Years of practice."

Isoamyl acetate, she told me, smelled like bananas. I sniffed again over the cap. Yes, there it was. Again, it became recogniz-able with her words. Bananas. Of course.

"Also, there's a bit of cotton candy," she said.

Cotton candy? I sniffed again, picking out the tropical mash, the powdery spins of sugar. Oh, yes. Wispy threads of cotton candy melting in my mouth at a town fair one summer near my aunt's summer home in Pennsylvania.

The next bottle she cracked open was ethyl acetate, which to me smelled a bit harsh—like the edge of rubbing alcohol, like nail polish remover. "We use this to add a juicy note to flavor," Grosinger explained. Although unpleasant to smell on its own, just a tiny bit of it could be added to a formula to make a fruit fla-vor taste just a bit riper, she said. "With some chemicals, it's not about how it smells or tastes." Then she handed me a container filled with white powder. "Maltol," she said. "This can also make

something taste more ripe." It smelled like candy. Like inhaling over a cookie jar.

She decided to demonstrate and took two small plastic cups out of a drawer and placed them on the counter. She pulled a larger bottle of liquid off a shelf, one from the other side of the room. "This is a strawberry flavor," she said, one already consisting of around twenty-five raw materials, mixed together to create a flavor that imitates the fruit. She poured a half inch of the flavor, which was water-colored clear, into each cup. We each took a sip. It tasted of strawberry, the strong, slightly strained strawberry found in many types of yogurt, like the kind I often ate for breakfast with a handful of granola. To the cups, she then added a bit of maltol powder, stirred it, and handed it back. We sipped. It tasted sweeter, richer, like the strawberry had spent a few more days getting juicier, riper on the vine.

Then Grosinger took out a bottle of cis-3-hexenol and waved it under my nose. I inhaled. This one was immediately familiar, and certainly not sweet. Definitely not pleasant. I wrinkled my nose. I sniffed again. And then I began to laugh. This was the smell of fresh-cut grass I had breathed in while walking into the building from outside. Not exactly the same: this one had a harsh edge, a chemical twang. But it was recognizable nonetheless.

Cis-3-hexenol, Grosinger explained, is classified in the green family of smells. She showed me a list of categories—descriptive words used to define all of the hundreds of chemical aromas used for flavor. These, she told me, make it easier to recognize and relate. There were more than fifteen categories on her list— among them fresh, juicy, acidic, jammy, sweet, creamy, nutty, citrus, smoky, floral, caramelized. In this list, colors also make

an appearance. Brown is a category for the overripe, for the very sweet. It is cooked, like the sugared-fruit filling to my apple pie. Green, however, is fresh and grassy. It will make an apple flavor more Granny Smith than Red Delicious. It pulls the mouth back in time, transforming that strawberry from succulent to underripe.

Grosinger placed the bottles back on the shelf with a clink and walked me to the far side of the lab to the tasting booths. These booths had doors opening into a conference room on the other side of the wall but had small wooden covers that slid open toward the lab. Grosinger showed me how she could manipulate the lights within—reds and purples, bright and dim.

"We control the lights because the senses work together," she said. The booths are soundproof and smellproof. The entire building, in fact, is controlled with negative pressure, an HVAC system that keeps each room pristine with its own airflow, its own contained scent. Subjects enter the booths to blindly taste new flavors, and Grosinger and her team do not want them to be influenced.

Flavor is indelibly tied to the other senses. It's subject to suggestion. Contextual clues are key, especially the visual. In 2001, Frederic Brochet conducted a number of experiments for his doctoral dissertation ("Tasting: A Chemical Object Representation in the Field of Consciousness"), one with scandalous results. He had a group of wine experts taste a white wine and give a description, eliciting such words as "fresh, dry, honeyed, lively." When he later had the experts taste the same wine, this time dyed red with food coloring, he got a very different response. "Intense," they responded, "spicy, supple, deep." Tasting is a form of representation, Brochet wrote. "Indeed, when our

brain performs the task of 'recognizing' or 'comprehending,' it is manipulating representations. In reality, the taste of wine is a perceptual representation, because it manifests an interaction between consciousness and reality."

Grosinger herself told me that when her kids were growing up, she helped them conduct a science project: give a group of people a plastic cup of unlabeled, dark brown carbonated soda and ask them what it is. They will say Coke or Pepsi. Next, give them a cup of soda with the same exact flavor but this time without the caramel coloring, the distinctive soda-pop-brown. They will say that it is the more citrus tasting Sprite or Mountain Dew. "Without fail," Grosinger said. The visual plays a huge role in analyzing flavor.

Even sound can influence: in 2010, a study was published in the *Journal of Neuroscience* exploring the link between noise and scent perception in rats. "Smound," as Daniel Wesson and Donald Wilson, colleagues at the Nathan S. Kline Institute in New York, called it, does indeed seem to exist. They found a change in reaction to certain scents in the brains of rats if paired with an auditory tone, hinting that humans experience a melding of senses on levels we are not remotely aware of. "It's hard to find part of the brain that is purely one sense and not another sense too," Wilson told me. "We're blurring the lines between purely olfactory and purely auditory. The brain is, unfortunately, a lot more complex than we once thought."

Next, Grosinger and I paused in front of a row of glass cabinets hanging on the wall stacked with larger bottles—cabinets that they call the "flavor library," which consists of dozens of finished flavors ready, if they need them, to go. These are flavors that Grosinger has made, mixtures of dozens of chemicals from

the other side of the lab, their formulas locked in the computer system, accessible to only a select few. Each of the bottles was labeled with familiar names: mango, fruit punch, orange creamsicle, white chocolate.

She pulled out a bottle of jasmine and waved the cap under my nose. It was a familiar scent—that of tea, of flowers. Then, Grosinger pulled down a jackfruit flavor. This is one of her favorites. Grosinger first tasted the large and starchy tree-borne fruit while traveling for work in Brazil, where Citromax has another location. I inhaled over its cap. It smelled tropical, sweet.

"What is the flavor of jackfruit?" I asked.

She thought for a moment.

"It's custardy and banana-like," she said. "It's a little bit spicy and fruity, with a cinnamon note, maybe a bit of sulfur. It's very sweet." I could only marvel at her ability to put taste and smell to words.

When Grosinger travels, she tastes. The stranger, the more exotic, the better. She has eaten dragonfruit and jackfruit. Starfruit and the Brazilian superfruit cupuaçu. She's eaten pitanga, also known as the surinam cherry, and caju, the conical-shaped sulfur-smelling fruit with bright orange skin that grows on the cashew tree, the same that produces the nut. She writes down the details of everything that she has tasted so that she can recreate them later. Tropical fruits like these have inspired many flavors for her back in the lab. "Everyone is looking for the next new flavor," she told me, even if this flavor is not based on reality. "There are only so many bananas and strawberries you can do."

Fantasy flavors, Grosinger said, may carry names of real fruit or flavors, but can taste nothing like nature. Also called "white space" flavors, and common on the shelves of grocery stores,

they are flavors that do not correlate with anything that exists in reality. There is mango-acai and jackfruit-guava. Red Bull. Coca-Cola. Sprite. Fruit punch. Even strawberry-kiwi, that familiar flavor, is a fantasy. Pioneered by Snapple, it was seen as cutting-edge when first released. Even everyday, familiar flavors have an element of fantasy—the strawberry found in yogurt, or the grape of grape soda, of Kool-Aid, of Smucker's jelly. I had never really thought about how different these fruit products I ate as a child were from the real fruit. But it's true for many flavors. A peppermint-flavored hard candy does not resemble the fresh herb. A key-lime-flavored ice cream tastes little like the juice from the fruit. "Americans have been programmed to think that the candy lime flavor is real," the technician who operated Citromax's mass spectrometer and gas chromatograph told me. "If they eat a candy that tastes like real lime, 'something is off,' they'd say."

Fantasy can go even further. I interviewed Marie Wright, a chemist with International Flavors and Fragrances known for her simple and elegant flavors, a month after my first meeting with Grosinger. Wright has worked on a number of wild projects, including a collaborative one with a group of artists—among them painters, sculptors, and chefs. For this, she invented a flavor for "orgasm," which tasted like chocolate with an evocative, musky note. Completing that project, she told me, gave her confidence to go further. "Now, if someone came and said something like 'what would be the taste of electricity?' I could come up with something."

"What *would* electricity taste like?" I asked.

"I would probably put tingly things so that you would get that sensation in your mouth, so that your mouth would tingle," she

said after a moment. "I think for me something that would be electrifying would be citrus zest. And maybe a little metallic. It would have to be quite surprising, wouldn't it?"

But every flavorist has a different style, like all artists, using their materials in different ways, to different ends, and fantasy flavors can be tame or wild or anywhere in between. For Grosinger, fantasy can be a slight tweaking of a flavor based on reality—like removing a bit of the gritty taste to the acai berry. Once I asked her for an example of something fantastical she might do: pink grapefruit, she said. If she were to make a pink grapefruit flavor perhaps she would add a black pepper aspect. "Why not?" she said. "Might as well try it. Grapefruits do have that spicy note."

Toward the end of the day in the lab I sat at the small table in Grosinger's office and opened a big, thick black binder. It was creased in places, falling apart in others. The pages were brittle and old. Grosinger had handed it to me, instructing me to read. It was the book in which she had written out every single chemical—hundreds of them, in spindly ballpoint pen, one per page—years ago, when she first began work at IFF. On each chemical's page, she had listed all of the adjectives that came to mind when she first tasted them. She wrote about where she thought each one could be used. Under her entry for "eugenol methyl ether," she wrote that she smelled "subtle spice, clove-like but not as strong, sharp. Dirty, earthy note (perhaps a touch of sassafras, charcoal)." For its taste, in unsweetened water: "spicy, warm, musty clove note, but subtle and warm."

This book was her training manual. It was how she learned to smell. I flipped through the pages, one by one, entranced. I was fascinated by her attention to detail, by the techniques used

to internalize such invisible force. As I read, I thought of Laud-amiel, and the box of raw perfume materials he had given me those months before. I thought of how I had left them on the shelf above my desk, pulling them out every so often, but remaining too frustrated to give it an honest shot. I thought about what I should do next.

BACK IN NEW YORK CITY, thoughts of maltol and benzaldehyde infiltrated my mind as I stood by the stove ready to cook. In the days after my first visit to Citromax I had begun to look at everything consumed around me. I realized how much of Grosinger's work had long been part of my life. A stick of gum or packet of hot chocolate, that glass of cranberry juice, cold and refreshing after a run: natural and artificial flavorings included.

Although I respected the art of her science and the complication of the formulas for flavor, I wanted simplicity in my own kitchen. I felt best when I could combine a handful of known, good-quality ingredients to create something everyone would love. All it took was a chicken, some butter, and salt. Or perhaps a few eggs, Gruyère cheese, a dusting of herb. Chocolate, sugar, yolk. I let ingredients stand alone, like that bottle of Italian olive oil, like fresh ricotta cheese. And I felt calm in the kitchen. I loved to sit at the table with an easy, home-cooked meal and eat with Matt.

Matt could barely make grilled cheese, but he loved to eat, and he loved to eat good food. He had no interest in fancy restaurants, artisanal butter, or the techniques of boning a duck. The thought of paying $20 for a hamburger, as one can do in New York City, made him shake his head in disbelief. He grew

up in New Orleans, where his mother fried catfish for dinner and where every spring he and friends devoured tubs of spicy crawfish boiled with potatoes and corn. He spent five years as an officer in the army, eating in mess halls in Germany and Iraq, surrounded by colleagues, always with friends. Matt appreciated the communal aspect to food and could readily rejoice in flavor—even if it was a flavor I didn't understand, like that of the plump little Vienna sausages that came in a can, which I watched him eat with his fingers and then happily lick clean. I loved him for that.

The simplicity and heartiness of our meals together reminded me why I loved food in the first place. For many of the years I had been obsessed with cooking, I had pined after fancy meals, been wrapped up in the taste of truffles, my arms up to the elbows in chanterelles and pork confit at the bistro in Boston. I had followed celebrity chefs and purchased cookbooks highlighting recipes that required equipment I couldn't afford. But at our table, I toned it down. I relaxed. I concentrated on small numbers of ingredients. I chose recipes for their flavor as well as their ease, the kind that brought us together and left us uncluttered and full.

I cooked pots of beef stew and served it in bowls of buttered noodles. No cis-3-hexenol there. Just carrots, onions, and potatoes. Garlic, tomato, and a splash of red wine, a package of stew meat that I trimmed and cubed. I braised chicken and roasted pork, sautéed kale with caramelized onions, and served leaves of butter lettuce with toasted pecans and lemon vinaigrette. I cooked with ingredients that I could recognize, that I could count on my fingers. I wanted my kitchen to smell of home.

One freezing evening in February, I emerged from the subway

at dusk. I moved slowly up the steps out of the station, a paper shopping bag filled with groceries dangling from the soft crease of my elbow. I had picked up half pounds of ground pork and beef, garlic and canned tomatoes at a market uptown. I planned to cook a spicy pasta sauce with basil, oregano, and a touch of red wine. I smiled as I walked down the block heading east, a little spring to my step. Just that week Matt and I had found a bright, big apartment near where he worked, and I delighted in imagining how I would arrange the couch in the living room when we moved in the following month. I was already planning the menu for our first dinner party. There would be lamb—roasted, with a rosemary-mustard glaze—and some new potatoes boiled, served with butter and dill. A glorious apple tart. We were looking forward to spring.

As I passed Union Square I heard the familiar ping of a text message registering on my phone. It was from Matt.

"You need to call me now," it read.

Strange, I thought. I shifted my bag along my arm so that I could dial. It only rang once, and when Matt answered his voice was low in my ear.

"Something happened."

"What?" I asked, but he wouldn't answer. He sounded strange.

"Just come home."

I walked quickly across town, tendrils of fear floating behind. Had he been fired? Had our apartment fallen through? Had someone died?

Matt was sitting on the stoop to our apartment building. He wore a thin button-down shirt and no gloves. I could see him from a block away.

"What happened?" I asked as I approached, my voice a few notes higher than I meant. Matt looked at me for a moment, silent, his lips purple in the frozen February air.

"Just remember that I love you," he said.

I stood in front of him, the corner to the grocery bag suddenly digging sharply into my side.

"You're scaring me."

"My mom called . . ." he began. "She got a letter in the mail." A FedEx package had arrived at his parents' home in New Orleans that afternoon. Inside, there was a letter addressed to Matt. It was from the army.

Matt had been in his senior year at West Point when the World Trade Center, fifty miles down the Hudson, had collapsed and his expectation of a career as an officer in a time of peace crumbled. Under contract, he owed the army eight years of service after graduation. The first five of those were active duty, which he had split between Germany and Iraq and already completed when we met. For the final three, however, he was free to exit the service and live as a civilian. Unless, that is, he was needed.

The letter that Matt's mother received from the army contained orders. Matt had been recalled to duty.

It hadn't even crossed my mind that this was a possibility. After all, it had only been twenty-three days since President Obama was sworn into office. Even the man who sold us the papers at the corner store that morning had acknowledged the hope floating through the air. But in the face of an escalating conflict in Afghanistan and a continuing force present in Iraq, the army needed manpower. They needed it immediately.

"I have to report for duty in April," he explained, slowly, reading the shock on my face. Two months from now.

"And then I'll go back to Iraq. I'll go to Afghanistan. I don't know."

"For how long?"

"Four hundred days," he said.

I sat down next to him on the stoop, felt his arm squeeze tight around my shoulders, a shiver against my side. I could hear the voices of two women walking by, the deep growl of a truck as it stopped down the block. I watched as men and women bundled in winter coats, wearing hats and gloves, talking on cell phones or walking tiny dogs passed us one by one. I stared at Matt's dark blue sneakers. I wondered if he had come home from work and changed before coming outside to wait for me, or if those were the ones on his feet when he left that morning. I wondered why that mattered. I wondered if he could smell my fear. We sat in silence.

"Just remember that I love you," he said, again.

I looked at him—his brown-blond stubble, his eyes dark with disappointment. He looked younger than his twenty-nine years. Too young to face the possibility of death. Again.

"I love you too," I said.

He kissed me, warm against my numb face.

"Let's go inside."

That night, snuggled up in bed, I breathed in his smell—of sweat, of skin, of shampoo—trying to memorize it, to store it for later, when I would need it.

In the morning we called family and friends. I began to think of the myriad details that would need tending. Matt would have

to leave his job. I would need a new apartment, a smaller one, one that I could afford on my own. I didn't know how to begin, so I went to the kitchen. I would cook. That was something I could do.

I took out a sauté pan, a stick of butter, and a carton of eggs. I fried four for breakfast. They were crisp around the edges and the yolks, bright yellow. They smelled of butter, of farm, of mornings in Africa years past. We ate them with toast and coffee. I felt strangely calm.

IN THE HECTIC DAYS following Matt's news, I could suddenly smell *everything*. I didn't notice the scent of new things. It wasn't like that first aromatic burst of New York City, when the new tumbled back in with the strength of the old. It was the intensity that changed. The more I began to fear his leaving, to fear his time in uniform and under fire, the more I found I could smell . . . everything.

I could smell the chestnuts roasting on Broadway, the patchouli on a woman in the Strand. There was the stench of the subway, the body odor of the gym. Butter reeked in the fridge, but not nearly as much as the leftover wonton soup Matt ate in the next room. I could smell the steam heat and the frozen concrete, the stagnant puddles and a stranger's cologne.

I thought of Rachel Herz, and our conversation about the connection between scent and emotion. Happiness had played a role in my ability to smell. But what about anxiety? Could that, too?

I did some research and found a 2005 study that looked at the effect of personality and emotional state on olfactory percep-

tion. Pamela Dalton, the same sensory psychologist at Monell who had worked on smell and PTSD, and her colleague, Denise Chen, found that men perceived scents more intensely while in a positive or negative emotional state. She also found that women who scored high on anxiety personality tests perceived odors more fiercely, too.

I called Herz. What about me?

"Well," she said. "This is just speculation, but the depression-olfaction loop could go in the opposite direction as well." Anxiety, she explained, is a heightened emotional state in which levels of dopamine and serotonin are enhanced, invigorating the limbic system, that structure of emotion and memory that, of course, also deals in olfaction.

"Could that improve my ability to smell?"

"It makes sense," she said.

One evening a week after Matt got the letter, only a few days into my panicked search for a new apartment, I stood in a parking garage on the Upper West Side. I was on assignment for a freelance journalism gig, assigned to watch a group of high school kids build robots, and was reporting with a notebook and pen amid a crowd of teachers, students, and electrical wiring.

Inhaling and exhaling slowly against the back-lit scent of dank concrete, I caught a whiff of cologne, a hint of sweat, and the strong aroma of motor oil. Someone to my left opened the plastic lid to a cup of hot chocolate and the scent—rich, sweet—hit me from several feet away. A moment later there was the peppermint breath of an interview subject chewing gum. Someone was drinking orange juice; I could smell the pungent citrus before I saw the container in a teacher's hand. I could hardly concentrate in the face of so many scents. I was exhausted but alert,

jazzed on anxiety and caffeine and the thrill of so many smells. I was in a dark, cold parking garage, but it had been a long time since everything seemed so alive.

I MET WITH OLIVER SACKS again in the weeks before Matt was due to depart. On my way to his office in the West Village, I passed well-coiffed businessmen behind the glass wall of an upscale restaurant and hipsters tapping on their keyboards at a bakery called Soy. Schoolkids ran down the damp sidewalk to my side. I wore a short-sleeved gray dress, just long enough to cover the shimmering white scar that still crept down my left leg. I felt on edge, a little nervous, like everything around me was moving just a bit too fast.

I entered a building with a green awning on the corner and made my way up to his office, now familiar with its knickknacks and lore. We sat in rolling chairs and talked about the recent books on smell. We talked about Darwin and about Philadelphia and disgust. We talked about journals and notes and illustrations. We talked a lot about his struggle with his waning vision, and his loss of stereovision. He was, in fact, writing a book about it. We talked about how he is able to juxtapose himself as a patient and a doctor within the pages of the same book.

Toward the end of my visit, Sacks moved over to his desk and picked up the bright yellow stone, still in the same place as it had been a year earlier, when we first met there. He didn't seem to remember that I had tried to smell it before. I didn't want to smell it again. I hadn't been able to in the past, and I disliked being faced with reality on too regular a basis. But I said nothing as he held it up to my face, the crystal beads almost touching the tip of

my nose. I breathed in deeply and let the inhalation warm as it flowed through my nose.

I was surprised.

"What does it smell like?" he asked.

First it was sweet. A sugary, liquid twang clung to the back of my nose. And then there was an acrid scent, one of rotting eggs. It was an afternoon I spent with my family near my aunt's home in Hawaii, pausing on black lava rock.

"That's sulfur," I said.

And as I spoke, there was suddenly another memory, vaporous and light. This one of my family and me in another National Park. Years later, this time: Yellowstone. "It's like the geysers out west," I added.

"Yes," Sacks said, with a smile. "Like a volcano."

MATT AND I escaped to Argentina for the better part of March in order to avoid the manic schedule of New York, the thoughts of war, and the empty bags waiting to be packed.

We walked the streets of Buenos Aires, which, with its wide streets, cosmopolitan culture and pockets of French architecture, reminded us of Paris. We ate thick cuts of beef and rounds of sausage juicy from the grill. We drove hundreds of miles on gravel roads north to Salta, where we biked around vineyards, and ate wine-flavored ice cream in the sun. The tipsy midnight dinners and bumpy backcountry roads skirting the foothills of the Andes allowed us to forget, for moments, what was to come.

We returned to the States to spend a week at Matt's family's vacation home in Tennessee, where he would pack for his yearlong deployment. It was just the two of us and we had no

schedule. We spent days hiking among the Appalachian Mountains in tennis shoes and evenings watching movies on the couch. We shopped at Walmart, ate pulled pork sandwiches in empty restaurants off the highway, and tried hard to avoid the rain. I cooked a lot.

I made bowls of rice and beans, spicy with a Creole condiment from Matt's home state, Louisiana. I baked chocolate chip cookies and a pot of vanilla-scented rice pudding. One night I cooked spaghetti with a thick meat ragu, Matt's favorite dish, which he requested whenever he could. I made the sauce with a *soffrito* of onions, carrots, and celery and hunks of ground pork, veal, and beef. I added garlic, tomatoes, and white wine. I used dried thyme and a bay leaf. I let it simmer on the stove for hours with chicken stock. Later, I poured in some heavy cream. It smelled rich, like garlic and like meat. It smelled like Italy, and like Matt. We ate it all.

As the sun went down and the vaulted ceilings of the house grew shadowy and dim on our final night together as civilians, Matt packed his deep green rucksacks with uniforms and combat boots. I needed to distract myself. I wanted flour on my hands and my head in a recipe.

We had eaten empanadas almost daily while in Argentina. While there I loved the dish with origins in Spain: rich, spiced fillings nestled within crisp pockets of dough. We ate them with beef, with chicken, and with cheese. We ate them baked, piled on metal trays and plopped on the table at cafés. We ate them fried, wandering through antique markets in Buenos Aires, the whorls of my fingers left slippery with grease.

I started cooking late on that warm spring night. We had

spent the afternoon hiking and were moving slowly. Thoughts of the next morning, when I would drop Matt off amid a long beige line of barracks at an army base in South Carolina, were cold in the pit of my stomach.

In the kitchen I concentrated on the movement of my knife, the temperature of the oven, and the scent of butter. First I mixed the dough—a sticky, soft thing immediately sent to chill in the fridge. I sautéed onions and garlic. I watched the pink fade from a pan of crumbled beef. Olives and hard-boiled eggs came later when, combined, I let it all cool on the counter.

"It smells good," Matt called out from the living room where he was packing, surrounded by boxes of clothes and stacks of books.

I rolled the dough into small, flour-dusted circles. I filled them, pinched them, and brushed the sculpted mounds with egg wash. They came out of the oven crackly and brown. Later, we ate them sitting on the couch with our fingers.

I was disappointed. The empanadas tasted mild and bland. I had miscalculated the ratio of dough to filling. I hadn't used enough spice. That couch felt far from everywhere, especially Argentina. On our plates, butter replaced lard; bottles of Sam Adams for Malbec. The flavor paled in comparison to my memory of only a few weeks before. I wondered if the empanadas came out poorly because I couldn't smell the way I once was able. I wondered if my fear—for Matt traveling to Afghanistan, for me left here behind—muted the flavors, buried the taste.

I apologized for bungling Matt's last meal, my voice wobbly and hoarse. He just smiled. "Don't be ridiculous," he said, piling a second helping onto his plate.

The next day, he was gone.

*　　*　　*

I RETURNED TO NEW YORK to live in a studio apartment in Brooklyn, small but filled with light. My days were spent mainly at my desk, accompanied by the clack of fingernails on keyboard. I spent the evenings with friends, becoming a practiced third wheel. I began to take long walks, especially in the mornings when the firm grip of anxiety tightened my shoulders into hard knots, raising the tone of my interior monologue to a scream. I made myself omelets and salads. I drank solitary glasses of white wine.

I thought I knew what to expect. After all, I already knew what it was to sleep alone, to wake alone. I knew what it was to eat by myself, to cook by myself, to be in possession of only my own needs. I had done single; I had done long distance. I had missed before, longed before, felt anxiety so strong that I woke at 3:00 a.m. in chills before. "Lonely" had long been part of my vocabulary. But my definition of solitude changed when introduced to war. Especially that war, which had not touched the majority of my friends and family despite the eight years it had raged. Alone emerged painful and new.

And the intensity of my smell remained solid. Everything I ate was filled with flavor. More so than ever before.

Late that spring, I traveled to Chicago to visit my old friend Becca, who lived close by. I wanted to visit because it had been too long since we'd last seen each other. And I needed the comfort of a close friend. We had planned out our weekend reunion intricately, concentrating each day around our favorite thing, over what our friendship had first begun: food.

On that Saturday night Becca and I paused in front of Alinea,

an innovative Chicago restaurant belonging to Grant Achatz, a young chef known for his relentless push against the boundaries of flavor. Achatz, whose career I had been following for years, had kindly invited us to be his guests at his small restaurant—one that would be ranked seventh by the S. Pellegrino World's 50 Best Restaurants the following year. The dark brick building, inset with a heavy steel door, was unadorned. There was no awning or inscription, no movement, sound, or any signs of life. There was only an address: 1723, the numbers set in a cascade down the sidewall. We looked at each other and shrugged.

"I guess this is it," Becca said as she pulled open the door.

We stepped gingerly into the narrow hallway entrance of Alinea. It was long and dim, illuminated by pale red-pink light, eerie after the cloak of darkness outside. My depth perception skewed by the shadows, I was surprised when we reached the end. Becca and I stood side by side, unsure of what to do next, until *whoosh,* a pair of sliding doors opened to our left. Suddenly we had the view of a bright restaurant room.

I took in my surroundings: a staircase ahead of us, a small dining room to the left. And then the kitchen, which peeled back to our right. It was a large, open room fashioned in shining silver metal. We froze in place to watch, silently, for one charged moment. The kitchen was quiet and clean, breathtakingly so. The floor was covered in carpet and the room filled with chefs wearing simple whites, gliding seamlessly just feet away. "They look like they're meditating," Becca said as we followed the host to our table in the small dining area upstairs.

After my time in the lab at Citromax, I had wanted to come to Alinea in order to experience another layer of flavor. Grosinger and her team created flavors for the premade and the

packaged. They used a combination of taste and smell to reach flavor—an impressive combination, I knew, based on years of training. I knew that they experimented with novelty, pressing the boundaries on occasion, but only to a certain extent. In the end, their goal was simple: make it taste good.

The connection between these senses, however, could go farther. It could be concentrated and intense. It could be manipulated and maneuvered, made for shock and emotion. The connection between smell, taste, and flavor could change from science to art in the hands of a chef. Achatz, I had heard, was just such a chef.

Achatz grew up in St. Claire, Michigan, where he was surrounded by relatives who owned restaurants, where he could breathe in the scent of leaves burning on neighbors' lawns every fall. He began his career at age five, when he washed dishes at his parents' Achatz's Family Restaurant, later working his way up to cooking on the line. Achatz graduated from the Culinary Institute of America, the school I had once lusted for, in 1994. After, he worked for renowned chefs and restaurateurs—first Charlie Trotter in Chicago, and then Thomas Keller, known for his perfect execution at The French Laundry, an upscale bistro in Yountville, California, in the Napa Valley. While under Keller's tutelage, perfecting dishes like the chef's signature "Oysters and Pearls," or a sabayon of pearl tapioca topped with Malpeque oysters and Osetra caviar, Achatz visited El Bulli, the esteemed kitchen of Ferran Adrià, the father of molecular gastronomy, in a remote corner of Spain. It was there, I would learn the following day, when I had a chance to sit down with Achatz for an interview, that the chef first witnessed the power

of smell: Adrià had him pick up a whole vanilla bean in his hand and smell it before taking a bite of a sweetened potato puree. The potato, he found, tasted like vanilla, though there was none cooked within. It was the residual oil on his hand, lingering in his nose while he ate, that perfumed the dish. "It was the first time that a chef ever, that I knew of, deliberately introduced a smell solely to flavor the dish," Achatz told me. "And that was a moment for me."

At Alinea, which Achatz opened in 2005, at age thirty-one, he plays off the traditional. Here, he reinvents the familiar, reversing the role of the visual on the plate, manipulating expectation and distorting with suggestion. Within a year of serving its first meal, Alinea had earned four stars from the *Chicago Tribune* and *Chicago* magazine. Ruth Reichl of *Gourmet* magazine called it the "Best Restaurant in America."

Achatz's work had long intrigued me. My interest had increased exponentially in the years since the accident, however, as Achatz, I had read, was a master of the senses. Like all good chefs, he understood the importance of color, texture, temperature, and smell in his food. But he used aroma in new, entrancing ways. He used odor in his cooking to evoke emotion and memory, to trick and to tease, to intensify and satisfy both.

In the *Alinea* cookbook, which was published in 2008, Achatz devotes pages to the role smell plays in his food. Aroma, he writes, offers two possibilities for the chef. "The opportunity to flavor a dish by way of smell, and to add a layer of complexity to a concept by triggering an emotional response to a familiar smell." These techniques "became so important in our cooking that the idea of aroma itself became a creative avenue," he wrote.

I wasn't alone in my fascination. Achatz's use of smell has been gaining momentum and praise since before he opened Alinea. He began with lobster. As the executive chef at the Chicago restaurant Trio, a job he began at age twenty-six, he placed a small bowl within a larger one—the first holding the crustacean, simply prepared, and the second, fresh sprigs of rosemary plant. Tableside, a server would pour hot water over the herb to create a vapor, vividly scented and inhaled by the diner over each bite. In 2005, Pete Wells wrote in *Food and Wine* magazine: "Any good chef understands that smell plays a large role in taste, but Achatz is talking about something more: manipulating and exploiting the olfactory sense to deliberate effect."

When I interviewed Achatz, who looked craggy and thin under a mop of bright red hair, I asked him about his use of smell. He told me about another dish, one that he was known for at Trio using the same technique: pheasant with autumnal fragrance. For this, he used hay, ground cinnamon, orchard apples, dead leaves, and pumpkin seeds in the larger bowl. When the server poured the hot water within and the diner breathed in the resulting vapor, "it was fall in a bowl," Achatz said.

"People freaked out." He laughed. "We have people cry at the table—I mean, in a good way. It's a very emotionally charged thing. We are tapping into memories.

"We're trying to engage you on many different sensory levels: emotionally, cerebrally. We want it to be theatrical. We want it to be participatory. We want you to interact. A very important part of that is smell."

So there it was. I was at Alinea because Achatz knew the power of smell. But not only that. Achatz also knew the power

of absence. He knew what it was like to operate without a sense. After all, he had lost one, too.

In 2007, he was diagnosed with late-stage tongue cancer.

His doctors proposed a cure. Remove part of the tongue. Replace it with tissue from his arm. With this, however, Achatz's mouth would be rendered virtually useless. D. T. Max wrote about the chef in a *New Yorker* profile in 2008. He quoted Nick Kokonas, Achatz's business partner, as saying: "You're going to be the tongueless chef who's still a genius!"

And Achatz replied: "I'll just die."

In the end, he refused surgery. Instead, he sought alternative therapies that eventually brought him to enroll in a clinical trial at the University of Chicago, where he began treatment with radiation chemotherapy. He was lucky. The tumor shrank. Achatz, eventually, became cancer free. And still he cooked.

"It was incredibly important to me to remain as engaged as possible at Alinea while receiving treatment, and during that time I only missed fourteen services," he wrote in a press release after the news of his recovery rocked the food media world. "Through the use of a new and rigorous chemotherapy and radiation protocol, they were able to achieve a full remission while ensuring that the use of invasive surgery on my tongue was not needed . . . Onward."

Achatz's tongue, however, was not left unscathed. His sense of taste, like my sense of smell, had melted away, his taste buds incapable of detecting anything. Doctors told him this would last for at least a year. The tastes—salty, sweet, bitter, and sour— disappeared one by one. "Week one of radiation was fine," he told me. "Week two my mouth was starting to get sore, but it

didn't affect my taste. And then during week three, on my way
to the hospital, I opened a can of soda. It was Dr Pepper. I took
a drink, and thought, *Wow, this Coca-Cola tastes funny.*" Achatz
couldn't discern between Coke and Dr Pepper. For the chef, this
was unheard of. As he spoke, he gave a wan smile, and then a
shrug. "I looked at the can and thought, *Oh shit, here we go.*"
Achatz could do nothing but to keep moving, to stand by and
cook as flavor vanished, leaving him a world-famous chef with a
disease-free but nonworking tongue. In two weeks, his sense of
taste was gone. "It became an exercise of relying mostly on smell
and sight," he said.

Achatz relied, too, on his sous-chefs, many of whom had
worked with him for years—"for so long it's like I brainwashed
their palates to be like mine," he told me—to gauge the levels
of sweet, salty, bitter, and sour in the food. Achatz, after all,
could spoon salt onto his tongue and leave it there as it slowly
dissolved without tasting a thing. As a result, he had little inter-
est in eating. He gravitated toward things with very powerful
aromas, like milk blended with ice cream and the fragrant in-
nards of two whole vanilla beans. He would later write of the
experience in *The Atlantic* magazine: "The skin covering my
tongue and throat peeled off like sheets of wrapping paper, tak-
ing with it my taste buds. Of all of the side effects of treatment,
this is what I feared the most. If I could not taste, could I really
be a chef?"

I was there to find out. I had heard much about the pillows
of scented air, burning brush, smoke and fire and smoldering
sticks of cinnamon. I wanted to smell for myself. I wondered if
I could.

There in Alinea's dining room, which had neutral walls with

sparse modern oil paintings and thick black mahogany tables, I
felt giddy with anticipation. But nervous, too. I had never been
so nervous to eat.

"What if I can't smell everything?" I asked Becca.

"We'll find out," she said.

Over the next four hours, we were presented with a parade
of small courses that lay on plates and in bowls, hung on wires
or balanced on forks. They were placed in front of Becca and me
with ceremony, ferried away with grace by a phalanx of servers—
mainly male, mainly handsome, often sporting a striking hipster
haircut. The plates came one at a time. A bite here, a slurp there,
a constant curiosity, studying each mouthful like I would food
served to me on Mars. I felt as though I were watching a per-
formance, one that challenged all of my senses, highlighting the
connection—and the dissociation—between texture and color
and taste and smell. I wondered what Matt would think.

Some of the courses were just a nibble, like the single green
almond wrapped in a square of juniper berry gelée, which I could
taste strongly as I kept it balanced lightly in my mouth and ex-
haled gently through my nose. I could feel the salt, a touch of
acidic lime on the tip of my tongue. I closed my eyes and imag-
ined the backyard of my childhood home, where a juniper bush
laden with berries grew. I used to crush them between my fingers
to release their aroma.

Others were considerable, like the course that arrived on a
long and narrow dish, studded with dips and valleys like a min-
iature landscape, and was meant, as our server explained, "to
highlight things that go well with butter." A long line of pu-
reed popcorn ran the length of the plate, which was dotted with
corn kernels that were cooked in a way to make them crumble

in the mouth. There was a self-encapsulated butterball, which we popped with our forks and drew the length of the dish, like a stream. There were tiny, delicate mushrooms, a cheese crisp, dabs of curry, tiny tarragon leaves, and a square of mango gelée with a minuscule stick of red pepper poking out like a flag. There were purees and rings, honey and chives. I couldn't recognize half of what I was putting in my mouth. I often wasn't even sure how. But I didn't care. It felt like a visit to the Museum of Modern Art. There, I could stand in front of splotchy, monochromatic paintings for hours, flummoxed but entranced. The meal was unintelligible but beautiful, and I didn't want it to end. "This is wild," said Becca, as she puzzled over the taste of tarragon, inhaling the ether of curry.

We ate squab tarts and lemon foam, bacon brittle and creamy lilac pillows. We ate a small round of savory sorbet: half mustard, half passion fruit and laced with a thin line of nutmeg and a dot of soy. It was served on a pin and eaten in one bite. "Dissonance," I scribbled in the notebook I had balanced next to me on the seat. I had never tasted such a combination of bitter and sweet. It was at once uncomfortable and engaging. "It's like the mustard and the passion fruit are duking it out in your mouth," said Becca.

"I think the mustard won." I grimaced, unable to mediate the wild tastes.

There was "Hot Potato, Cold Potato," an Achatz classic. A small wax bowl of cold potato soup arrived at the table with a long metal pin skewering a ball of steaming Yukon gold potato topped with a slice of truffle on top. Also on the pin were a small cube of Parmesan, some chive, and a square of butter. After instructions from the server, we slid out the pin to let its holdings

slide into the soup. We downed it in one bite. The temperatures contrasted shockingly, magnificently.

But it was Achatz's use of scent that left me fighting to find words.

Toward the middle of this parade of courses, an orb of sweet potato tempura, flavored with brown sugar and bourbon, was placed in front of each of us. It came on a long stick of smoldering cinnamon and sent its smoky, spicy scent directly toward my nose. I ate it in one explosive bite. It was sweet and gooey, playful as I held it on its warm mount, reminiscent of a treat at a State Fair. Its fragrance lingered, hinting of campfires, of Christmas, of drinking mulled wine in Germany with Matt on vacation the winter before. In one bite, I had used all of my senses. "Holy shit," I said, too loud, and then looked around the dining room to see if anyone heard. When the server came to the table to pick up our used utensils, a small pile of ash remained.

For dessert—one of many, when I feared my stomach could hold no more—a server placed a small cloth pillow on the table in front of me. Becca got one, too. We looked at each other, confused. I wasn't sure what to do and moved my arms awkwardly over my lap. On top of the pillow, though, the server placed a large white plate covered in food and as I inhaled and exhaled, I understood why. The weight of the plate slowly sank the pillow, letting out its air, which, I realized, had a scent. A familiar, billowy scent. It smelled herby, like a garden in Provence. Lavender. The plate held a strange mixture of texture and temperature in bites of cotton candy, rhubarb ice cream, crisps, and meringue. There was goat's milk cheesecake and small slivers of sweet onion. I had to challenge myself to try every element of the dish. We ate over the perfumed air.

Achatz would tell me that there were days he came into work and found it incredibly rewarding to cook without the sense of taste. "Because I was always impressed," he said. "Not impressed with myself. But just generally impressed with how much you could discern by using your other senses. By touching the food, by smelling it, by looking at it, by listening to it while it's cooking. It's pretty amazing."

For one of the final courses, Achatz served a glass tube laying on a napkin in a bowl in front of both Becca and I. Inside was a layer of bubblegum tapioca, then crème de fraiche, and then a hibiscus jam.

Bubble gum? I thought of the lab at Citromax. In some ways, Achatz's work mirrored Grosinger's. He constructed complex, nuanced flavors out of dissonant parts, only able to place them side by side with success through his training, through creative thought.

"We were walking around back there a couple weeks ago," Achatz would tell me. "And we were asking ourselves, what is in bubble gum? What the hell is bubble gum? And when you say, oh it tastes like bubble gum, what is that? I mean, literally, what is bubble gum? So then we laid out a packet of bubble gum and we smelled it. And somebody would be, like, I smell strawberry. I smell vanilla." He used the deconstructed scents of bubble gum to manufacture his new whole.

Becca and I were instructed to suck the sweet bubblegum mixture out of the tube like a straw in one mouthful. When we did, the other end, which was coated in gelatin, made a loud sucking sound, a farting sound, a sound completely incongruous to the atmosphere. It was surprising and playful, a little bit obscene. *Slurrrrrrp*. Becca began to laugh, and then so did I. I

laughed so hard that tears came to my eyes. We sucked on the tubes again, another wave of laughter with its juicy sound. A group of four sat next to us, on roughly the same schedule of courses. They ate their bubblegum squeegees soon after. Becca and I watched as they lapsed into giggle fits of their own. It was close to 1:00 a.m. on a Saturday night, and it felt as though the entire city was laughing.

opoponax
and
cedarwood

IN WHICH I RETURN TO MY SENSES

IN THE BEGINNING OF MATT'S DEPLOYMENT, before he was transferred to a less-equipped military base close to the Pakistan border, we were often able to speak on the phone. In each conversation we strove for normalcy: I asked him about his day, and he about mine. I tried to stay positive, but my skin tingled when he reported the foot patrols, the Afghan children and their skin ripped by shrapnel, the flat, lifeless eyes of the old men he passed on the street. I didn't know how to tell him about the worries in my own life, the ones that paled in comparison to his. The ones about my sense of smell.

It had been four years since I smashed the windshield of that Ford with the back of my skull. I had regained the majority of my ability to detect scent, slowly and carefully, a gift of luck

alone. But could I smell everything? Was the aroma of Cyndi's apple crisp the same as it was before? Would I ever really know? These questions had fluttered constantly in the back of my mind for months. Back in Brooklyn, worried and alone, I decided to find out. I bought a plane ticket to France.

I ARRIVED IN GRASSE, a small hamlet in the southeast of France, late one morning in July. I hadn't slept on the overnight flight from New York and I struggled to keep my eyes open on the bus from the airport in Nice as we rumbled past the red- and yellow-painted homes, over the cobblestone streets that littered the route through the Côte d'Azur.

Grasse is a quiet town on a hill. Vine-decked homes and squat apartment buildings boast views of the hazy blue Mediterranean miles away. It's a flower hot spot—fields of jasmine and lavender dot its outskirts with deep purples and blues. As a result, Grasse has long been important in the history of fragrance. I had come for the perfume.

So had Grenouille, the hero-villain of Patrick Süskind's novel *Perfume.* He arrived in Grasse in the late eighteenth century in search of new techniques to create a fragrance that he thirsted for, that he had murdered for, one that he long craved: that of young virgin girls. He arrived by foot. Of that time, Süskind wrote:

> At the other end of the wide basin, perhaps two miles off, a town lay among—or better, clung to—the rising mountain. From a distance it did not make a particularly grand impression. There was no mighty cathedral towering above the houses, just a little stump of a church steeple, no commanding

fortress, no magnificent edifice of note. . . . It looked as if it had
no need to flaunt itself. It reigned above the fragrant basin at its
feet, and that seemed to suffice.

Not much had changed in the last two hundred years. Grasse
seemed small and dilapidated when I stepped off the bus into the
warm country air. I rolled my suitcase behind me through the
streets dotted with cafés and shops, most of which sold perfume
or soap and were closed on Sundays. There was hardly anyone
outside and I wondered why I had come.

But the paperwork was in my purse, and I had a map with
my destination circled in ink in hand. Like Grenouille, I had
traveled to Grasse—a town filled with perfume companies, and
therefore perfume schools—in order to learn about the tech-
niques of creating scent. Like thousands of hopeful perfumers in
the hundreds of years before me, I had come to Grasse to train
my nose. I was there to learn how to smell.

Grasse, I had been told, was the historical center of fragrance.
It was the center of development and production of commercial
fragrance for hundreds of years—"the cradle of perfume," writes
Celia Lyttelton in her book, *The Scent Trail*. It was "the Rome
of scents, the promised land of perfumes and the man who had
not earned his spurs here did not rightfully bear the title of per-
fumer," writes Süskind.

It hadn't always been that way. Grasse began with the produc-
tion of leather. In the Middle Ages, this hillside town was filled
with successful tanneries and, as a result, was redolent with the
stink of their materials. To combat this, as well as the many other
evils associated with foul smells, residents liberally perfumed
their products—especially gloves, a specialty of the region. These

scented hand-covers grew wildly fashionable. So fashionable, in fact, that in the sixteenth century the Earl of Oxford is said to have given a pair to Queen Elizabeth I.

But Catherine de Medici, Queen of France, was a true patron of Grasse. She loved these gloves and their fragrance so much that in 1553 she set up a laboratory in town to produce just scent, writes Lyttelton. "She wanted France to make perfumes to rival the then fashionable Arab perfumes, and *gantiers-parfumeurs* (gauntlet-perfumers), as they became known, and apothecaries sprang up everywhere. Local peasants strapped copper alembics (distilling apparatuses) to their donkeys and distilled wild herbs and flowers on the spot. Mountaineers in the Alps collected lavender and other wild aromatic plants and came down to sell their wares to the *gantiers-parfumeurs* of Grasse."

Soon, Grasse's fragrances became even more celebrated than the items on which they were doused. The microclimate of the elevated town located twelve miles away from the stifling heat of Cannes and Nice proved perfectly suited for the growth of such fragrant flowers as jasmine, rose, and lavender. Today, two-thirds of the natural aromas from France are produced in Grasse's factories before being shipped around the world. Some of the old perfumeries—among them Galinard, Fragonard, and Molinard—are still in operation.

I checked in at my hotel in the center of town, a tattered affair festooned with mirrors and silver-wrapped candies in jars. That night I ate mussels fragrant in garlic sauce and *frites,* steaming and salty, piled on parchment paper to catch their grease. I breathed in the evening air—fresher, cooler than New York's. I was ready to smell.

The Grasse Institute of Perfumery opened its doors in 2002,

the brainchild of Han-Paul Bodifée, the president of Prodarom, a national association for fragrance professionals. It is one of the few schools to teach the art and science of perfumery without being connected to a larger fragrance house. The institute offers a coveted nine-month course for aspiring perfumers, selecting only a dozen of the many applicants it receives each year. But the institute also holds workshops in natural materials and in cosmetics, and every summer it offers a two-week crash course in the basics of perfume, which was the reason I had come.

I found myself sitting at a table in the bright ground-floor laboratory at the institute's elegant building on a hill outside of town. It was a casual little lab, much smaller than the one I had seen at Citromax. There were shelves lined with small brown bottles of scent, and counters outfitted with scales for perfumers-in-training to measure the droplets of their craft. The room smelled strongly of something I couldn't quite place—a sweet scent, but one with depth.

I eyed the eight other students around the table warily. We were a diverse and international group. There was an aromatherapist from England, two biochemistry students from India, a soap maker from Texas, a chemist from Argentina, a cosmeticist from France, a college student from Korea, and a woman who worked in publishing in Austria. They spoke of commercial fragrance companies and famous perfumes, throwing names like *Shishedo*, *L'Air du Temps*, and *Tresor* around the room. Names that, for me, had no meaning at all.

The instructor, Laurence Fauvel, was a soft-spoken female perfumer. She sat at the head of the table wearing a lavender-hued linen shirt. English, I had been told, is the language of fragrance, and she spoke it with a lovely accent.

Our lesson plan is simple, she explained. We would smell. The first step for every perfumer-to-be is the same: memorize. We wouldn't memorize mathematical formulas or flash cards inscribed with names. We would memorize scents.

Every perfume student in every school around the world begins by memorizing the raw materials. Although there are small differences among students' abilities to pick up on and distinguish between smells upon arrival, the genetic propensity for scent memory is minimal. All perfumers learn through training. No one is born with the ability to blindly recognize the scent of benzyl acetate, a synthetic jasmine note. The only way to understand the materials is to smell and to smell and to smell.

To effectively create a fragrance, perfumers must know every raw material. He or she must know them instinctively. This means learning each scent so well that one can blindly identify the aroma of neroli, linalyl, or triplal without pausing for thought. It means smelling a raw material with hints of rose and mint, hay and wood, and a touch of citrus and knowing immediately that it is geranium. A perfumer often knows the materials so well that he or she can imagine the scent of bergamot like the way most can easily conjure and silently sing the melody to "Happy Birthday" without humming a note.

And there are a lot of raw materials: more than two thousand of them—some made from natural substances, and many created synthetically in the lab. Each one not only carries its own distinctive scent, but also a way of relating with those around it. Some burst quickly into the nose and fade just as fast, others move slowly, lasting long in a hazy cloud above the skin. Every commercial perfume contains somewhere between twenty and hundreds of these ingredients. The creation of a masterful scent,

one worn by hundreds of thousands around the world like the complex aldehyde of *Chanel No. 5* or the caramel vanilla of *Angel,* begins with raw materials. They are precisely mixed and mathematically formulated. Fragrance, like flavor, is an art form, and a science at the same time—one that begins with these bottles in the lab. Professional perfumers generally use fifteen hundred with some regularity. Of all these scents, we students in Grasse would hardly have time to reach the triple digits. But we would try.

We would begin with the naturals, which are made from fruits and flowers, leaves and roots. They come from animal glands and tree bark. They have names like opoponax, neroli, and tonka bean. They are created through means of expression, extraction, and distillation. Until the mid-1900s a technique called *enfleurage* was used, primarily in Grasse. In this, flowers or bark or leaves would be pressed into swaths of gelatinous fat—usually pork or beef—and left for days to allow the scent to seep in, later sold as was, or used to transfer its scent to an alcohol solution.

We would move on to the synthetics, or man-made scents, next. They have names like damascone, galaxolide, and heliotropin. They often imitate smells already occurring in nature, like cedryl acetate, which smells like cedarwood, or eugenol, which smells like clove, and are used in perfumes because they are more stable and less expensive. They can also create entirely new scents, ones that smell like nothing occurring in nature.

An expert can tell the difference in quality from one type of juniper to another. An expert can tell the difference between a rose from Morocco and a rose from Grasse. It takes a long time to learn to recognize and identify all of the raw materials. Some

say months; others, years. To be a master perfumer, Fauvel told me, it takes decades.

We had two weeks.

I looked over at the shelves filled with small bottles behind me. There were hundreds of them, taunting me with the their labels. I wondered if I would even be able to smell them all. What if Fauvel opened a bottle of something potent, something primal, something that everyone already knew, and I would have to sit there blank and uncomprehending?

"You have to practice," Fauvel told us.

She must have noticed my worried look. "You will have fun," she said. "It's not mathematics," she added. "It's art."

I SAY THAT I went to Grasse to train my nose. But, really, my decision had nothing to do with the olfactory receptors, with the scent molecules riding up my nostrils. It had nothing to do with my nose. After all, I could detect all sorts of aroma, both good and bad. I *could* smell.

I went to Grasse for something bigger, for a problem that rose much higher, one that I had begun to broach after the smell test at UPenn, after my continued inability to recognize the scented world around me. The problem was in my ability to interpret, to discriminate and label. I came to Grasse for my brain.

After all, the brain is plastic. It has the ability to change.

Though the concept is simple, this revelation is relatively recent. For hundreds of years scientists believed the ribbed entity in our heads to be static, to be what it was and nothing more. They believed the brain to be a machine in stasis.

A scientist named Paul Bach-y-Rita became interested in the

possible changing nature of the brain when he watched his father, at age sixty-eight, recover his ability to function after a debilitating stroke. When his father passed away, years later, an autopsy was performed and Bach-y-Rita discovered that his father's brain still had huge lesions from the stroke, ones that had never healed. The brain, he realized, had the power to reorganize itself.

He published an article in the science journal *Nature* in 1969 about the work this experience inspired. In it, he described a machine that he had invented to help people who had been blind from birth. This machine used a camera and a computer that turned the visual world into a complex system of vibrating stimulators placed on the patient's skin. With practice, these patients were able to use the tactile information and translate it into a visual understanding of their environment. In essence, they learned to "see."

"The now forgotten machine was one of the first and boldest applications of neuroplasticity—an attempt to use one sense to replace another—and it worked," wrote Norman Doidge in his book *The Brain That Changes Itself.*

The brain, as Bach-y-Rita and a growing group of scientists realized, isn't a machine. It is capable of change, wildly so. It can bypass a damaged area to make use of what is still functional, even going so far as to replace one sense with another. It can also operate on a level much more specific, one much more attainable; for example, on the level of an American child speaking French, or regularly practicing the piano. Learning can change the structure of the brain.

"The idea that the brain can change its own structure and function through thought and activity is, I believe, the most important alteration in our view of the brain since we first sketched

out its basic anatomy and the workings of its basic component, the neuron," Doidge wrote.

Though I have spoken with anosmics who are sure that they can "smell" through other senses, like Bach-y-Rita's patients could "see," I needed nothing so serious as a replacement for sight. But I knew that my inability to recognize and identify smells was not static.

Whether this inability stemmed from an injury or distortion or simply disuse, I could train myself to recover, I thought. I could train myself the way Grosinger had. The way Achatz, Laudamiel, and Fauvel had.

After all, I knew the possibilities. Olfaction is an especially plastic sense. The perception of smell in particular—from the ability to discriminate between odors, to label, to the simple likes and dislikes of specific scents—is subject to emotion and memory. It is subject to suggestibility and language. But even more so, it is subject to exposure. It is subject to learning.

Hence: Grasse.

The sense of smell is a largely learned ability, Jay Gottfried, an associate professor of neurology who specializes in olfaction at Northwestern University, told me. The typical human can detect tens of thousands of smells. But how does one discriminate and remember each one? Training, he said.

Gottfried and colleagues conducted a study at his lab at Northwestern that showed that after a test subject smelled the essence of mint for three and a half minutes, he or she had a largely increased ability to discern different odors in the same group—such as spearmint and peppermint—for up to twenty-four hours following. Gottfried qualified this heightened awareness as "expertise," and, he says, it only grew over time.

Even for those who cannot smell, training can help. Thomas Hummel, a scientist and physician at the Smell and Taste Clinic at the University of Dresden Medical School in Germany, did a study in 2009 on just this. He had two groups of anosmics—one that smelled four intense odors (the synthetic equivalents of rose, eucalyptus, lemon, and clove) twice a day for twelve weeks, and the other that did nothing. He tested each group before and after and found that those who practiced, or trained, had a decided increase in their ability to smell. The others? They remained exactly the same.

But beyond the simple exposure to smells, more has been shown to improve recognition and identification. Words, for one. It's been found that assigning labels for novel scents greatly improves the capacity to learn.

I spoke with Donald Wilson, a senior research scientist at the Nathan S. Kline Institute and also the scientist who worked on the concept of "smound," about the role the brain plays in the way we smell, in the way I smell, in the way I used to smell. He began simply. Peanut butter, he said, is a smell with thousands of molecules. When intercepted by the olfactory neurons, each of these molecules sends a signal to the brain. The brain does not interpret each of these signals as a separate element, however—it interprets them all as a whole. "If you smelled one molecule alone," Wilson said, "perhaps it would smell like pineapple. But you would never say that peanut butter smells like pineapple."

The brain then takes this collection of perceptions and, processing from the top down, puts them together. We make assumptions gleaned from the bits of molecules, the disparate pineapple notes, put together into a cohesive whole—a whole that comes from experience, learning, and training.

I asked Wilson about my inability to process and recognize the scents around me. After my accident, the majority of my olfactory neurons regrew, he said, but it was possible that they did not rewire themselves in exactly the same way. Perhaps there were gaps. It was possible that all of the smells over the years—the ocean, the bananas, the charcoal waft of the summertime grill— were no longer able to be evoked in the same way as they once were. The signals sent to the brain were just a little bit different, the familiar patterns gone. Peanut butter is no longer the same peanut butter as it was before. I would have to relearn them all.

"You can train your olfactory system," Wilson said. "It's been shown that if you give a new smell to someone, something that has never been smelled before, he or she will quickly learn to recognize and apply some label to it." Attention will increase sensitivity to smells, and time and practice will decrease the threshold at which they can be perceived. "The olfactory system is very plastic," he said. "It learns very quickly. That seems to be maintained throughout life."

In Grasse, I asked Fauvel what she thought. "Why not?" she asked, as she often did.

AT THE GRASSE INSTITUTE, we began with lavender.

Fauvel stood at the head of the table and opened the small brown bottle, nestled in her hand like a baby bird. She dipped a small bunch of white paper strips—blotters, we called them— carefully within, so that only their very ends touched the liquid. When removed, she shook them lightly and handed them around the table, one for each of us.

I held the blotter in my hand for a moment before I began, a light sweat already coating my forehead. My classmates had immediately begun to smell, their strip held under their noses parallel to the table like mustaches. They looked comfortable in the act of sniffing, every single one of them, closing their eyes and nodding to some silent voice in their heads. I could hear the breath around the room.

I lifted the blotter and inhaled.

There was an aroma, subtle and flimsy but there nonetheless. An image of tiny blue flowers flitted behind my eyes. I inhaled again deeply, exhaled long. I was unsure of how to pace myself. I tried to act normal.

Lavender oil is a natural, as were all of the scents we would tackle in the first week, Fauvel explained, this one made by the distillation of the flower and stem.

"What do you smell?" she asked, bringing her own blotter under her nose and away, one small breath at a time. She looked around the room. She wanted words to describe. She wanted any words but the one from the label: *lavender*, the only one I knew.

I waved the strip under one nostril and then the other, inhaling again.

I thought of the bright purple bars of soap in my father's home, the ones collected by my stepmother, Cyndi. I thought of the pillow that had slowly deflated at Alinea those months before, the one under a plate of deconstructed rhubarb, a scientific coda to a symphonic meal.

But I couldn't find any words to describe this smell, here and now. I had no adjectives, no adverbs, no clue. I looked around the table blankly. My tongue lay heavy in my mouth, like a foreign

creature. I began to feel panicked as my classmates called out
answers to the air.

Floral?

Herbal?

Warm?

A little spicy? A little green?

Like hay, like men's cologne, like the fields of Provence...

I sat silently, hunched down in my chair.

"Lavender has rustic, camphoraceous notes," Fauvel said,
pointing to the classification table she had handed out, a piece of
paper entitled "Basic Natural Raw Materials." There, sixty raw
scents were listed, categorized into larger aromatic families such
as spicy, floral, orange, rosy, and resin.

I read the list again and again, trying out the terms silently in
my head. Categorizations like these have been used by perfum-
ers—and flavorists—in one form or another for decades, after all.
It's that labeling that will help with recognition, memorization,
and description, providing a concrete vocabulary for those in the
business and those, like me, peeking in.

As soon as the words used to describe lavender were fed to
me, the adverbs and adjectives lodged in my head, I found that I
could smell them. I understood what Fauvel described. Context,
as I had witnessed before, changed the way I picked up on every
smell. What I didn't know: Would I ever be able to come up with
these words on my own?

After a few minutes, we smelled the blotter of lavender a sec-
ond time. I was surprised to find that it had changed. Most mate-
rials do, Fauvel explained. Some burst into the nose immediately
and leave just as fast, ones like lemon, like orange, like ginger.

Those, she said, are called top notes. Middle notes, like geranium and rose, linger but not for the long term. Base notes like sandalwood or musk stick around a while. *The music of perfume,* I thought.

Lavender is a middle note—a heart note, says natural perfumer Mandy Aftel in her book, *Essence & Alchemy.* "Floral heart notes can be combined into voluptuous chords that are sultry, sophisticated, radiant, narcotic, exotic. They bridge the distance between the deep, heavy base notes and the light, sharp top notes, rounding off the rough edges and making the perfume cohere as a whole." For Fauvel, she explained, lavender begins fresh but then changes quickly. "It gets a little bit warmer," Fauvel said. I breathed in and out, wondering what the hell that meant. She asked us to notice the herbal elements that came out, "like a touch of hay."

But, again, with her words, there it was: a lighter, brighter aura to each inhale. The power of suggestion, Grosinger had said.

We smelled sandalwood, which was warm and woody, like a strip of beige tree bark in my mind. When I first lifted the blotter to my nose, I thought there was nothing there, nothing but the faint crawl of liquid at the paper's end. But, Fauvel reminded me, sandalwood is a base note, the low rhythmic drum of a jazz standard. It can take time to register. And as I inhaled, it slowly crept up through my nose.

"Sandalwood is a linear smell," Fauvel explained. This one won't change.

"It's a well-rounded composition, which makes it rich." She smiled. "I think it's magic."

My classmates from India—the only males in the room, two

quiet cousins who wanted to move their career paths from science to scent—nodded knowingly. Sandalwood, they said, is common where they are from. For them, it's as familiar as home.

We smelled lemon oil, which is made through the cold expression of its zest. It smelled like the pale yellow hard candies I loved to suck on as a child, which came in small silver cans and left a powdery residue on my fingertips. Then there was clove bud oil, spicy and complex, whirring in the back of my throat. I loved it, reminiscent of baking with my mother at Christmas, and was surprised to hear that in this I was largely alone. In France, Fauvel explained, they use clove in the dentist's office, and the smell is irrevocably tied to drills and tooth decay.

Our whole class ate lunch that day together at a small bistro in town. I picked over my plate of silky scallops St. Jacques as I listened to my classmates' conversations in English, accents from around the world. The flavors of my food seemed muted in comparison to our morning of such intense scent. I took careful sips of a glass of rosé wine—frosted, baby pink—and could taste little but a florid hint of lavender. The scent seemed now everywhere.

Against the background clink of china and soft chatter of French, everyone around the table spoke of smell. My classmates spoke of their loves for perfume and the first bottles they ever bought. They spoke of handmade soaps and visits to fragrance factories in Provence. They spoke of advertisement campaigns for celebrity scents and the famous perfumer—or "Nose," as the masters are called in the business—who lived in the hills nearby. I smiled and nodded. I threw in a comment here and there. But I rarely wore perfume. Before the accident, smell had existed for me only on the plane of food and flavor. Even then, there, attend-

ing perfume school in the heart of the history of fragrance, I had a hard time understanding such an obsession. I mean, where was the substance? Perfume didn't nourish like a meal, it didn't bring people together around the table, not like we were right then. It was a solitary act, an invisible act. Perfume and cooking, it seemed to me, were nothing alike.

But I had to smile as I listened to the chatter. I had thought *I* was obsessed with smell. I had thought there were few people out there in the nonprofessional world as fascinated by the nose as I was. But I saw that I was wrong. My classmate from London, a trained aromatherapist with platinum blond hair and bright purple mascara, told me that she and her husband had purchased a condominium in Grasse to be close to the heartbeat of scent. "It's always been a dream," she said.

In the following days—long, bright days spent sitting around the table in the lab—we sniffed these raw materials in eight-hour spurts under the expert guidance of Fauvel. We sniffed them one at a time, slowly and carefully, our noses poised over the strips of smell. We smelled dozens a day. Hundreds with time. We smelled and then discussed, and then smelled again. I took notes on names, on categories and descriptors. I tried to drill them into my memory like the French language flash cards I had attempted, and then discarded, in the weeks before I left for Grasse. It was difficult, and mentally exhausting. Smelling with such precision and concentration seemed to access a different part of my brain—a part long dormant, one that subsumed my energy and left me lying in bed at night asleep not long after the sun went down.

We smelled rose, bergamot, and lavandin, a hybrid lavender plant that yields much more essential oil than the original and,

therefore, is more commonly used. We smelled cistus, tuberose, and myrrh. Jasmine absolute was light and floral, bursting in my nose. When Fauvel pointed out that it had a note of indol, with its musky, sexy underside, I could smell that, too. I could smell everything. I could smell it all. I wished I could pick up the phone and call Matt, who given the hour was probably asleep in Afghanistan. *I can smell!* But I wouldn't let myself rejoice. Not yet.

Recognition remained elusive. My ability to identify a smell without knowing its source was completely gone, its absence slapping me constantly against the cheek. This wasn't surprising. But it was frustrating. Especially because of the tests. The tests drove me mad.

And Fauvel tested us often. Each day, multiple times a day, she would select a small collection of bottles, their labels hidden from our eyes. She would dip the blotters in, one at a time, and hand them out. Silently, we would sniff. We would think, and then sniff again. We were supposed to identify the unknown scent. We would write down our answer and wait for everyone to finish so that we could compare.

I had a hard time.

For the first test, on the very first day, Fauvel passed out six raw materials that we had smelled earlier that morning.

I sniffed each blotter, one at a time. I could smell every one. But when it came time to write down their names, I struggled. I inhaled scents that seemed at first spicy, and then warm, or perhaps minty? Maybe with some wood? I stared at the sheets of paper with lists of categories, descriptors of scent. *How the hell do these aid in my memory?*

I inhaled and exhaled, closing my eyes, trying to let the scent waft casually up to my brain, trying not to impede my recogni-

tion with panic, but I couldn't help myself. With each inhale that I didn't recognize, with each one that could be sandalwood or jasmine or lavender, who knows, I felt a little bit more wild, a little bit more out of control.

Without the verbal cues, without the guidance and instruction, my sense of smell, so celebrated only minutes before, became slack and unwise. I felt like I was trying to walk through a maze in the pitch-black dark. I opened my eyes and began to search for clues in the faces of my classmates, in the size of the bottle in our teacher's hand. With each inhale that I couldn't identify, my panic escalated. Notch after notch, I could barely think outside the internal scream: *You'll never learn!*

When Fauvel went over the correct answers, I braced myself. Instead of cedarwood, I wrote galbanum. I mistook tuberose for rose. I thought petitgrain was jasmine, and lavender petitgrain. I had failed.

IN FRENCH, the word for "to smell" is *sentir.* Pronounced sahn-teer, it hovers on the roof of the mouth like a hum. A word with dual meaning. Also, "to feel."

It's an important overlap, Fauvel told me one late afternoon toward the end of my time at perfume school. We were sitting on the porch overlooking Grasse, drinking fragrant cups of hot green tea despite the warmth of the fading day.

"In perfume, we don't speak," she said. "But smell is a way of communication."

Fauvel began to work in fragrance at a young age. Like many perfumers whom I've met, she has strong memories of the scents of her childhood near Grasse: the garden, her mother's

perfume, the floral lotion worn by a teacher at school. Fauvel's father worked for a fragrance company, one of the gargantuan perfume companies in town, and she would often accompany him around.

In France, perfume is traditionally a family affair, a career handed down from father to son. But as a woman, Fauvel was not so encouraged. "My father explained to me the job and said maybe it is a job for a man," she said in her cautious accent. But she knew what she wanted. "I said, I don't care."

Once she began to work in the industry, Fauvel moved up the ladder like most perfumers: one tiny step at a time. She trained hard. She smelled constantly, continually. She studied the raw materials and their interactions. She memorized formulas and worked on accords, or simple combinations of raw scent notes blended together to form a coherent whole, and imitations. She watched experienced perfumers create from scratch. She learned about prices, legislation, colors, and mass-market techniques. She learned about cosmetics, shampoo, and how the alternative mediums change the chemical formulas. Just like Grosinger in the world of flavor, step by step she repeated.

But it all begins by memorizing the raw materials, Fauvel told me. This can take a long time. Perhaps it is a study that never ends.

"How long does it take to feel comfortable?" I asked.

"Maybe five years," she said. "But after ten? Then you can play."

Fauvel, who is still relatively young within the hierarchy of the industry, likes to play with rose and orris, cedarwood and sandalwood and ambroxan. She likes balance and harmony. She

is inspired by food, and by travel, by color and by music. "It's psychology, it's medicine. It's a sensibility," she said.

In this, she's not alone. Christophe Laudamiel has often been inspired by fleeting impressions to create his fragrances. He can invent a scent inspired by lines of poetry or the shade of gold in a woman's necklace. He worked for years on the scents to accompany the film *Perfume*. No matter what, he once told me, it's a personal thing. "You want to feel good and dynamic—even joyful—when you create a scent. And here it's about your own education: what makes *you* feel joyful," he said. For him it is citrus notes, which make him feel refreshed and dynamic, or fresh bergamot, the herb used in Earl Grey tea, which is bright without being too sweet or "jammy."

Other perfumers create fragrance with inspiration from things that do not have a distinct or recognizable smell. Lisa Camasi, a botanical perfumer in California, tends to work from abstract ideas: poetry about the Phoenix or the color green. Gail Adrian, an aromatherapist and perfumer in New Jersey, creates her scents after the essence of personality and auras that she detects in her individual clients. Once aware of the power of smell, she said, there is a broader depth to how you see people and the world. "It's much more intuitive sense, and with that comes much more of an emotional context," she said.

Much of the commercial side of fragrance, however, is determined by more conventional inspiration—things like money, marketing, and PR. The industry has been suffering in the last decade, crumbling in the hands of a celebrity-driven consumer and an escalating number of new fragrances to launch.

Chandler Burr, former perfume critic for the *New York Times*,

has written books on smell, including *The Perfect Scent: A Year Inside the Perfume Industry in Paris and New York,* in which he follows the creation of a perfume for the actress Sarah Jessica Parker and of one for Hermès in France. He writes about the reality of the business, the underbelly to the magic of a beautiful scent: "The closest industry to perfume—in its protestations of artistic integrity and its manic attention to profits, in its ratio of limpid niche gems to ground-out meretricious mass market product, in the sums of money it risks, in its mating of visions and dreams to the bottom line—is Hollywood."

Beneath the white noise of commercialism, perfume has long been cloaked in secrecy. This is in part because there is no protection against plagiarism in fragrance, like flavor. Copying already-known perfumes is part of the learning process. If perfumers do not keep their formulas hidden, another can easily subsume their creative work. But, I wondered, was this also to preserve the aura of art? If the public understands the chemicals, the naturals and synthetics, the mathematical formula, would they still appreciate its beauty?

Well, no, wrote Burr to me in an e-mail. "I'm an atheist, and atheists think the idea that you need the 'mystery' of God etc. in order to appreciate the beauty of the world is ridiculous," he wrote. "What's truly beautiful and awesome is reality and our search to understand it. Perfume has been coated in commercial marketing shit for a century. It's grotesque. Take the art for what it is, understand it, and it only gains in beauty."

Burr received wide criticism after being named the first (and only) perfume critic for the *Times,* implying that the public (or at least the media) viewed the art of scent as less worthy than the others. "Did that surprise you?" I asked.

"I understand that many people think that perfume, because it's a hugely commercialized art form, is not an art form. The idea was completely new to most people. But saying that perfume is not an artistic medium is like saying film, which we mostly experience as commercial product, is not an artistic medium. It's simply wrong."

In fact, an increasing number of olfactory artists have been showing their work in mainstream venues. James Auger, whose playful work "Smell+," which included a device to allow men and women to smell each other before meeting, was displayed at the Museum of Modern Art in 2008. Sissel Tolaas, a Norwegian artist based in Berlin, has worked with smell for decades, notably in an exhibition at the Massachusetts Institute of Technology called "The Fear of Smell—the Smell of Fear," which involved collecting the underarm sweat from nine men in various states of anxiety, synthesizing each in the lab, and then applying them to strips of paint on the showroom wall, where visitors could partake with a gentle touch. I spoke with Maki Ueda, an artist in Holland, whose work was included in a 2008 gallery show in Sunderland, England, called "If There Ever Was, An Exhibition of Extinct and Impossible Smells." Here, among the scents of the Hiroshima atomic blast and one to make a woman beautiful forever imagined by perfumers and artists from around the world, Ueda created the fragrance of the body odor of political suspects in East Germany, stored in jars by the Stasi in order to later track them with dogs. "Constructing a smell is like composing music," Ueda told me. Burr wrote of the show in the *New York Times Style Magazine.* "The first thing you should know about olfactory works of art—scents made by artists who work not in paint or clay but in the medium of scent—is their rare, visceral beauty,"

Burr began. And " . . . someday MoMA will recognize an entirely new category of art," he concluded, "perhaps the most viscerally, instinctively powerful art form we will ever experience."

Denis Dutton, author of *The Art Instinct,* believes that humans are not wired to think of smell as art, not in the way that we use sound or sight. Why? Because of our ability and tendency to build structures in the mind. We can remember words, sounds, and images. We structure them logically in our head, whether through the narrative of a novel or the melody to a song. But how do we create meaning in a sample of fifty smells? As I knew all too well, it was hard. There is something about smell that defies structure, as well as something about sound that invites it. He quotes philosopher Monroe Beardsley, who wrote: "This, and not the view that smell and taste are 'lower senses' compared with sight and hearing seems to explain the absence of taste-symphonies and smell-sonatas."

Well, not a complete absence.

In the late spring of 2009, I descended a ramp at the foot of the Guggenheim Museum on the Upper East Side of Manhattan and took a seat in an auditorium lit softly with green. Each chair was outfitted with a spindly metal microphone. This was not a microphone for sound, however. This one was for scent.

I had arrived for the third performance of "Green Aria: A ScentOpera," written by Stewart Matthew and composed by Nico Muhly and Valgeir Sigurdsson. This was a musical opera, but one without voice. There would be no lyrics or words. Instead, there would be smell. Laudamiel, who sat on the stage before the performance began wearing patent red leather sneakers and a metal-studded belt, had invented unique smells to represent thirty-five characters, effectively standing in for lyrics. They would be piped

through the microphone throughout the forty-minute piece, each representing a different character.

When the performance began, I leaned forward in my seat so as to best position my nose for perception. I needn't have worried. Each scent, piped one at a time into the room, came in time to the music. Each scent played a role in a rather unintelligible aria about the rise of technology, as the prologue had informed the audience with words cast against a screen. The music was at times beautiful, and I fell into the low, melodic notes that came with the deep salty scent of "Water." I closed my eyes and willed my mind to focus only on smell and sound, awash with some sort of invisible color.

There were green notes to some smells, reminiscent of grass— ripe and clean. The "Fresh Air" character felt remarkably light while the "Funky Green Imposter," which always arrived alongside a playful little jazz riff, was sweet and sticky, like bitter moss. There was "Base Metal" and "Shiny Steel," "Wind" and "Earth" and "Fire." As I smelled I saw images: colors of blue, of dark green and brown. I saw trees and clouds. Something, at one point, reminded me of my father. Later, I saw a mustache in the air.

At the end of the show, the audience clapped. A bit halfheartedly, I thought. I looked around. No one seemed to know how to react.

Afterward, I walked down Fifth Avenue toward the subway and home. I took my time, looking at the large windows of upscale apartment buildings overlooking Central Park, window-shopping boutiques. I inhaled the damp-plastic scent of the vegetable stand that I passed on my way, and then the exhaust from a truck at a red light. I walked by a man smoking a cigar on a corner, and I could smell an aluminum edge to the aroma,

which reminded me of the opera's heady Metal character. As I continued to walk, I sought out the operatic elements to the scents surrounding me. They were everywhere, I realized—the Wind note to the subway tunnel, the Earth of Central Park.

AFTER THE FIFTH DAY of school at the Grasse Institute, I felt saturated in scent. My nose screamed in protest. I wanted to quit.

Every day that first week had been filled with raw materials. We had smelled. And then we smelled some more. One blotter after another, one potent scent at a time. We smelled, and we tested, and then we smelled again. We smelled until my brain ached and I thought my forehead would melt down to my chin. We smelled until smelling became abstract.

By 6:00 p.m. I couldn't distinguish the difference between cedryl acetate, the synthetic equivalent of cedarwood, and aldehyde C 16, which smelled of a powdery pink strawberry. I felt like I was floating. When I arrived at my room that evening, I collapsed onto my bed. But then I heard the soft ping of an incoming call on Skype, the Internet-based video system that occasionally allowed me to speak with Matt, who had been stationed in Gardez, a small mountain town on the Pakistan border. For the moment his base held a relatively sound Internet connection and Skype allowed me to see him in his desert-stained uniform, dim in the fluorescent light of his office, his rifle perched on a shelf behind.

It had taken almost a week before I told anyone in Grasse that I had a boyfriend at war. The language barrier between my classmates and I was sometimes steep, and we avoided talk of war

or politics, newspapers or books, family or friends. We stuck to smell.

But just that afternoon, in fact, I stood with the aromatherapist during our break for lunch while she told me about her work. She spoke of clients who had experienced shock or pain, and which scents she could use to help. Once a man came in for a scented massage when she worked in a department store in London, she said. He had asked her to massage his stomach with essential oil.

"Why there?"

"It's where he had been injured," she said. He was an American, a soldier, a veteran of the war in Afghanistan. She used neroli oil, she explained, "because it's good for trauma."

I had told her, then, somewhat awkwardly, that I had a boyfriend in Afghanistan.

"I can't believe I just told you that story," she said, looking aghast.

"It's okay," I said. I didn't want to hide from the realities of war, or its aftermath. But part of me did want to keep this strange, insular world of fragrance and the troubles I was experiencing hidden from Matt, who was in Gardez, stuck in the smells of baking sand and human waste. I hadn't spoken with him since I arrived in France. He had been angry with me before I left. An anger that was out of his control, and out of mine, one that stemmed from his jealousy and my guilt. He was trapped and I was free. Neither of us knew how to cope. But I felt rejuvenated by the sight of his familiar face, the man I loved, someone who didn't know the difference between aldehyde and opoponax, between Yves Saint Laurent and Frederic Malle. Over the dim,

pixilated connection on our computers, I told Matt about the vetiver, which smelled deep and woody, like balsam. I told him about the violet, which had a hint of cucumber on the exhale. I told him I was afraid I would never train myself to be better, that I was afraid I would never be okay.

"I'll never trust myself in the kitchen again," I said, the words sprung unbidden to my lips. I hadn't been thinking about the kitchen. But then suddenly it made sense.

"Yes you will," Matt said, leaning in closer toward the camera. "You can cook. And you can smell. You just need to relax." I could see maps of Afghanistan hanging on the wall behind him. Here he was in one of the most dangerous places on earth, and I in one of the superb—and yet he managed to soothe my fears.

That night for dinner I met a classmate at a restaurant downtown. I ordered a Niçoise salad: fresh lettuce, hard-boiled egg, tuna, green beans, radish, tomato, and anchovy. It was fresh and flavorful, washed down with a glass of white wine, which was sweet with honey and fruit and cleared my palate of those lingering vestiges of scent. We watched the tourists and the locals walk by, the faint kiss of cigarette smoke hanging in the air. For dessert, we shared an *il flottante,* or "floating island," a light meringue nestled in a cloud of crème anglaise. The air smelled of lemon, and of salt. Later, I slept deeply, without dreams.

I walked from town to school the following Monday morning—up a long hill dotted with stucco-topped homes, past the bakery's aroma of espresso and warm butter croissants—feeling renewed. When I arrived at the lab, I sat down and began to study my notes. I was ready, once again, to smell, and I tucked into the day's materials with newfound enthusiasm. I smelled the

raw scents over and over, drilling them into my brain with repetition and a rejuvenated desire to learn.

I would relax. I couldn't let two measly weeks at perfume
school carry so much weight. Instead of giving in to my panic
when unable to place word to scent, I consciously relaxed my
shoulders, closed my eyes. I reminded myself: smells do not come
with words. Just let the letters go.

After lunch that afternoon, while milling about outside the
lab as we waited to resume work, one of my classmates, a voluptuous woman who worked in cosmetics and wore layers of
makeup so thick I wondered that if I touched her face it would
dent, told me that it would help to think in "triggers."

"Triggers?"

"Yes," she said, speaking slowly in her limited English. Using triggers to memorize smell was a technique she used when she trained
as a cosmeticist. "I use them to remember. Sometimes the triggers
relate to the smell."

"Like the dentist and clove?"

"Yes," she said, gesturing into the air as she grasped at her
words. "And sometimes they don't relate. Ylang-ylang, to me, is
sausage. Jasmine is butter." She shrugged and then laughed. "Try
it," she said.

I did. With each new scent, I began to consciously assign associations. I used colors and sounds. I resurrected memories both
vaporous and fine. I assigned them to the smells that conjured
them, bringing them back again and again, hoping to glue them
together as the odor molecules sent their signals to my brain. It
didn't always work. But sometimes it did. And once I began, I
couldn't stop.

As I smelled, I often thought of synesthesia, the neurologi-

cal condition in which the perception of separate senses become combined. In his memoir *Speak, Memory,* Vladimir Nabokov writes about hearing the sounds of the letters of the alphabet as colors. "The long *a* of the English alphabet (and it is this alphabet I have in mind farther on unless otherwise stated) has for me the tint of weathered wood, but a French *a* evokes polished ebony. This black group also includes hard *g* (vulcanized rubber) and *r* (a sooty rag being ripped). Oatmeal *n,* noodle-limp *l,* and the ivory-backed hand mirror of *o* take care of the whites. I am puzzled by my French *on* which I see as the brimming tension-surface of alcohol in a small glass," he wrote. There are those who taste shapes, see sound, or smell color. It comes in many different forms, and in many different levels. Matt, for example, sees numbers and letters as colors, as well as days of the week. He told me this for the first time when we were on a walk around Central Park. "You see the days of the week as colors?" I asked, floored. "Yes," he said. "The words for the days of the week are always in color. They always have been. I didn't realize this was strange until I was a teenager." Monday, he said, is blue. "Tuesday is a goldish brown or a brownish gold. Hard to describe. Wednesday is decidedly green. Thursday is light brown. Friday is purpleish. Saturday is matte gold. Sunday is red. Dark red." In synesthestes, it is believed that the barriers between the senses are significantly reduced. At perfume school I found that forcing myself to lessen the barriers—as much as I physically was able—helped me to remember each scent.

Geranium smelled floral and sour, minty and fresh. To me, it became the image of a shimmering green-blue swimming pool. Neroli was a long gray line, hovering again behind my eyelids, a few golden pinpricks of light above. Cedarwood be-

came the closet in the basement of my childhood home. It was a closet filled with mothballs and plastic containers of clothes, but a closet lined in the light wood that smelled of pencil shavings, the one where I would sometimes go to hide. Ylang-ylang, the delicate tropical flower that grows on trees in the Philippines with its overpowering floral with a slight animalistic edge, took me to Hawaii, where I visited my aunt often as a kid. Cystus, with its soft, warm balsamic notes, became the Boston Flower and Garden show, the massive indoor plant expo my father took me to each year. It was housed in a huge warehouse that smelled of dirt and plants, of green and brown. Once, he bought me a miniature cactus in a tiny earthenware pot, which I watched every day on the kitchen counter, as it slowly grew toward the sun.

We continued to smell eight hours a day. We smelled naturals: bergamot, petitgrain, galbanum. We smelled synthetics: benzoin, cedryl acetate, ambroxan, eugenol, phenylethyl aldehyde. Some were familiar, like patchouli and nutmeg. Others were strange: civet, isobutyl quinoline. But all, I felt, were beautiful. I repeated the names to myself on my walk home like poetry: opoponax, coumarin, labdanum.

When I inhaled over unlabeled blotters during a test the second week, I closed my eyes and recognized cedarwood by its closet, its pencil-shaving dream. I found the Hawaii of ylang-ylang and the flowers of cystus. I distinguished between mandarin and orange, because one looked more pink, and the other yellow, somewhere in the recesses of my mind. I was certainly not as successful as my classmates, who could complete Fauvel's tests with perfect scores, but I was improving.

One day I found the small note of cucumber in the raw ma-

terial violet. I got the mushroom to myrrh oil. Smell had never been so alive as it was around that table that final week. It changed and grew every day, with every scent, inviting colors and sounds and emotion with each breath. Is this why so many are intoxicated by perfume? I wondered. Is this what inspires? Is this why fragrance is considered an art?

By the final day, when I detected the bitter orange peel of neroli with the long gray line, the sun-speckled dots above, I felt the underpinnings of something that had long been foreign: confidence.

BACK IN NEW YORK, I made an appointment to visit Ron Winnegrad, director of the in-house perfume school at International Flavors and Fragrances. I wanted to witness another school in action, one with professionals and not in France. I wanted a glimpse into this world, which, like flavor, is shrouded in secrecy, an opaque trade, whispers abound.

I walked into Winnegrad's office one morning in August, accompanied by a member of the company's PR team. I shook hands with Winnegrad, who is a tall, thin man with a shock of gray hair and a tiny silver hoop earring in each ear. I fumbled for words for a moment, distracted by the thick stack of wood bracelets running up each of his arms, his loud-colored tie, and the mismatched, primary-hued socks, which I could see peeking from beneath the cuffs of his pants. And then there were the teddy bears. His office was filled with stuffed animal bears big and small, brown and purple and blue. There were dozens of them lining shelves and tables across the large room.

We sat at a table near the window. A teddy bear named

Gris—"for Grisly Bear," Winnegrad explained—sat between us, wearing a vest covered in small pins.

"What have you got?" he asked, sitting back almost shyly in his chair.

I began by asking about the school, which he opened in 2002 and from which only sixteen students had graduated seven years later. But Winnegrad wouldn't tell me much. He couldn't. The secrecy enveloping much of the industry is fierce, and perfumers are often wary of press. His teaching methods, he said, were proprietary. There were only a few things he would share.

He told me that he concentrates on teaching only three hundred of the fifteen hundred raw materials frequently used in perfume, a small percentage compared with Fauvel's techniques in Grasse. His students work less with triggers to enhance memory, and instead rely on the repetition of smelling and smelling and smelling again.

I wondered if he had noticed that some of his students had a greater propensity to smell. "Or is it all training?" I asked.

"It's passion," he told me, simply. Passion and training, that is. "You can have all the passion in the world, but if you don't have the basic skills, it's not going to get you to do what you should be doing. And it's the reverse also: you can have great skills but if you don't have the passion . . ." He trailed off.

"Have you always had the passion?"

"Yeah, I think so," he said, speaking louder. "I still have it."

Winnegrad had a vibrant career creating fragrances for the mass market before he began teaching full-time. He was mentored by the now legendary Jean-Claude Ellena, who is the head perfumer at Hermès and today lives in the hills near Grasse.

Winnegrad, who grew up in Brooklyn, loves to teach. He loves

the way his students' eyes light up when they suddenly under-stand a scent or a concept. He loves to have fun in the classroom, combining the other senses into exercises involving such things as watercolor paint. For him, color is big. I could see that in his own paintings—mainly of bears—framed and hung around his office. Emotion is big, too. But that doesn't mean he's soft. When Winnegrad really likes a student, he told me with a laugh, "I tell them that they're full of shit. It's my highest form of compliment."

Intrigued by his synesthetic approach, I asked him how his other senses worked when he made perfume. He gave me an ex-ample.

Once, he explained, there was a customer who wanted a fra-grance. She knew what kind of fragrance she wanted and had de-scribed it in the formal manner, which is through a brief, a memo handed out to perfumers willing to try, a competition of sorts. This particular customer knew Winnegrad, though. She knew he didn't work in words. So she took him aside.

"I want you to forget everything I said," she told him. "All I want is this: if you held a piece of marble in your hand, you know how cold it feels?"

He said yeah.

"You know how it gets warm from your body temperature?" she asked.

He nodded.

"I want that transition," she said. "That's what I want."

Winnegrad smiled, and said: "To me, that made much more sense than any of the words."

He had an assistant bring out a sample of that stone-warming fragrance. He dipped a blotter within and handed it to me. I in-haled. I could smell it—fresh and cool to start. I nodded, breath-

ing in and out. He had used juniper and pepper, he said, among many other things. I put down the blotter for a moment, to let it rest. A few minutes later I smelled again. Indeed, it was warm. The transition, as Fauvel would say, was magic.

"I can see the stone," I said.

Winnegrad looked at me, inquisitively. "How much can you smell?" he asked, already knowing my story of loss and regain.

"Well, I'm not sure," I said, immediately nervous. I began to speak too quickly. "I'm pretty sure I can smell. Everything? Yes. I can smell everything. But recognition is still a problem."

He sat up straight in his chair and nodded.

"Well, let's see," he said.

He picked up a small brown bottle from a box on the table, and then a blotter from a jar nearby. My heart began to race. It had been at least a month since I returned from Grasse, no longer a practiced student of perfume. What if I failed? What if I had lost it all? I wanted to slink out of my seat, melt into a puddle on the floor.

Winnegrad handed me the white paper strip. "Now tell me what you smell," he said.

I inhaled over the strip, my mind racing. I could smell it. The scent was familiar. But I was immediately devoid of words.

"I, um . . ." I trailed off. "Well, I . . . I don't know."

"Never say that in this room," he said, suddenly harsh. "You cannot say you don't know."

"Okay," I said, embarrassed, my cheeks red hot.

"Try again. Close your eyes." His voice was again calm. I took a few deep breaths before I lifted the blotter again to my nose. I reminded myself to relax. I inhaled and exhaled three times over the strip.

"I smell hay," I began, slowly. "I smell a little bit of wood, some citrus notes. I smell bark and field."

"Something cool?" he prodded. "Tangy?"

"Yes."

Inhale. Exhale.

"I'll give you three options," he said, "and you decide . . . camphor, mint, wintergreen."

I seized up. I couldn't remember camphor. I guessed it anyway.

"No," he said. "It's mint. And there's a flower, too."

"Violet?" I asked. I detected a cucumber, somewhere to the side.

"No," he said. "Now you're thinking too much. You just wanted to smell violet. It's rose."

Suddenly it all became clear. "It's geranium," I said.

"Good work," he said. I smiled with relief, my heart still banging away in my chest.

"You *can* smell," he said, leaning in toward the table, moving Gris a bit to the side. "It's a confidence thing." And then he laughed a warm, enveloping laugh. He paused for a moment, and then took a breath. "I could teach you, but I'd have to beat you up a bit. You're afraid to be wrong," he said. "You think too much."

I nodded. I forgot that I was supposed to be interviewing him. I forgot about everything but that moment, the scent of geranium still lingering in the air.

"You can't hide behind not smelling," he added, and then smiled.

"Also, you're full of shit."

Later, on my way out, Winnegrad handed me a teddy bear—a tiny light brown one, the size of my palm, a tiny orange ribbon

tied in a bow around his neck. "This is for you," he said. "Put it someplace where you'll see it. So that you remember that you can smell."

PERFUME SCHOOL HAD CONCLUDED on a Friday, and for my final day in France, I took the train to Cannes, only a half hour away. The shops and cafés were filled with bikini-clad tourists. I walked through the old section of town and ate a bowl of tart yogurt-flavored gelato on the beach. I entered Taizo, a niche perfume shop recommended to me by Fauvel, around lunchtime and spent a few minutes talking to a clerk, a handsome young Frenchman who had spent some time studying in London.

He asked me what I liked to smell. I thought of rosemary, of neroli, of cedarwood and clove. I told him that I liked woodsy, spicy scents.

He brought me samples from the artfully arranged shelves around us, spraying the perfumes on blotters, and letting me sniff. I was shocked at the complexity of the aromas presented, as I had grown so used to immersing myself in the single note materials of the lab. But in the shop, I smelled many perfumes— rich ones hauntingly so. I smelled bright ones and dim ones, floral and fruity and fine. After a half hour, I had narrowed my favorites down to two: Miller Harris's *L'air de Rien* and Frederic Malle's *Noir Epices*. We sprayed one on my right forearm, and the other on my left.

"Come back in a few hours," he said. "And then you will know."

I walked along the street in the direction of the water, sniffing one arm then the other. When I got to the beach, which was

filled with bronzed vacationers tanning on the sand and small kids with castles, it smelled of Coppertone lotion and the Nutella-filled crepes sold nearby on the street. I continued to place my nose on the warm flesh of my wrists, inhaling over and over. I loved the glowing spice of the *Noir Epices,* and the amber pale of the *L'air de Rien*—"the air of nothing," I translated in my rudimentary French, and smiled. That's a scent that I already knew. They both changed, slowly, as the hours progressed. I found myself migrating toward the darkness of the *Noir* and decided that I would buy it. I wanted to remember this moment, one in which I felt so content.

As I returned to the store in the late afternoon, the hot pink of a sunburn just beginning to emerge on my cheeks, I thought of my mother, who had once worn perfume every single day, that lilac scent that I had bought her in Italy as a gift. She had stopped wearing any fragrance at all after my accident. "For solidarity," she had said. She hadn't told me that for years, though. She didn't want me to feel responsible for how deeply my loss affected our family. The *L'air de Rien* on my right arm, with its light, gossamer tone felt right for her.

In the end, I bought them both.

epilogue

MATT RETURNED FROM AFGHANISTAN EARLY on a Thursday morning in March 2010. When he arrived, I had been at the airport in Atlanta, Georgia, waiting for hours among a small crowd of military wives and girlfriends, many who held signs that read welcome home. We watched one uniformed soldier after another emerge from the terminal to our smiling crowd, which burst with applause after each entrance. When Matt finally ascended the top of the escalator—looking tired, dressed in his war-worn fatigues—I shimmied under the rope separating the arrivals from the gate and leapt into his arms.

I could feel my fear begin to melt in the soft warmth of touch, of flesh and cloth, of nose against nose. It seemed strange that an event so long anticipated could so suddenly come.

Matt looked different. His face was skinnier, but his torso had a new muscled bulk. His army-short hair gave rise to a ridged skull and his boots were covered in dust. But beneath the scent of recycled air off the long trip from Kabul, I could detect the same Gillette deodorant, the same Dove soap. I inhaled and exhaled, my face scrunched up by his neck. He smelled of sweat, of breath, of the caramel notes to skin. Our kiss tasted of cinnamon gum. Just like before.

We spent the next week in Georgia. Matt had to finish up the stacks of paperwork that were involved in arriving home from war. We stayed together in a nondescript hotel off the side of the highway halfway between Savannah and Fort Stewart. Matt had his evenings free, and we drove a plastic-scented rental car into the city to wander under the soft southern evening light. We poked around antique shops and art galleries. We walked along the river running through town. I slowly grew used to the feel of my hand in his, the low tone of his voice, the slow wheeze of his breath at night. But I couldn't wait to go home. I couldn't wait to cook.

I had been thinking a lot about the stove. With the gradual return of my sense of smell, my kitchen skills had undeniably improved. I had cooked many meals for my family and friends while Matt was in Afghanistan—some of them phenomenal, others just okay, but all of them cooked with confidence, consumed with both flavor and, more important, fun. My ability to smell the details of Moroccan mint and lemon thyme arrived accompanied by a renewed use of intuition and improvisation, uncluttered creativity at the stove.

The short time that I had worked at the Craigie Street Bistrot was frequently on my mind. I thought about the hours I

spent plucking the blossoms and leaves off fresh stalks of mar-
joram, wild sorrel, burnet, and a pungent black basil. The hours
I chopped *cornichons,* or tiny pickles, into a microscopic mince
for garnishes, and the hours I peeled garlic and onions, tears
streaming down my cheeks. I thought about the various stages
of veal stock, an aromatic pot that had always been bubbling on
the back burner, strained and intensified over and over before
its flavor was fully deepened. I remembered the rhythm of water
and soap as I washed those heavy, greasy dishes at the sink. I re-
membered the arthritis in my hands. But, mainly, I thought about
the woman I was then, five years before. I had been so confident
in my future. I had been so sure that I had found my passion, my
vocation, myself.

Will you go to culinary school? I was often asked now, on the eve
of Matt's return. After all, I could smell. I could taste. Why not?

I had thought about it. Originally, I wanted to learn the art
of the stove to get at something more, and that desire still held
strong. But there I was in Brooklyn, more confused, more hap-
hazard, less sure of everything I once thought I knew. Except for
one thing: I knew now that I could cook. Perhaps not in the way I
once wanted. I wasn't sure of the proper technique to fillet thirty
pounds of tuna, to julienne bags of carrots, to cure pork belly.
But with the concentration and practice that had come alongside
my loss and the frustrating pace of my regain, I had learned. I
could concentrate on the small things, the living details of our
rich sensory world, ones that brought people together over the
table, the ones that could transcend culture and time. Perhaps
more than ever before. Perhaps I had become exactly what I once
wanted.

When Matt returned, on our first night together in my tiny

Brooklyn studio, I broke out the sauté pan and chef's knife. I had been thinking about this evening for months—reading cookbooks and culinary magazines, preparing a menu to impress. I wanted Matt to notice my olfactory training, to notice how much I had improved. He would see my attention to detail, taste my nuance of spice. I wanted Matt to eat and to think: *Wow.*

I would cook scallops—a smooth set of diver scallops, seared on the stove, served with a sauce of tarragon-infused *beurre blanc.* A lemon risotto, luscious with white wine and salty cheese. A shaved fennel salad with green apple, arugula, and lemon oil. A chocolate soufflé. I looked up where I could buy the best seafood, the finest greens. But when I asked Matt if he cared whether or not we had goat cheese or brie with the fig spread from France, he just looked at me silently for a moment. And I immediately changed my mind.

Over the last year, Matt had eaten loveless dinners cooked in bulk by companies contracted by the army—soulless and soggy broccoli, rubbery chicken-fried steak, beef soaked in the sweat of a day on the steam table. Alcohol was not allowed on deployment, and Matt missed the dark tang of his favorite German beer alongside a meal. In Afghanistan, he often ate alone.

I thought of the day that past winter when I had decided to bake a loaf of zucchini bread. I had used a recipe from my stepmother, Cyndi. It was a simple recipe that made a moist, flavorful loaf, one that Matt had once tried on a visit and talked about ever since. I shredded the squash into a thick pile of green, mixed it with flour and sugar and eggs. It came out of the oven golden brown, scented a pale garden-sweet. I let it cool and then wrapped it carefully in layers of plastic and foil. I tucked it in a box, and took it to the post office. When it arrived at the army

base in Afghanistan, fourteen days later, Matt told me that it had been marred by a few splotches of mold. But, he said, that didn't matter. He had shared it with friends and they had finished it in a day. It was the best they had ever had.

"You ate it with the mold?" I asked, a bit repulsed.

"We cut out the most egregious spots."

Back in Brooklyn, I crumpled up the sheet of paper where I had scribbled my potential menu, thankful that I had not already gone shopping for a pricey load of ingredients. I had recently read *Home Cooking,* a classic book by writer and cook Laurie Colwin, and her words jumped immediately to mind. "When life is hard and the day has been long the ideal dinner is not four perfect courses, each in a lovely pool of sauce whose ambrosial flavors are like nothing ever before tasted," she writes, "but rather something comforting and savory, easy on the digestion— something that makes one feel, if even for only a minute, that one is safe."

I decided to roast two sweet potatoes, pricking their skins with my fork and laying them on a piece of foil in the oven. I decided to steam a pile of asparagus, served with butter and Parmesan and a spritz of lemon juice as they hit the plate. I would pound two chicken breasts thin between sheets of plastic wrap, dredge them in flour, and then sauté until golden brown. I would reduce down their sauce with mushrooms and sweet Marsala wine.

In theory, this meal would be perfect. Earth orange, bright green, and golden brown, it would be visually pleasing and texturally warm. It would be simple but beautiful, executed exactly. The flavors would be balanced yet bold. Matt would be impressed with the ease to which I could show my love in food.

Things didn't go exactly as planned.

I didn't have a mallet to pound the chicken so I used an empty wine bottle instead, which I had trouble handling, and left the meat stringy and too thin. As I dredged the pieces in a shallow pie plate, I knocked against the table and sent puffy sheets of flour into the room, falling like rain. Distracted, I left the sauté pan with its layer of olive oil on the heat for too long, and when I began to cook the chicken, smoke billowed up, crowding the unventilated kitchen like a cloud of volcanic ash. The smoke alarm began to scream.

As Matt stood on the bed in his socks, waving a towel in the air to quiet its piercing wail, I opened windows and swung a broom with both hands to dispel the smoke. After a few minutes, the alarm grew quiet. But then I turned the chicken too early and it finished with a disappointing, halfhearted shade of brown.

I scurried around to put together my sauce: I sliced the mushrooms, which smelled dark and earthy with that little lichen taint. I peeled open the box of chicken stock—"I would have made it from scratch," I said by way of apology, even while knowing Matt wouldn't care, "but I didn't have time!"—and poured it to deglaze the pan. I stepped back to pick up the Marsala on the counter, but felt my foot slip on the slick, flour-coated floor below. I felt one leg, and then the other, fly high into the air. My body lifted up, my torso hanging parallel to the ground. And then I landed. Hard.

"Shit!"

Matt rushed over to pull me to my feet. "Are you okay?" he asked, hands on my shoulders. "That was quite a fall."

I nodded. I could already feel the welt blossoming on my

right hip—a bruise that would stain my side in neon shades of purple and blue for weeks.

When we finally sat at the table, my leg ached and the asparagus had already grown cold. Sweat caused my T-shirt to cling to the small of my back. I looked at the kitchen behind me, with its greasy counters and dirty pans piled in the sink.

But we poured two glasses of red wine and toasted ourselves. "To home," he said, lifting his up, clinking it against mine. I took a sip, which tasted familiar, a burgundy bronze. I willed my frustration away. The food was plain, and the kitchen a mess, but Matt was home and I was cooking. We began to eat.

I had forgotten the butter in the sauce, and left the Parmesan untouched and unremembered in the fridge. The asparagus was a bit tough, and the sweet potatoes, plain. But I could taste the green to the vegetable, the tangy citrus bite. I could taste the earth of the mushrooms, and the sweet depth to the Marsala wine. I relished the heat of the potato and the glisten of butter against its orange flesh. For a moment, I didn't think about the flavors I could not detect, or what their absence meant. This plate, this bite, this breath—right here, right now, they didn't need to make sense. I looked at Matt, who sat comfortably across from me, happy and near. We laughed as we ate. We clinked together another glass of wine. We both scraped our plates clean.

ACKNOWLEDGMENTS

This book began many years ago, as a desperate attempt to understand what had happened to my sense of smell, and what it would be like to live without it. I started to report and to write because that felt less terrifying than waiting, which was all I was told to do. I could not have gotten very far without help. Lots of help. For every single person who was generous with his or her time, interest, e-mail, money and, most important, encouragement: thank you. I have never felt so humbled and so lucky as I have while working on *Season to Taste*.

Thank you, first, to all of the scientists who took the time—lots of time, multiple times—to meet with me and explain (and re-explain) his or her work, especially Richard Doty, Stuart Firestein, Rachel Herz, and the folks at Monell.

Thank you to all of the experts who let me step into their worlds and their work: Oliver Sacks, whose knowledge seems to have no bounds, and Ron Winnegrad, whose kindness has touched my life much further than this book. To Christophe Laudamiel, Robert Pinsky, Ellie Kellman-Grosinger and everyone in her lab, Laurence Fauvel and the whole crew at the Grasse Institute of Perfumery. To Grant Achatz: I will never forget that meal.

And, of course, thank you to all of the anosmics who spoke with me and e-mailed with me, opening their lives to my pen, allowing all of us to feel a little less alone. To Debbie and Robbi, Matthew and Bobby. Especially to Vito, who, I'm so happy to report, has almost completely regained his normal sense of smell.

This book crystallized under the watchful eyes of Sam Freedman and Kelly McMasters, phenomenal teachers who challenged me to reach further than I thought I could. It would have been impossible without Anna Stein, who believed in it, and Matt Weiland, whose tireless edits and almost inhuman enthusiasm, made it real. Also to Dan Halpern, Rachel Bressler, Allison Saltzman, and all the rest at Ecco; and to Janet Hill, whose beautiful work appears on the front cover, and to Suet Yee Chong, who did the interior—thank you, thank you all.

Thank you to all members of Neuwrite, to Erin Savner, who read the manuscript with a watchful neuroscience eye, and to Therese Ragen, who listened to me babble about smell for years. To the Woodstock Byrdcliffe Guild, to DW Gibson, and to the folks at the Ledig House for giving me the space and the silence to write. To all the good friends who cooked with me, ate with me, and distracted me when I needed to escape: Becca, Katia, Ben, Philissa, Sarah, Emily, Ashley, Jon, and David, to name only a few. Thank you to Alex, whose generosity and spirit have pushed me to be better since the first day we met.

Finally, thank you to Mom, Dad, and Ben, to Cyndi, and to Charley: you all have picked me up from my lowest and kept me standing at my most confused. And thank you to Matt, who read every page of this book, multiple times, even from the mountainous wastelands of Afghanistan. I would be lost without you all.